S0-AEV-845

factoriesinthesnow
textbylilianhaberer
worksbyliamgillick

jrp|ringier

LIAM GILLICK
PARALLEL THINKING BETWEEN STRUCTURE AND FICTION

LIAM GILLICK
FACTORIES IN THE SNOW

What meanings do the recognition and demonstration of structures and processes and their underlying principles generate in modern society? The tendency to identify certain developments as comparable and draw conclusions from them is not confined to analysts, strategists, or scientists, but is also the subject of artistic observation. But unlike a collation of empirical data made in order to render structures readable, artistic thinking is more freely construed, as an analogue of the "picture." Directions towards action or the description of a project both operate differently. The analogue of the picture corresponds to what Aleida Assmann refers to as "wild semiosis": "staring" and "gazing," the interplay between a quick look and the long gaze (the "referential" and "transitory process" and the "mediative act") into layers of meaning in the picture, into a language of things, which takes place beyond a determination of principles and economic and political analysis.[1]

What if this very process of discovering connections and structures itself became the subject of analysis? What if both were involved, the scrutiny itself and the method of the scrutiny as an instrument of cognition?

Liam Gillick reflects both operations in his installations, books, and scripts, which function as artistic works that propose a mixture of fictional narration and analysis of communicative and structural processes. His works meander between formal placing in space, a reflection between text and subtext, and function between narrative strand and parallel narration. In each element there is also simultaneously implicit a parallel level that sheds a different light on the ideas reflected in his works. And at the same time it is that parallel itself which is subjected to an ongoing, playful scrutiny in the installations and texts. In the face of the dialectic principle Gillick proposes a parallel principle, which does not select possible antagonisms in order to create a complex picture, but looks for structural similarities in different "pictures" or levels. His interest focuses on models that could play a role in analysis and political planning, which are enacted by scenarios, but also reflects upon parallel societies such as communes, or on key figures within economic and political development.

His books, which are just as much works of art as his installations, frequently have a model in literature. B.F. Skinner's *Walden Two* was the source for ideas about the commune and search for utopia in *Literally No Place*, 2002. Edward Bellamy's *Looking Backward 2000–1888* echoes the flickering between times in *Erasmus is Late*, 1995— Gillick's London travel guide as time travel. And Gillick reprinted Bellamy's novel and Gabriel Tarde's *Underground (Fragments of Future Histories)* with a text updated from the original 1904 translation. With these books it is first and foremost social Utopias that interest the artist. But here it is not so much the examples of a forecast and projected vision of the future customarily used in narrative from the much-debated tradition of Utopian literature, as the unusualness of the Utopias selected by him that

is remarkable. What knowledge could the revised 1998 version of Bellamy's retrospective offer towards the end of the 20th century? He was looking at his own 19th century from a fictional 20th century he had invented in a book written in 1890 as social criticism. And what potential for ideas for today is concealed in Gabriel Tarde's 1896 vision of a future aesthetically-minded community living underground in the year 2489 following an ecological exodus? Generally the new editions go hand in hand with a critique by the artist of the firmly fixed models of Utopia, but in each case it is a radical figure of thought that Liam Gillick updates for contemporary questions and puts up for discussion with these revised editions.

SHOULD THE FUTURE HELP THE PAST?
TEMPORALIZED HISTORY AND UTOPIA

FLASH #1

A dark brown, unevenly undulating carpet is spread out right across the front of the exhibition area and is reminiscent of an imaginary landscape or the crust on the surface of an as yet unnamed planet. Towards the middle of the space a little mound of carpet appears and on top of it stands a Brionvega Cuboglass television showing a text animation with a disconnected computer score derived from Early Music. All of this creates the frame for Gabriel Tarde's book, *Underground (Fragments of Future Histories)*, which has been reissued in a new edition by Gillick for an exhibition at Micheline Szwajcer gallery in Antwerp in 2004. The artist installed a setting for his book that reminds us of Tarde's vision of the future—moving into the interior of the earth after an exodus, and continuing to live a new artistic and philosophical life in an architecture with no exterior. In the rear of the space, however, with four platforms made of transparent brown Plexiglas hanging at slightly different heights, and a work by the American conceptual artist Allen Ruppersberg borrowed from the gallery storage, Gillick has created a place that intensifies, and also a place of self-reference. The emptiness and expanse of the front exhibition area, which conjures up Gabriel Tarde's Utopian scenario by means of text and sound alone, are given a different focus by means of the works presented in the rear exhibition area. In parallel with this metaphorical landscape Allen Ruppersberg's works, which also use multimedia, reflect themes such as recollection and memory; in this context they relate to Tarde, so introducing a self-conscious historical level of commentary within the art context.

In the exhibition, Tarde's formulations become explicitly apparent: in Utopia a new aestheticized life can be realized on a historical basis, even if the underground living space no longer demonstrates any connection to the living conditions of the present day. The surviving population in *Underground* is guided in its artistic disciplines by the Greek ideal of classical Antiquity, memory has become a substantial constituent for the new society and is

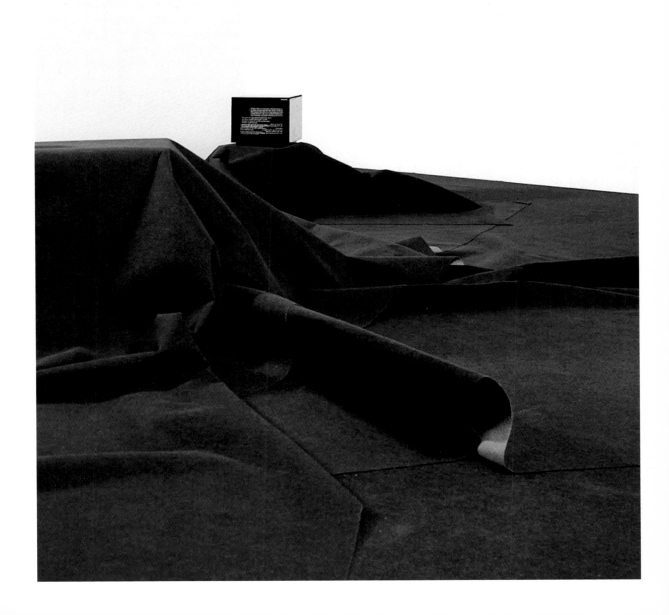

the method for passing on tradition and spatial conceptions of the old world. It is revealing that, in the ancient mnemonic technique, which expands natural memory with artificial memory by means of a special learning technique, the contents to be remembered are recorded in pictorial formulae and are often assigned to specific places in an equated yet differentiated space. The method goes back to the Greek, Simonides of Keos; during a banquet he was called outside, so escaping the fateful collapse of the house, which buried the guests. He was able to identify the unrecognizable victims due to his memory of the seating order.[2] The fact that forms of remembering are linked to space has a long tradition, since, as Aleida Assmann describes, building metaphors in memory is linked to different forms of recollection. She describes the library (knowledge of the past and the present) and the temple (a memento for the future) as the best-known metaphors of cultural memory.[3]

Social Utopias and the evaluation of past and present social systems via the writing of their history are themes frequently discussed in Gillick's work. The multiplicity of the Utopias cited and a critical review of them by Gillick show his fundamental interest in structures and evaluations of temporal categories and their spatial manifestations, which ultimately constitute history. The historian Reinhart Koselleck notes a change in the perception of history since the 18th century, as the categories of space and time are increasingly related to one another, and consciousness of a "new time" or "New Age" with its present history is set against the primacy of past history. Koselleck has made a central contribution to the anthropology of historical temporal experience with his observation that since the end of the 18th century our experience of time has become more dynamic and history has been temporalized—i.e. "by virtue of passing, time changes today at a pace and with increasing distance even in the past, or to put it more precisely: time arises in its relative truth of the moment."[4] His concept of temporalization ("Verzeitlichung") or even of "futures past" describes an aspect of the perception of time which Gillick, with various works on memory of the future, has recognized and formulated as having considerable potential for models of thought. Arthur Lovejoy, Georg Simmel, and Koselleck came up with a term which, rather than adopting Heidegger's idea of temporalization, used a different one: it is not pure temporality that causes content to become a historical event, nor understanding of the content; the content only becomes historical if it is temporalized on the basis of timeless understanding.[5] This means that qualitatively the temporal dimensions of past, present, and future are enmeshed in one another so that the beginning of a new history appears over and over again. Hence the whole view of past history changes too; thus history itself becomes the temporal structure, and is temporalized. The new time in each case becomes the "indicator of an accelerated historical transformation of experience and its heightened processing by the consciousness."[6] Koselleck devotes himself to the concept of temporalization with respect to Utopia; his findings have relevance for Bellamy's Utopian novel *Looking Backward 2000–1888* in particular,

but also for Gillick's *Erasmus is Late*. He describes the temporalization of Utopia as an incursion of the future into what used to be a spatial Utopia.

In one of his essays on the scenario, Gillick considers the question, "Should the future help the past?" or to put it another way, the temporalization of Utopia. In his text "ILL TEMPO. The Corruption of Time in Recent Art," he points out how thinking about the future changes the future.[7] For Gillick this theme represents considerable potential for altered perception and its influence on human action. At the same time he emphasizes that temporal understanding as an element of visual practice is of importance not only for him, but also for contemporary art production.

The idea of jumping to and fro between times is presented in Gillick's story *Erasmus is Late* through Erasmus Darwin's conversations with figures from different historical eras as he walks through Georgian London. This 1995 "travel guide" moves back and forth between 1810 and the near future of 1997. The book form itself also echoes this mental flicking forwards and backwards, and hence a time-free understanding. The idea of "prevision," i.e. seeing forward, is a key concept in Gillick's work; it does not refer to pure forecasting, but to the description of an event before it happens. As Kant put it, this prevision is derived from the power of the imagination, a foreseeing that contains desire and entails looking back at the past in order to make the future possible.[8] Thus Gillick's pre-vision corresponds in Kant to a mixture of "presentiment" ("praesensio") and "advance expectation" ("praesagitio"). "Prevision" can be seen particularly strongly in the realms of film and fiction (by means of flashbacks and time slips), while it can even be brought into action as a theme, for example in the form of time travel. To this extent the questions raised by temporalization and those raised by "prevision" are close to one another, as filmic and narrative structures can be implemented in a similar and specific way. The simultaneous image of space and text can be generated in both mediums via the technique of temporalization. While the Utopian idea is not subject to any fixed place in space and time, it operates here, as well as in Gillick's other works, as a model, and has a normative function for social life.

PRODUCTION AND THE SPACE OF DIFFERENCE

"The mental space left by the reduction of our needs is taken up by those talents— artistic, poetic, and scientific—which multiply and take deep root. They become the true needs of society. They spring from a necessity to produce and not from a necessity to consume."[9]

A quotation from Gabriel Tarde appears before the main text of *Underground* in Gillick's reissued and updated edition of the book. It is the concept of production that Tarde

an experimental factory

recent closure of the plant

primary activity produce objects

methods of production to alleviate

the most destructive aspects of life

on the production line

subsequent discovery and closure

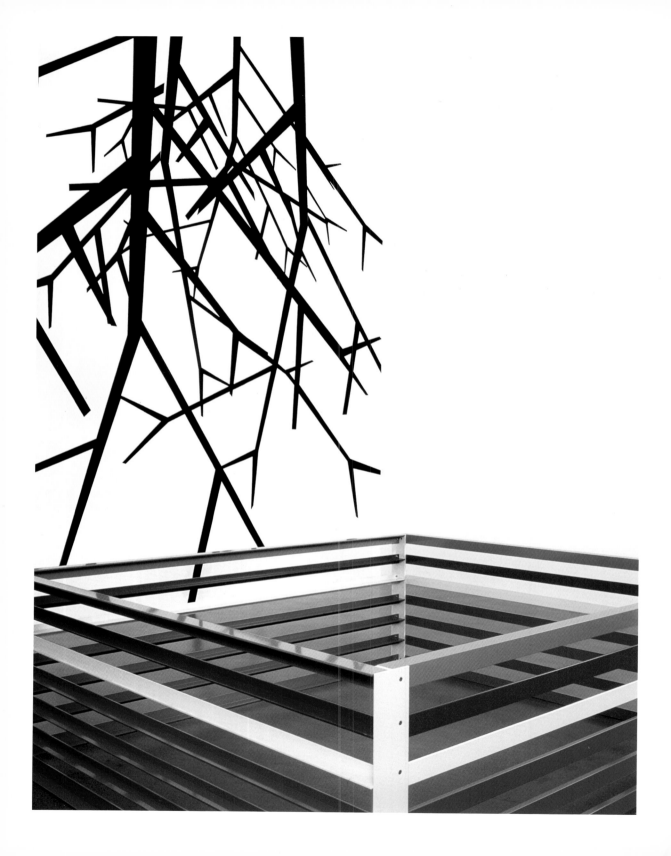

emphasizes as an essential function of society. At the time his book was published Tarde must have been familiar with the concept of production according to Karl Marx and Friedrich Engels; they saw production as an element constituting the social system around which interests and power crystallized. However, in Chapter 5 of *Underground*, which deals with the constitution of a new quasi-religious aestheticism as the basis of a new society, Tarde explicitly rejects the ideas of socialism. According to Tarde, being traditional visionaries, the socialists had been unable to realize their vision of a new social life, as they had concentrated on the development of commercial and industrial life instead of promoting the ideals of a true, aesthetic life.[10] Tarde does not perceive himself as part of Utopian socialism, although his design for society is in the tradition of a socialist Utopia (since Thomas More in *Utopia*, written in 1516, had opposed feudalism and recalled the polis of antiquity). Instead he promotes an underground life that reproduces the achievements of a classical antiquity where the concept of production is assigned an important role, primarily in the arts.

What is unusual in his Utopia is the role of aesthetics and the fine arts within society, even if Tarde, operating completely in the spirit of the 19th century, places them on the level of restoration and reproduction. Hegel, in his lectures on aesthetics in the first half of the 19th century, had already described production as an intellectual activity by human beings in which they reproduce themselves (their thinking) outwardly, for example in a work of art, in order to gain a new view of themselves.[11]

Now these words are placed at the front of an updated text by Liam Gillick in the reissue of the book as a key concept; this raises the question of whether this concept of intellectual and material production is again playing a role, and to what extent new functions are assigned to it from today's point of view.

Gillick has applied his thoughts about the processes of change in society and how it is organized to a new project that he has been exploring since 2004 in a series of exhibitions and lectures with the overall title *Construcción de Uno*; the ideas may be brought together in a new book or left as a productive process in their own right.[12] The concept of production is important here. The text starts with the consideration of a factory in Sweden that has recently closed down. He proceeds to examine how the former workers deal with this situation and how they develop new models of working practice in their new idle situation. The artist wrote the outline text on the basis of research material regarding new working practices in Brazilian factories derived from academic papers focusing on progressive Swedish production models dating from the 1970s.

Both Gillick's presentations and his texts fluctuate between the consideration of fundamental social questions and fictional plots describing the ongoing development

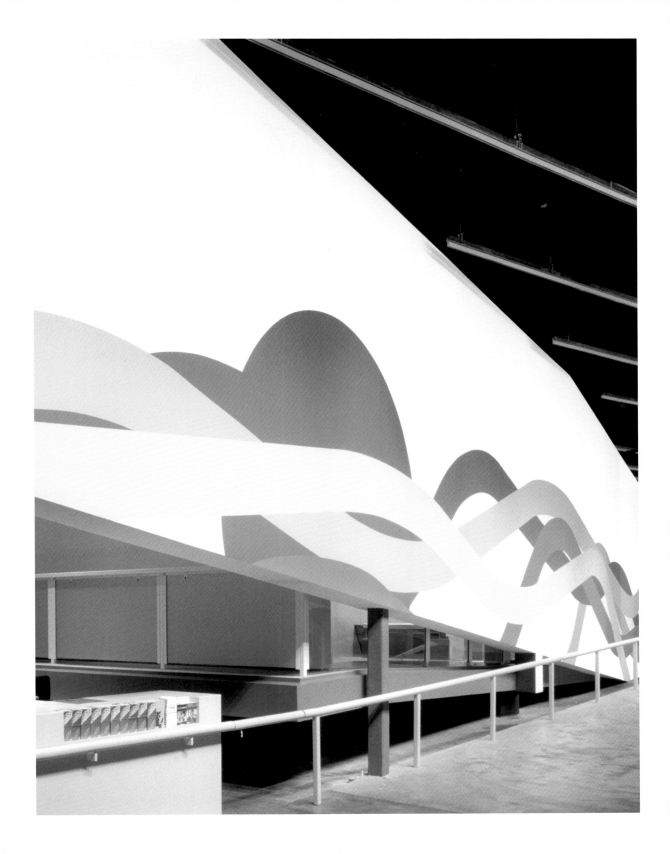

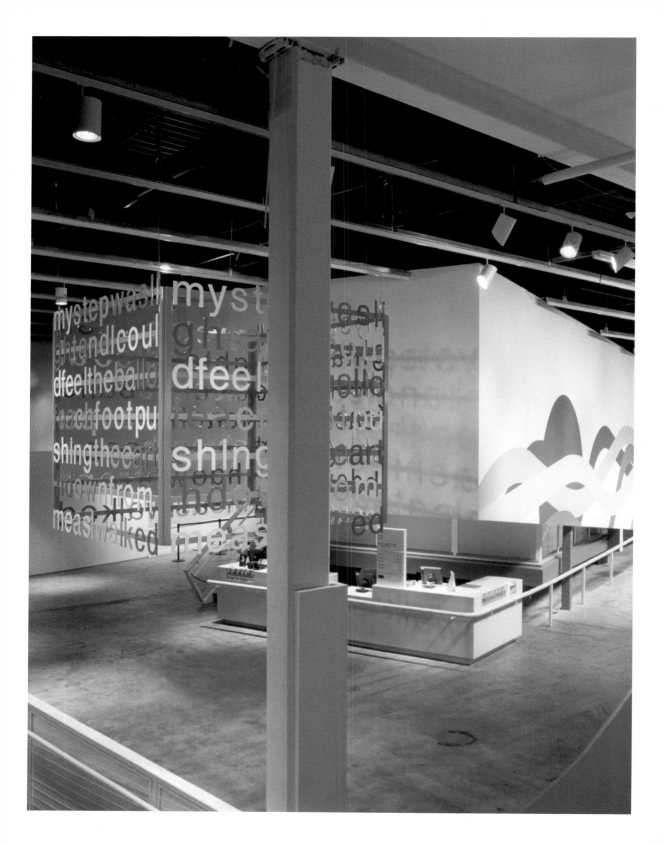

of the former employees, and their separatist or integrative behavior with respect to cooperative techniques towards the formulation of new models. He explains how, after the closure of the factory, deliberations about the progressive working model of this experimental car factory with its non-hierarchical dimension and breakdown into infinitely flexible production processes gave way to the post-employment phase. After initial anxiety about how to exist in a well-funded redundancy, the employees develop new thoughts about the experimental forms of work and redistribution they had been involved in. Their new model proposes a situation where those employed become part of an idea that does not elevate personal equality to be the paradigm, but reflects on the idea of the creation of an "economy of equivalence." In this economy it is a matter of making units correspond, units such as energy, time, ecology, and efficiency, which are weighed against one another. In order to become part of the production process again, the former workers in Gillick's structure reflect on production conditions and the collapses inherent in flexible working practices, while seeking to revolutionize the process with new concepts concerning exchange value.

These ideas immediately remind us of Karl Marx's notion of the opposing relations of use value and exchange value. A situation where categories such as work and working time are understood as exchange values. In its details, the "economy of equivalence" or correspondence outlined by Gillick may have a similarity with the comparison of values. But the exchange value in Marx was measured according to the laws of the market, by supply and demand. In Gillick's economy we confront measurable units that are equated to one another in terms of input and output, but above all, he is presenting an experimental method. Henri Lefebvre sees a dynamic, dialectical relationship in such concepts. For him, use and exchange represent essential categories of everyday life and promote the political occupation of space.[13] Thus in Gillick's project thought is given to the old "new" models from the 1970s such as flexible working hours and production techniques, that had led to the eventual closure of the factory following a brief return to standard practices. With respect to this concept of post-production, which describes a new process of value categories and active leaps of thought, it is important to remember Lefebvre's questions about how work occupies space and engenders it and how a product occupies space and circulates within it. For space itself is generated via the relationship of things (products/works), but also via communicative and social factors, which are becoming ever more visible, although analyzing them has become more obscure.[14] This is what Liam Gillick describes in his concentration on one locality: how space is generated differently depending upon structural decision-making, but also how it is altered by the dynamics of a new group of people who reflect upon fundamentally new production relationships, permanently splitting up and reassembling the value of things and ideas. Lefebvre stresses that social space infiltrates the concept of production and penetrates into its conception.[15]

Gillick develops the themes of the project as a criticism of the socio-ecological debate and as a means to formulate questions regarding the extent to which ideas about political and social progress have been co-opted by the marketing of ecological models and concerns (e.g. a car manufacturer making grand claims about the ecological value of their product). There are four development factors, which Gillick elucidates using the example of the recently closed experimental factory: stagnation/crippling in the post-employment phase; depression at the failed attempts to establish flexibility and models in the recent past, the return to the traditional production line just before closure; and as a third factor he defines a sense of "negative potential" which, while it represents an impetus for change, cannot ultimately really achieve it and may possibly again lead to the necessity to revert to traditional forms of social revolution; finally he describes the introduction of a form of exchange economy by means of a constant revolution of relations that causes production to become a constantly evolving exchange of abstract and concrete values. Thus he does nothing other than name four stages of possible development following a fundamental intervention into a local production model. In this case shifts in group dynamics and analyses of the potential of temporary group-ings and their actions play an important role. Gillick's investigation therefore does not seem to differ much from that of an analyst of social processes, were it not for the fictional elements and the use of art as the place of reflection and presentation.

In 1996 the literary scholar Fredric Jameson made a precise analysis of various constructions of Marxism as it currently exists, and in the process highlighted aspects that support Gillick's ideas. Jameson sees the originally socialist idea of freedom as being endangered by the provocative element of the discourse and anti-Utopian fears of change. He suggests identifying these processes by means of diagnosis and making space for a radical change. Accordingly, revolution as a Marxist idea where theory and practice form an entity does not mean implementing piecemeal reform which then proves illusory, but in the literal sense means recognizing the need for a change and implementing it simultaneously in a non-violent process. Jameson regards the uncoupling of certain areas and the continuation of social change in an altered social system as a necessary step for a fundamental transformation. Thus on an abstract level he sees the current themes such as unemployment, financial speculation, and major changes in society as connected categories. Jameson favors the idea of holding onto the negative as a way of coming up with new unexpected possibilities.[16] In this way negative potential is arranged as a trigger for a possible development, so favoring Gillick's technique of filtering out the thinking and development elements of dynamic processes from analysis, and presenting them as intitiators for the alteration of micro-processes.

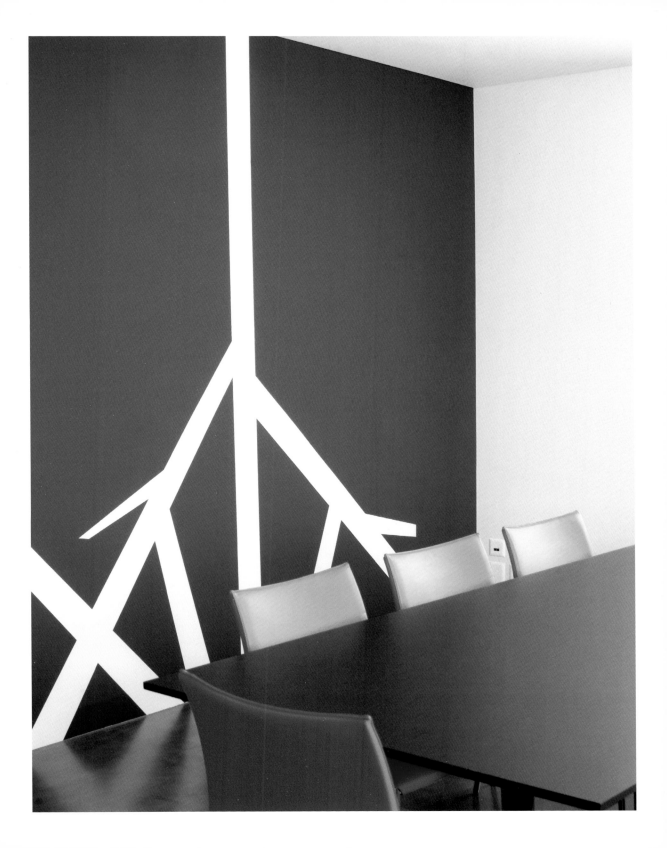

In January 2005 a wall of posters, all in a striking red color, is installed in the foyer of the Palais de Tokyo in Paris. The poster takes the form of a T-shirt design with an upraised clenched fist announcing an "economy of equivalence." At the same time Gillick's exhibition, titled *A Short Essay on the Possibility of an Economy of Equivalence*, is installed in the adjacent space. The poster wall opens up to a view of a mountainous silhouette of brightly-painted layered steel sheets, and at the rear of this area stands a structure made from multicoloured steel extrusions resembling the skeleton or sketch of a steel building, and derived from the schematized structure of a factory building. Between the installations the floor surface is fitted with narrow ramps leading to each structure, and the gap between them is strewn with 100 kilograms of red glitter, which is gradually carried into all the exhibition areas. Here are two poles that produce the rhythm between work and leisure: the countryside surroundings and the "factory" as a place that structures everyday working life. The installations sway between a concrete picture of nature and the schematized sketch of the place of work. The places providing social space are very different from natural space, Lefebvre notes. They are not simply arranged side by side, but overlay one another, enter into alliance, or can collide with one another.

Accompanying the installation Gillick has set up a reading room and invited the education group of the Palais de Tokyo to select a film program. Here the film *Week-end à Sochaux* (1971) by the French Groupe Medvedkine from Sochaux, is shown. At the beginning of the 1970s this group made films about everyday working life at the Peugeot factory, and protested against the conditions there, using fictional and documentary elements, to which Gillick explicitly refers in his scripts for *Construcción de Uno*.

The Groupe Medvedkine was formed in response to Chris Marker's 1968 film based on interviews, *A bientôt j'espère* (*Be Seeing You*) about an abandoned strike at Rhône-Poulenc's Rhodiaceta textile factory in Besançon. On reflection the emerging group felt that the viewpoint of the film was too far removed from the workers' environment. The name of the subsequent film collective came from the Soviet film director Alexander Medvedkine, who in the 1930s had a cinema train fitted out, completely equipped for film production and projection. He used this mobile site to edit films on the spot and screen them immediately. The group was formed predominantly from workers from the factories in Besançon and later from Sochaux too; the film directors Chris Marker and from time to time Jean-Luc Godard worked alongside them. The production of a color film just long enough to function as a feature film was an important factor for the group. Accordingly, in *Week-end à Sochaux* there is one protagonist who goes from factory to factory and later on organizes the workers' strike, as well individual narrative elements such as Peugeot's employment tests and the description of everyday working life. These scenes are combined with documentary material about a workers' uprising and

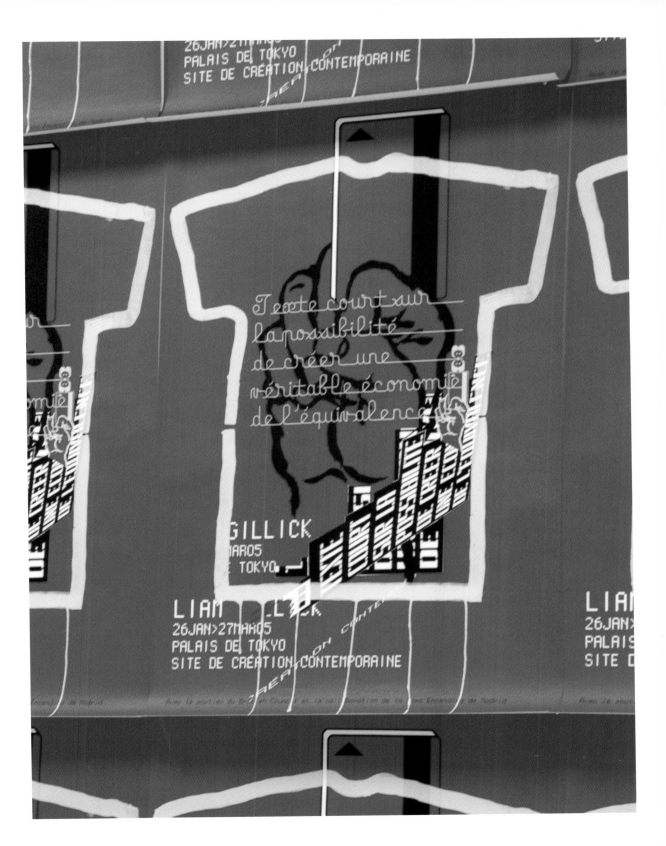

interviews, as well as passages of film—acoustically backed by a speech-sound collage, of the factory environment and the rhythm of work—these provide an aesthetic and abstract portrait of the workplace.

Week-end à Sochaux shows several phases ranging from the engagement of new workers, methods of work rationalization, rules and regulations in the factory, and collectively organized acceptance of the ideas and wishes of the protagonists. Fiction and documentation here generate their own, modulated film language that describes how state power attempts to dominate the social space of work and reduce the natural contradictions that materialize with the workers and their activities (Lefebvre). State and company power, employee powerlessness, and the resistance resulting from them were the themes of the workers' movement of the 1970s, which Gillick also uses as a foil and material for his workers' scenario and their subsequent reassessment of self-organization. However, his focus is directed primarily on progressive models that are motivated partly from the need for different constellations in the post-employment phase, and partly from a vision about new concepts of production. The source of these changes also lies in new 1970s approaches; they were the nucleus of his analysis and go along with observations about subsequent departures from the European social model of the post-war period.

Therefore it is questions about social conditions that preoccupy Gillick too: how does a different form of work organization change the social space? To what extent does a spatialization of power take place as a result of changes to and occupation of the original place of production? For Lefebvre the predominance of space is the most favored form of endowing space with power, which means controlling social processes. To counteract abstract space as a tool for predominance, and counter an economization and functionalization of the town as a profitable entity, the space theorist Henri Lefebvre formulated his theory of the space of difference. Space cannot come about unless it is produced by differences. Therefore he defines differences between what is conceived and what is directly lived, between the smallest and greatest variations, and among them the self-caused and exogenously, i.e. externally generated, differences.

CONCEPT AND PROVISIONAL STRUCTURES

A characteristic feature of Gillick's scenarios that emerges before the books have been completed (a feature that also resurfaces in the book *Literally No Place*) is the dominance of the concept over the completed text. So far he has produced his books after varied trials and scenarios; only in the case of the developing concept around *Construcción de Uno* does it remain uncertain whether a book is still needed after these varied descriptions of social behavior lying between fiction and general observation, a theme the artist also takes up towards the end of the text. In sketching out of a series

of models that name essential elements of social communal living by way of example, there is just as much, possibly more, potential for structural exploration as in a fully elaborated book version of his project. Gillick's concepts preserve the status of the "provisional," a key word frequently used by him that always indicates a possible alteration. Turning to the vague and provisional could attract criticism of a procedure that is not fully formulated; however, it is a necessity for Gillick to formulate a vocabulary of analysis and fiction that highlights the triggers of processes via alterations and radical changes as he goes along. The choice of chapter titles in *Discussion Island/ Big Conference Centre* published in 1997, his most extensive book so far, is guided by interfaces of communicative exchange: conciliation, compromise, negotiation, consensus, and review, which can turn a drama based on the dialogue between representatives from the worlds of politics or business, depending on the circumstances, into instruments of diplomacy or statesmanlike change. Consideration must be given to the situational context as well as to the communicative models as it is also a factor in generating situations of radical change. So there are places that serve as a model for Gillick's exploration of various phenomena (for instance the house of the opium eater Erasmus Darwin in *Erasmus is Late*, or the conference center of *Discussion Island/Big Conference Centre*), which in turn prompted ideas for an extensive series of sculptures and installations made of plywood and cloth, and later aluminum and translucent Plexiglas, intervening in the space and structuring it with a sequence of provisional forms that could function as a backdrop to activity and speculative thought.

As a synonym for (non-place) Utopia, *Literally No Place* deals with a commune as a counter-design to existing society, but unlike other locations it highlights the absence of a place or social condition that can by reached by the senses or the mind. The theme of unattainability is apparent in the reference works' attempt to describe Utopias, as well as in Gillick's versions. However, his focus is primarily on communication within the commune (*Literally No Place*), between state representatives of the political middle ground (*Discussion Island/Big Conference Centre*) or even between the formative characters from epochs (*McNamara* and *Erasmus is Late*).

EN ABYME—PARALLEL STRUCTURE AS INTERNAL REFLECTION

FLASH #3

The narrow tree trunks rising vertically upwards are ramified at their tips into a dense network of branches. This impenetrable thicket of a winter wood is only explained by a long look at what is in fact a stylized sequence of small and large trees, and hence the same structure repeated. The logo that Liam Gillick designed for the Frankfurter Kunstverein in 1998 directs attention at viewers' perception and their way of looking. At first it suggests a materialization of the rhizome described by Gilles Deleuze and Félix Guattari who visualized the hierarchical organization of knowledge by

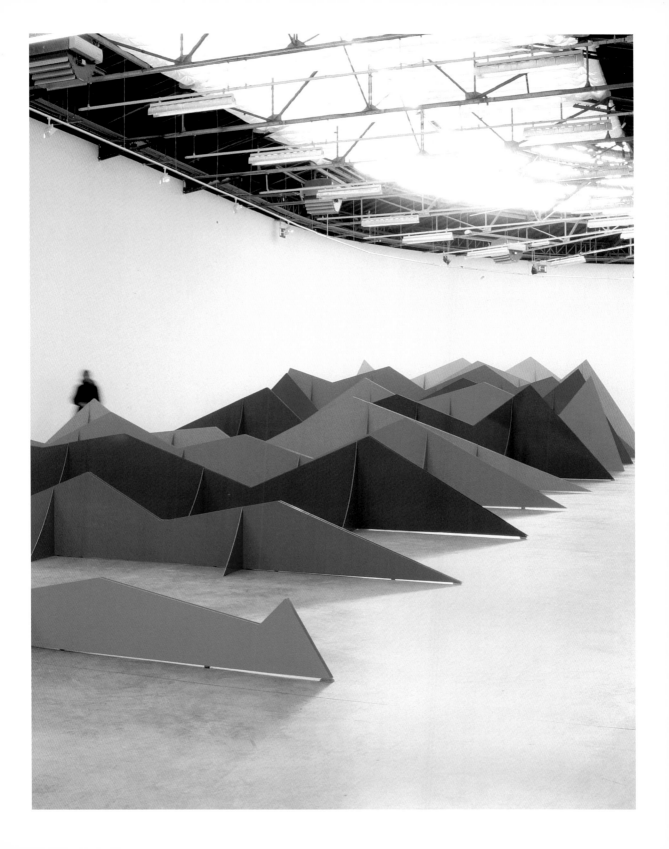

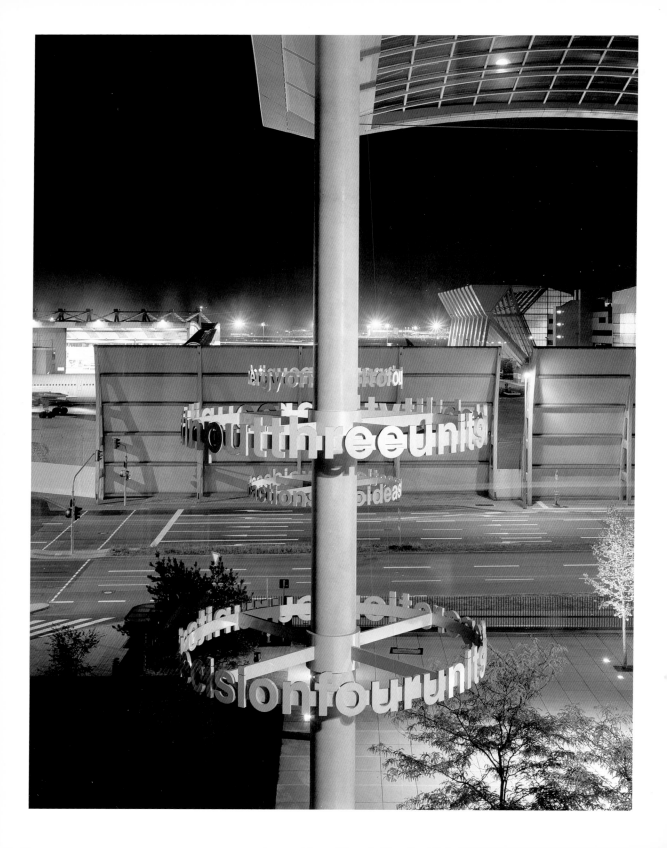

means of a network composed of roots. "A first type of book is the root-book. The tree is already the image of the world, or the root the image of the world tree [...] The law of the book is the law of reflection, the One that becomes two."[17] On closer inspection the sign consists quite simply of the endless repetition of the same complex form which perception and recognition challenge anew.

The logo for the Frankfurter Kunstverein represents a compact early example of a series of works and installations in which internal reflection is a central theme. This series was produced mainly from 2000 on in connection with his book *Literally No Place*, which Liam Gillick published shortly before his solo exhibition at the Whitechapel Gallery in London. The text, with its two subordinate titles *Communes, Bars and Greenrooms* and *Ethics, Conscience and the Revision of Form in the Built World*, plays with the structure of three elements. In the first subtitle three different places, or rather non-places (according to Marc Augé—transitional places with no historical ties), are presented, locating his stories which were originally planned as radio plays. The second subtitle refers to the subjects treated in the text, which can again be assigned to the three places, "ethics" (for the social), "conscience" (for personal perception), and "revision of form" (for an exemplary transitional place where ideas for new forms of town and society are generated). But the central focus is on the structure of the text: there are three narrators who tell three stories within the commune. The first thinks about another commune, the second about a bar, and the third about all three scenarios. How often the projection of the stories is undertaken on different narrative levels is deliberately left open. One theme is the duplication of the scenarios by means of the these different narrative levels, for example in the "Commune," where the framing story is mirrored by a micro story. The same happens in the "Greenroom," which as a non-place or a transitional place between narrative levels again reflects all places, and hence ultimately refers right back to the author's narrative level.

Gillick's installations likewise play with reflection and internal mirroring as a figure of thought in parallel to his texts. *Literally No Place* was introduced during the exhibition *Indiscipline* curated by Barbara Vanderlinden and Jens Hoffmann, with an improvised script presented live as an attempt to speak a book in real time with little or no preparation. His exhibitions such as *Literally No Place* at the Galerie Air de Paris in 2000 and *The Wood Way* in 2002 at the Whitechapel Gallery in London brought a whole spectrum of reflection and refraction before our eyes in installations made from translucent room dividers and platforms. In exhibitions such as *Övningskörning (Driving Practice)* at Milwaukee Art Museum in 2004, the doubling of a narrative structure was present in freely suspended sections of text made from aluminum outlining the first stages of the project *Construcción de Uno*.

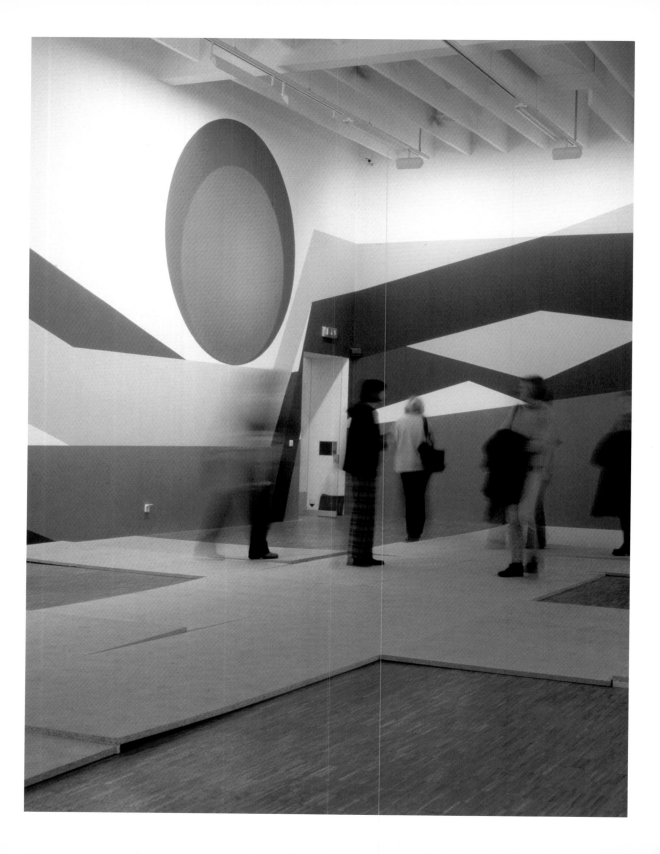

The principle of internal mirroring means duplicating a pictorial or textual element and reflecting it on various levels. In this process the mirrored textual or pictorial figures should demonstrate the same structure. This structural principle, referred to in French as *mise en abyme*, comes from literary theory and goes back to André Gide's book *Tentative Amoureuse*.[18] In a passage from his *Journal* with personal notes, Gide thinks about the theme of doubling and about the reciprocity between the subject acting in the novel and the theme that is presented. In his opinion, there is an indirect reflection of the same subject between the real and the imagined theme. By way of illustration he compares *mise en abyme* with the convex mirrors in Dutch paintings by artists like Hans Memling or Quentin Massys, in which a mirror often shows an imaginary pictorial space that is not directly depicted. The real theme is revealed only by means of the reflection. As a comparison Gide takes a procedure from heraldry where the same emblem is often represented within an emblem in a coat of arms, and the author describes this as being embedded *en abyme*. Jean Ricardou applied this principle to the French nouveau roman of the 1950s as a story within a story, in attempting to express the influence that the work has on its author as much as the relationship of the author to his or her fiction.[19] He also sees André Gide's text as a reference to Victor Hugo, who wrote explicitly about double actions in which ideas are repeated within a bigger and smaller dramatic narrative, as with an echo.[20] Accordingly, *mise en abyme* means the endless duplication and reflection of the same motif on different levels. This introduces the refraction of a unified action and a difference in perception as well as an additional level of meaning, which in the endless mirroring refers back again to the author.

Apart from a text by the art critic Craig Owens written in 1978 about the endless mirroring in photography, this phenomenon has hardly been discussed in art history up to now.[21] However, it serves as a tool for analyzing the work of Liam Gillick. The doubling, and the internal reflection of a picture, story, or text, can be described as his key theme. The artist addresses this via parallel thinking and the establishment of parallel levels within his working practice. Parallel structuring has been a concept in art since the 1990s; however, it has rarely been so explicitly articulated. The idea of the parallel and the extent to which it has to do with endlessly reflected elements has been set out in an exemplary way in some exhibitions. In his analysis of the mirror motif in the photographic process, Owens refers to examples of repetition from structural linguistics and classical rhetoric, which show how semantic lexical meaning arises through duplication. He transfers this process to the photographic technique and claims for the photograph the capacity to generate meaning independently of the structure of reality onto light-sensitive film. *Mise en abyme* is therefore described as an internal mirroring which not only contributes to a fragmentation of the motif, but indicates an inner reality (independent of the visible theme of the text or picture) which has become independent of the idea of an endlessly continuing process.

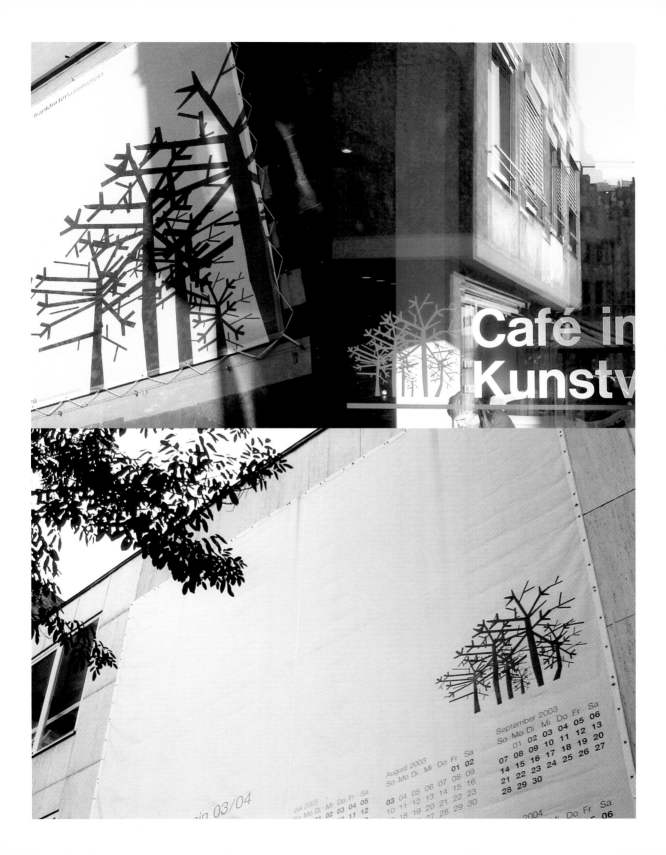

In his installations Liam Gillick uses text in the form of an unending chain made of vinyl or aluminum letters that are laid out in rows with no breaks between the letters or words. Sentences used can also consist of cubes or circles made of powder-coated aluminum which reciprocally overlay or repeat one another: for instance in *Consciens Lobby*, 2001, a commission he designed for Telenor in Oslo, or his installation *Literally (structure and diagram)* at The Museum of Modern Art, New York, in 2003; *Idea Horizons* for Fort Lauderdale/Hollywood Airport in 2002; or his *Övningskörning (Driving Practice)* exhibition at Milwaukee Art Museum in 2004.

At Telenor, the Norwegian telecom company, Gillick designed a work for the lobby of the building that is intended to promote communication and the exchange of ideas at the point of entry or exit from the building. At first glance the hanging, multicolored cube seems to structure the space as a creative element alone; but the repeated phrase "Wittes Learning and Studie"[22] becomes a message to be committed to memory, and which will now characterize the place. For The Museum of Modern Art in New York Gillick's transparent cube structure consists of a key sentence from *Literally No Place*, created in a yellow and orange color spectrum. "My step was light and I could feel the ball of each foot pushing the sand down from me as I walked." This sentence was originally borrowed from B.F. Skinner's *Walden Two*:[23] the transfigured version of an alternative model of society which Gillick analyzed critically for his own text. While at the end of his text Skinner depicts the auspicious future of a parallel society, in *Literally No Place* the sentence is used twice, and as the prelude to a problematic situation in which the members of a commune are moving in a circular journey in an attempt to leave the commune, in a literal and metaphorical sense. In Gillick's text the sentence has the dual function of explaining the change between different narrative levels and levels of reflection, and of relating transitions between the different story frameworks. At The Museum of Modern Art the installation seems to float freely in space, and yet the mirrored text acts as a focus for initial and final observations and therefore forms a framework for the itinerary through the museum, the work functioning like a corrective in the exhibition space from its location just above the ticket desk.

At Fort Lauderdale/Hollywood Airport, the glass curtain wall of the building was altered by the application of long strips of text in various sizes. In accordance with Craig Owens' conclusion that the mirror effect in linguistics points beyond the lexical meaning in its significance, Gillick's design for the facade, *Idea Horizons*, works with endlessly repeated and strung-together words that play with the connotations of the place, even if the mirror effect here is of a different order than photography. The repetition of syllables and words seems to reflect the automation of daily processes at the place. In addition, as a result of the use of a varied repetition, the combinations of words assume their own dynamics and take on a certain tempo that represents a

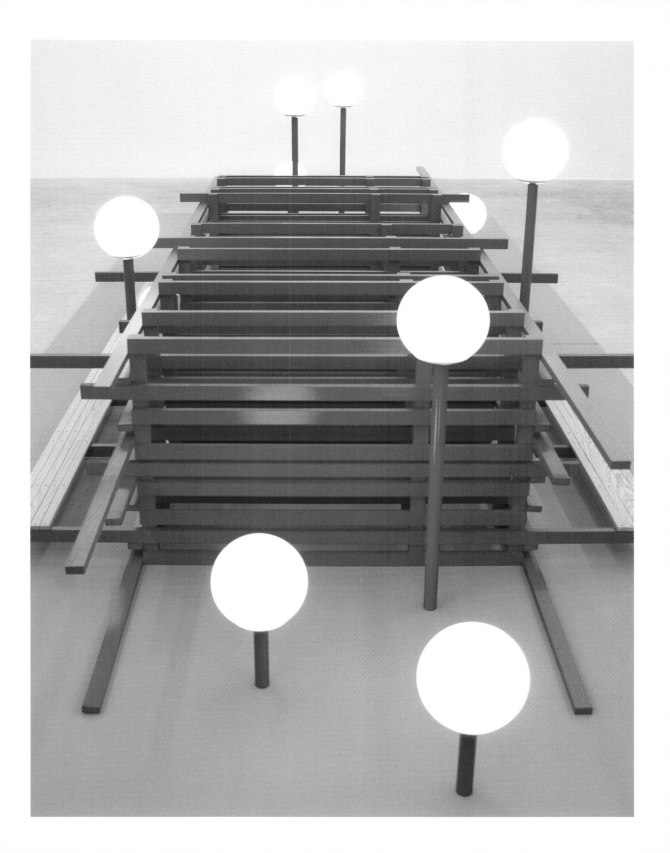

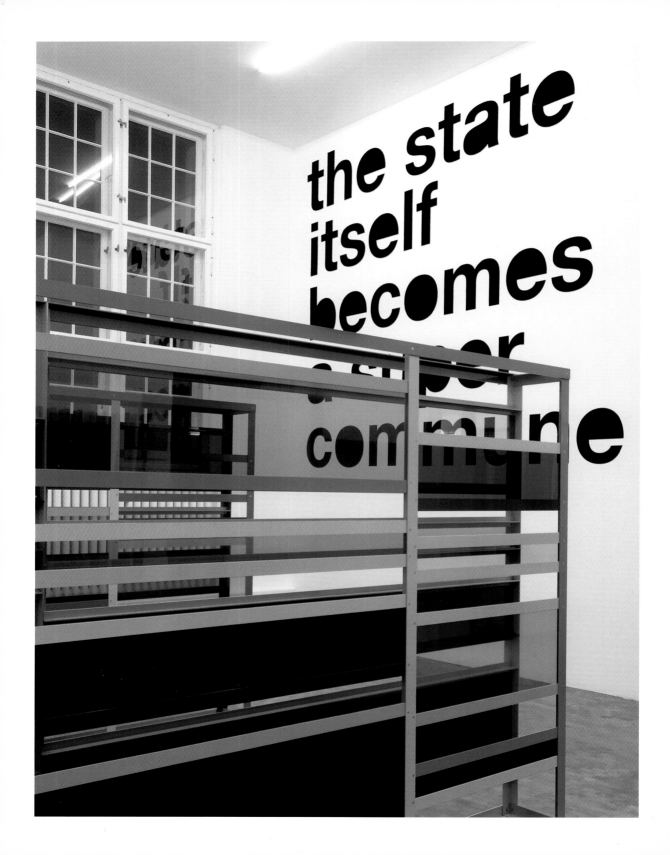

the state
itself
becomes
a super
commune

correspondence to the principles of speed and movement in this place, as with the word combination "gliding by gliding by and gliding by," for example.

In 2004 Liam Gillick created an installation of free-hanging text elements arranged one behind the other for a long gallery space at the Milwaukee Art Museum. The title *Övningskörning (Driving Practice)* refers to the factor of movement which has central significance for the conception of this installation—the lines of text are disclosed only gradually as the viewer moves through the space.

FLASH #4

A long, open corridor with a sloping roof penetrated by windows on one side. The skeletal architecture of white wall pillars which turn gradually into ceiling supports has a diaphanous structure. The white ceiling and the gleaming white marble floor provide those passing through with little or no spatial orientation. It seems to be a non-place representing a staging point for other places, like the open seating areas in airport departure lounges. Horizontal black strips of text are visible below the ceiling, ranged along the corridor in straight lines and floating freely in the air, becoming decipherable only by walking down through the space. Do they designate the beginning of a story? Are they an echo of individual concepts? The reflective floor creates a refracted mirror for the text. The way through the space, step by step, from start to finish, generates the description of a scenario: "an experimental factory—recent closure of the plant—primary activity produce objects—methods of production to alleviate the most destructive aspects of life on the production line."

All words are strung together, seeming to have no beginning and no end. The installation becomes a *stream of consciousness*, an inner monologue, similar to the everyday stream of thought that accompanies the visitor. But the work does have a focus: a general reflection about production conditions and work processes in a factory. The corridor at Milwaukee Art Museum is an unusual exhibition space: it feels like an airport corridor. In either place, the work would function primarily through a stream of visitors moving along the passage. It operates as a space such as Marc Augé has described, in which the movement of the images prompts the viewer to assume the existence of a past and gain the fleeting impression of a possible future.[24] Augé describes the space of duplicated and parallel movement for the traveler as an archetype of the non-place, in which isolated impressions surge up in the memory and a fictional relationship develops between the traveler's gaze and his or her surroundings. To that extent, the corridor in the museum, aside from its function as a transit area from one exhibition room to the next through which people are constantly moving, exists solely through the thoughts and the impressions of the traveler who brings the place into existence as a unique specificity.

As a result of reflection, the intervention in the exhibition area turns into a double flow of text: a description overhead in space and an indecipherable

LILIAN HABERER
PARALLEL THINKING BETWEEN STRUCTURE AND FICTION

stream of thoughts on the floor. The text opens the eyes to the description of an industrial space. The infiniteness of the non-place is therefore lent contrast by the idea of an actual place. Both elements are grasped by the visitor in a synchronous moment.

The ambiguity of the gaze resulting from the *mise en abyme* technique in an endlessly reflected space or in a story finds definition in what Liam Gillick calls "parallel structure." This concept designates both a mental and a formal principle and has to do with two autonomous and independent processes or scenarios, which are nonetheless related to each other; only in looking at both structures together does each principle shed light on the other and make a new interpretation of the other field possible. The concept can equally signify the shift to a different level, or a structure, action, or story created in parallel to the notional source or multiplying scenarios. For Gillick, parallel processes represent a formal, contextual tool, and hence a different form of thinking about and a different way of receiving cultural production. Attention focuses on the receiver and his or her capacity to grasp two or more independent elements that are chronologically or structurally parallel at one glance. We are not dealing with a general form of comparison as the levels of the elements here are different and independent of one another. It is only the process of parallel observation that brings enlightenment and gives a broader idea of the other principle in each case.

Gillick describes parallel thinking as a process and an inspiration for the visualization of art that is not expressed in unified constructions, but in provisional structures.[25] If meaning in the postmodern work of art—as Markus Brüderlin stresses—arises from the relationship of tension between "aesthetic experience and discursive reflection," looking at Gillick's works ranged alongside one another, consisting of installations and books or scripts, is illuminating.[26] With respect to Gillick's unpublished script *Robert McNamara*, 1994, and the installations created at the same time as "parallel artworks," Stephan Schmidt-Wulffen points out the change in perception that happens as a consequence of looking at the script and the object together. Because of the adoption of low-tech film production mechanisms, the works, whether they involve an animated cartoon film, sketches, or slides, appear as a collective that allows a gradual interpretation. Gillick often uses the concept of the scenario for thought processes: on the basis of a simultaneous presentation of differing perceptions of discursive areas, the boundaries between author and receiver, thinking and acting, object and idea are called into question.[27] Looking in parallel favors a field of endless communicative exchange beyond subjectivist staring, as Nicolas Bourriaud expresses it: a movement in art where inter-subjectivity represents the substratum and the central theme is the meeting between the viewer and the work of art.

The Wood Way was the title of a solo exhibition at the Whitechapel Art Gallery in London in 2002 that brought together the various groups of works Liam Gillick had produced in relation to the book *Discussion Island/Big Conference Centre*, with some allusions to earlier and subsequent projects through the inclusion of wall texts, and the simultaneous publication of the book *Literally No Place* on the opening night of the exhibition. The title is a literal translation of the German expression, "auf dem Holzweg sein," i.e. to be on the wrong track or lost in the woods. The use of a direct German concept meant that it had to be explained in English. So in her introduction to the Whitechapel catalogue, Iwona Blazwick pointed out that taking the wrong path, in the metaphorical sense, means getting lost in the tangle of one's own thoughts. The title also describes the classic non-place, for according to Augé's definition, such a location does not represent an anthropological place bearing the imprint of human relations (a relational place), but is instead a place of transit in which decisions can alter directions or formations of thought and action, and which can also be exploited in a productive way.

FLASH #5

A wooden structure designed as a see-through room divider consisting of planks arranged longitudinally facing one another, with platforms and projection walls on either side, forms a ramified path through the exhibition space. The subdivision of the space longitudinally and transversally produces an itinerary with separate recesses, making it possible to group artworks in different ways. The view of texts made of vinyl letters stuck on the rear walls of the gallery is primarily provided through the translucent Plexiglas walls of the artworks. The wooden structure concentrates the works exhibited into the middle of the room. On the one hand the structure fulfils a separating, articulating function, on the other it ensures that different visual connections are created when looking through it, while the inside of the structure is preserved. The wooden floor of the gallery has been wiped with vodka, water, and brilliant silver and gold glitter. The exhibition begins in the foyer with six platforms, and there are other formal alterations in the lecture room and café by means of chair covers, wall texts, and ceiling designs. Between the entrance area and the exhibition area the artist has inserted, almost unnoticed, a two-leaf glass door with a wooden frame on one side, like the eye of a needle. The glass allows a direct view of the exhibition space and ensures conscious access into a different space, which in his original architecture is open. Gillick originally renovated the door in 1997 when converting the entrance to Le Consortium in Dijon during his exhibition there, *Documentary Realization Zone 1# to 3# (Part)*, and it seems to give the whole exhibition a frame, although it actually represents the linking element between the outside and the inside of the presentation. The brass doorknob supports this impression of a frame, as it functions as a concave mirror that reflects the view of the exhibition. A detail photograph in the catalogue underlines this interpretation. The view of the exhibition with its unusual wooden structure is now duplicated in the mirror in the sense of the *mise en*

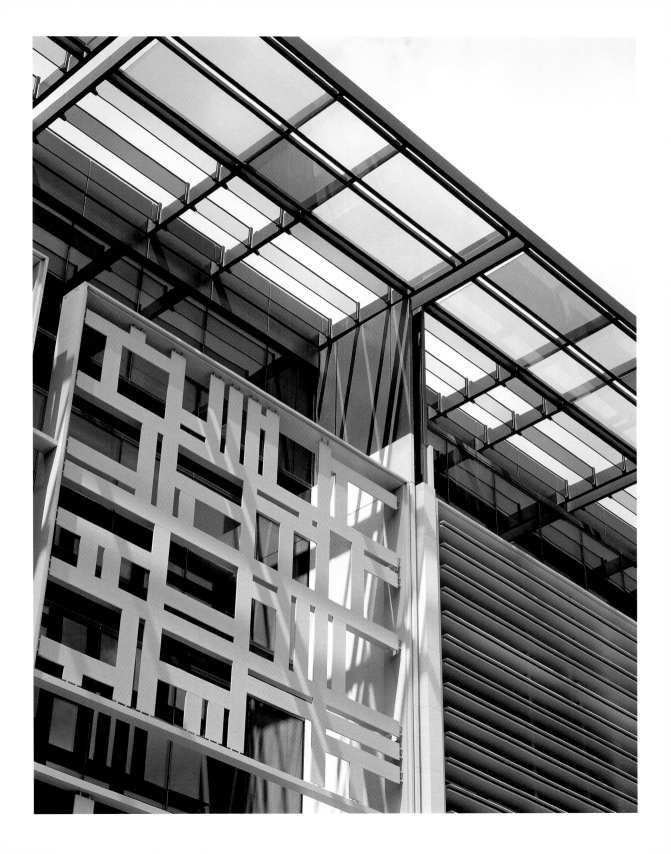

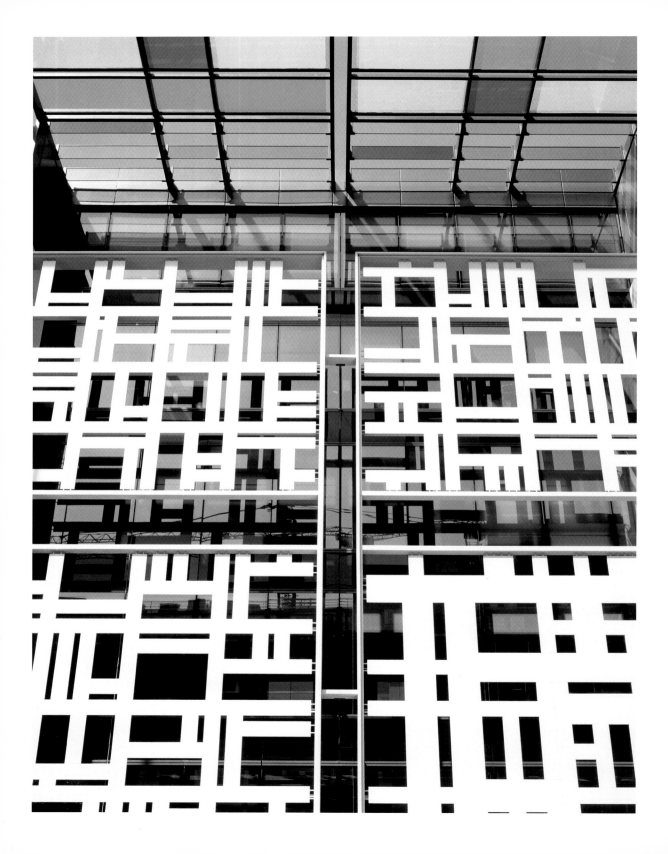

abyme; as in Flemish interiors, the mirror reflects more than just the view from the entrance—it also reflects the visitor and the photographer.

The Wood Way brings to mind the descriptions at the beginning and end of *Literally No Place*, where the group from the commune has set out on a long march on foot. While at the beginning of the book they get lost in a thicket, at the end of the book the situation has been transformed into a productive one in which they have covered a good distance. Just as the sentence "My step was light… " frames Gillick's text formally, as with his use of the door (renovation/relocation), there is a playful element in the metaphor of the sentence, a metaphor that changes depending on its position in the text. Getting lost in the woods becomes an image for the condition of the microcosm of the commune.

For this partial retrospective exhibition, the "wood way" element is a necessary tool as a formal place marker for place-specific works that were originally developed for specific contexts; on the other hand the structure introduces a double view of the things by means of the borrowed concept of *The Wood Way*. The wood way becomes the leitmotif of a thought process in which viewers are called upon to think for themselves. It is an exhibition itinerary which constantly frustrates a complete view because of the structure of wooden planks; *The Wood Way* therefore reflects the actual and figurative levels of this concept, and at the same time its own function as a structure, a vehicle of interpretation. The motif of going astray becomes the productive element, not the collection of precise sculptural forms collected by the institution.

The doorknob of the *Documentary Realization Zone* illustrated in detail n the catalogue, with its reflection of the exhibition as a whole, makes us think of Craig Owens' observation about the photographic image that generates meaning independently of the object depicted. To this extent the artist, with his interventions in the foyer, café, and lecture room, has introduced a parallel level that turns the exhibition into a figure of thought.

The picture as a motif that is endlessly perpetuated in reflection, as well as showing the duplication and mirroring of the elements, points to the refraction of a unified and continuous theme. In his studies on *mise en abyme* Fernand Hallyn described this *en abyme* refraction as indicating a doubled experience and doubled truth where reflection emerges as a sign for both unity and discontinuity.[28] Jean Ricardou regards internal mirroring as a literary device, conceit, or trick which often runs counter to the text and competes with it. This happens not as a result of the repetitions of the text at different levels, but by means of the divisions that the internal mirroring conjures up. Using the novel *Passage de Milan* by the French writer Michel Butor as an example, he describes how the motifs achieve a relative autonomy and a parallel narrative therefore comes into being, which Ricardou equates to a stratification that breaks up

any unity in the narrative by means of the layering of many metaphorical narratives.[29] Gillick also undertakes this breaking up of a unified action and layering of many parallel narratives in *Literally No Place*, by dividing it into a multitude of sub-stories. He gives this technique visual form in the exhibition *The Wood Way*, and so creates a central aspect of the *mise en abyme*.

Fernand Hallyn sees a similar refraction, in a spatial respect only, in the transference of *mise en abyme* to Hans Holbein the Younger's painting, *Double Portrait of Jean de Dinteville and Georges de Selve (The Ambassadors)*, 1533. The breaking up of the unity or of the homogeneous space here brings about a change that turns the work into a structure consisting of two different, systematic spaces. The division into two takes place at different levels in the picture. Viewers are encouraged to view it in a double manner by the perspective construction in the work; the skull distorted by anamorphosis in the middle of the picture seems to violate the laws of perspective. The second view is disclosed by means of the original hanging of the picture in the Dinteville Family Room at the Château de Polisy where Holbein's painting hung on a long wall beside and above a door so that viewers could experience the double view and two quite different perspectives as they walked through the room. Only when viewed at a steep angle from below does the anamorphic image of the skull in the middle of the painting become clearly visible, while the other elements in the picture appear distorted. Hallyn describes the function of perspective as a code for pictorial representation, which in each case completely excludes the other view and suggests a metaphor for life and death.[30]

In the pictorial representation the skull functions as a *mise en abyme*. It is more than just the introduction of another space that is located within the larger pictorial space and subordinated to it by the structure. Here an analogy of the optical and emblematic principle takes place too: the anamorphosis of the skull distorts and dismantles the recognized perspective, and the principle of death behaves in the same way as the principle of life. Hallyn sees the slanting and the frontal view as in fact being confused, since the frontal view, with its indecipherable, deconstructed skull, is closer to the representation of death as it undermines our trust in (visual) systems of reality. Here the metaphor of death becomes the realization of a different viewing angle in the picture, explained by the *mise en abyme*, in which death, according to Hallyn, becomes an "absent presence and a present absence."[31]

These aspects of the refraction and layering of parallel narratives or representations become clear in Liam Gillick's installations and fictional texts too. The key element bringing about the process of a doubled and mirrored view is often clearly differentiated as with the use of the skull in Holbein's double portrait of the ambassadors. In Gillick's case it can be achieved through the use of a wall text in an installation of

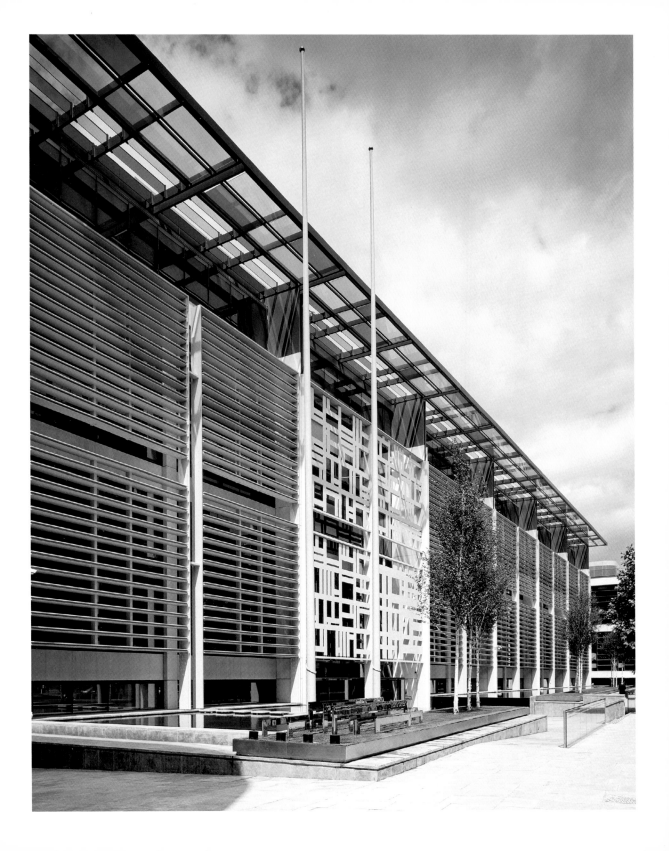

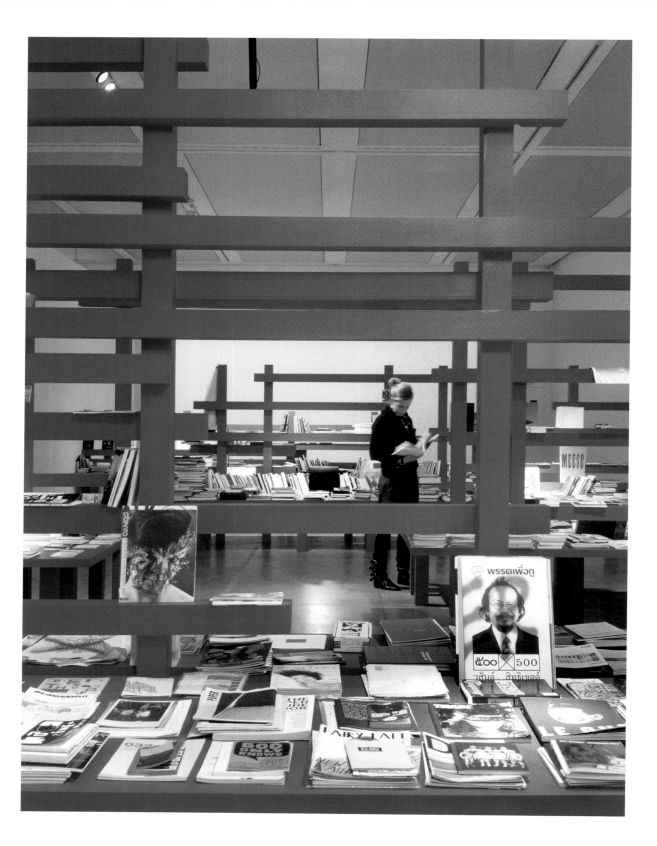

translucent wall screens and platforms. In some situations it is via a realist pictogram, a theme in the text, an exhibition structure or a reflected image in a mirror. It is this technique of internal mirroring that conjures up a certain sense of vertigo before the abyss and through which individual elements claim autonomy within their own, parallel level. The *mise en abyme* brings about a process of discontinuity in our gaze which not only relativizes our own perceptual standpoint, but again and again sets off a chain reaction of references in the imaginative process and hence proposes new forms of spatial conception.

Therefore, alongside strictly symmetrical elements such as mirroring and parallel structures, there are also narrative elements within the work. Social observations of a general prognostic nature and metaphorical motifs endow Liam Gillick's work with a specific equilibrium. This develops via structural interests in social modes of behavior and the way they feed back as material into the flow of history and its temporalization. All this takes place alongside the creation of a permanent development of space-forming processes and fictional visions. These in turn function as vehicles for sleepwalking movements between past and future, hence for the actual understanding and reading of the concepts within and beyond the work.

It may be that this flow is perceived as a general characteristic of the production of art over the last 15 years and as a process for highlighting social models of action, reflecting them in the field of art and so making a contribution which adds an element of prognosis to the analyzed field outside of the art discourse. In Liam Gillick's work we began to understand the potential of these processes when his fictional conversation between the Herman Kahn of the RAND Corporation and Robert McNamara, US Secretary of Defense under John F. Kennedy, appeared as a relevant contribution to a textbook on the period. Gillick demonstrates with his works what fiction and speculative knowledge can accomplish and encourage in other fields that are otherwise elaborated on an empirical basis; this makes a crucial distinction between the picture arising from artistic reflection and that of the analyst and strategist. The moving back and forth between fictional and structural thinking creates a space of reflection anew which places the known and the speculative against each other. In this space both are subjected to critique and revision and therefore spaces of possibility are formed in an ongoing process.

NOTES

1 Aleida Assmann, "Die Sprache der Dinge. Der lange Blick und die wilde Semiose," in Hans Ulrich Gumbrecht and K. Ludwig Pfeiffer (ed.), *Materialität der Kommunikation*, 1995, p. 237–251, esp. p. 241 f.

2 Harald Merklin (ed.), *Marcus Tullius Cicero, De oratore/Über den Redner*, Lat./Ger., Stuttgart 1976, p. 430.

3 Aleida Assmann, *Erinnerungsräume, Formen und Wandlungen des kulturellen Gedächtnisses*, Munich 2003, p. 160.

4 Reinhart Koselleck, *Vergangene Zukunft. Zu der Semantik geschichtlicher Zeiten*, 3rd edition, Frankfurt am Main 1984, p. 327.

5 Georg Simmel, "Das Problem der historischen Zeit," in Arthur Liebert (ed.), *Philosophische Vorträge der Kantgesellschaft*, Berlin 1916, p. 12–13. Cf. Lovejoy, *The Great Chain of Being*, Cambridge, Massachusetts 1950, p. 242, 244 ff, and Koselleck, *Zeitschichten. Studien zur Historik*, Frankfurt am Main 2000, p. 78 f.

6 Koselleck, *Vergangene Zukunft*, p. 320.

7 Liam Gillick, "ILL TEMPO. The Corruption of Time in Recent Art," in Gillick, *Five or Six*, New York 1999, p. 21.

8 Immanuel Kant, "Anthropologie in pragmatischer Hinsicht," Book 1, § 35, in Walter Kinkel (ed.), Immanuel Kant, *Sämtliche Werke*, vol. IV, Leipzig 1920, p. 91–92.

9 Gabriel Tarde, *Underground (Fragments of Future Histories)*, updated by Liam Gillick, Brussels/Dijon 2004, p. 7.

10 Tarde, *Underground*, p. 68.

11 Georg Wilhelm Friedrich Hegel, *Vorlesungen über die Aesthetik*, 3rd edition, vol. 1, Stuttgart 1953, p. 379 f.

12 Presentation by Liam Gillick, script for the book and lecture of May 7, 2006, and revised version of December 2005.

13 Henri Lefebvre, *The production of space*, Oxford 1991, p. 356 f.

14 Lefebvre, *Space*, p. 73, 83.

15 "[...] here we see the polyvalence of social space is 'reality' at once formal and material. Though a product to be used, to be consumed, it is also a means of production; networks of exchange and flows of raw materials and energy fashion space and are determined by it. Thus this means of production, produced as such, cannot be separated either from the productive forces, including technology and knowledge, or from the social division of labour which shapes it, or from the state and the superstructures of society." Ibid., p. 85.

16 Fredric Jameson, "Five Theses on actually Existing Marxism," in Michael Hardt and Kathis Weeks (ed.), *The Jameson Reader*, Oxford 2001, p. 164–171.

17 Gilles Deleuze, *Shortcuts*, Berlin 2001, p. 45 ff.

18 André Gide, *Journal. 1889–1939*, Paris 1948, p. 40.

19 Jean Ricardou, *Problèmes du nouveau roman*, Paris 1948, p. 40; Christian Angelet, "La Mise en Abyme selon le *Journal* et la *Tentative Amoureuse* de Gide," in Fernand Hallyn (ed.), *Onze études sur la Mise en Abyme*, vol. XVII, Romanica Gandensia, Ghent 1980, p. 13.

20 Ricardou, *Nouveau roman*, p. 61.

21 Craig Owens, "Photography en Abyme," Scott Bryson, Barbara Kruger, Lynne Tillmann, & Jane Weinstock (ed.), *Beyond Recognition. Representation, Power, and Culture*, London 1992, p. 17.

22 The text of this work is composed of different languages, English, Old English, and French, thereby reflecting three main forms of English before the unification of the language via *Johnson's Dictionary*. This text part is cited from Thomas More's *Utopia* from 1518.

23 Burrhus Frederic Skinner, *Walden Two*, New York/Hampshire 1948, p. 284.

24 Marc Augé, *Non-places: Introduction to an Anthropology of Supermodernity*, London/New York 1995, p. 87.

25 Liam Gillick, "The Semiotics of the Built World," in exhibition catalogue, *Liam Gillick. The Wood Way*, Whitechapel Art Gallery, London 2002, p. 83/84.

26 Markus Brüderlin, "Beitrag zu einer Ästhetik des Diskursiven. Die ästhetische Sinn- und Erfahrungsstruktur postmoderner Kunst," in Jürgen Stöhr (ed.), *Ästhetische Erfahrung heute*, Cologne 1996, p. 287.

27 Stephan Schmidt-Wulffen, "Gillicks Konjunktiv," in Schmidt-Wulffen (ed.), *Perfektimperfekt*, Freiburg im Breisgau 2001, p. 249–254.

28 Fernand Hallyn, "Introduction," in Hallyn (ed.), *Mise en Abyme*, p. 6.

29 Ricardou, *Nouveau Roman*, p. 85.

30 Fernand Hallyn, "Holbein: La mort en abyme," in Hallyn (ed.), *Mise en Abyme*, p. 166.

31 Ibid., p. 181.

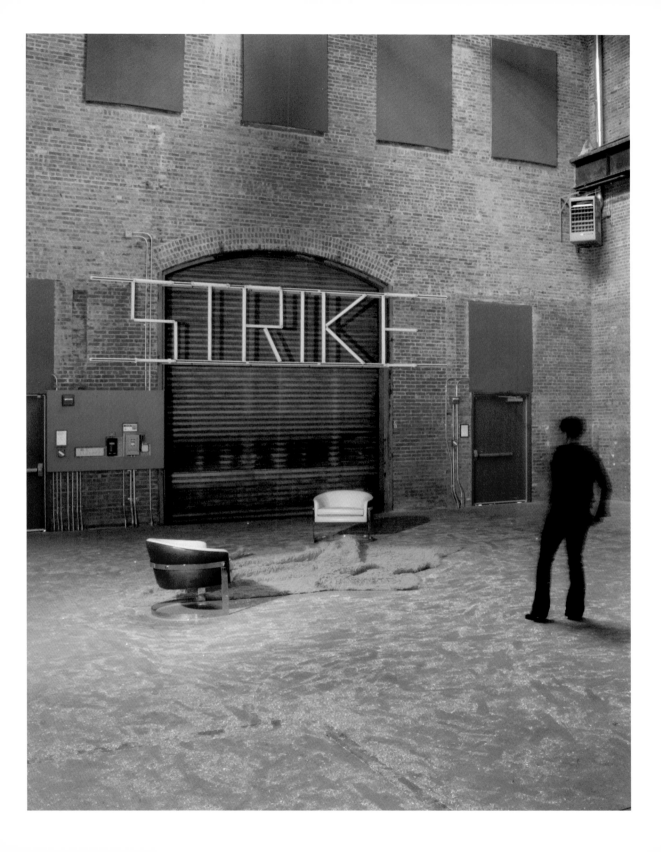

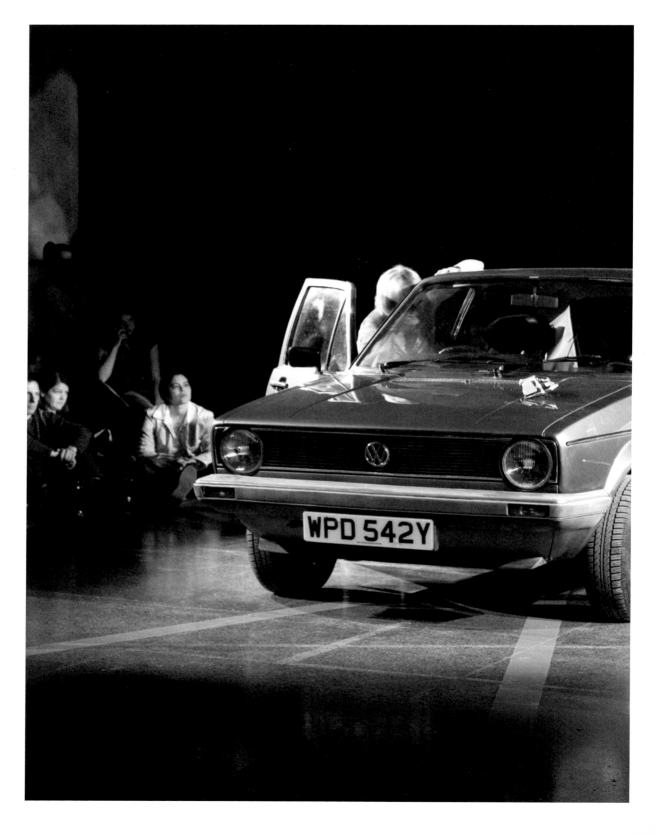

LIAM GILLICK
PARALLELES DENKEN ZWISCHEN STRUKTUR UND FIKTION

Was bedeutet Erkennen und Aufzeigen von Strukturen und Prozessen, was generieren die ihnen zugrunde liegenden Prinzipien für unsere heutige Gesellschaft? Der Impuls, bestimmte Entwicklungen als einander vergleichbar zu benennen und daraus Schluss-folgerungen abzuleiten, ist nicht nur derjenige von Analysten, Strategen oder Wissen-schaftlern, sondern wird ebenfalls zum Gegenstand der künstlerischen Beobachtung. Doch im Gegensatz zu einem Zusammentragen empirischer Daten, um Strukturen ablesbar werden zu lassen, ist die künstlerische Reflexion freier ausgelegt, als Analogon des „Bildes". Handlungsanweisungen oder Projektbeschreibungen funktionieren in einer anderen Weise. Das Analogon des Bildes lässt sich mit der „wilden Semiose" Aleida Assmanns in Verbindung bringen: „Starren" und „Lesen", das Wechselspiel zwischen schnellem und langem Blick („referentiellem" und „transitorischem Verfahren" und „medialem Akt") in die Bedeutungsschichten des Bildes, in eine Sprache der Dinge, die jenseits einer Prinzipienbestimmung und wirtschaftlicher und politischer Analyse abläuft.[1]

Was wäre, wenn eben dieser Vorgang des Entdeckens von Zusammenhängen und Strukturen selbst Gegenstand der Analyse würde? Wenn es um beides ginge, die Untersuchung selbst und die Form der Untersuchung als Instrument der Erkenntnis?

Beide Abläufe reflektiert Liam Gillick in seinen Installationen, Büchern und Skripten, die als künstlerische Arbeiten fungieren und eine Mischung aus fiktionaler Erzählung und Analyse kommunikativer wie struktureller Prozesse einbringen. Seine Arbeiten mäandern zwischen formaler Setzung im Raum, ihrer Reflexion zwischen Text und Subtext, zwischen Erzählstrang und paralleler Erzählung. In jedem Element liegt auch gleichzeitig eine parallele Ebene begründet, die einen anderen Aufschluss gibt über die in seinen Arbeiten reflektierten Gedanken. Gleichzeitig ist es auch das Parallele selbst, das in Installation und Text einer fortwährenden, spielerischen Untersuchung unterzogen wird. Dem dialektischen Prinzip stellt Gillick ein paralleles Prinzip gegenüber, das, um ein komplexes Bild zu erzeugen, nicht die möglichen Antagonismen wählt, sondern struk-turelle Ähnlichkeiten in verschiedenen Bildern oder Ebenen sucht. Gegenstand seines Interesses sind Modelle, die auch für Analysen und politische Planung eine Rolle spielen könnten, die durch Szenarien durchgespielt werden; es ist aber auch das Nachdenken über Parallelgesellschaften wie Kommunen oder Schlüsselfiguren innerhalb bestimmter wirtschaftlicher und politischer Entwicklungen.

Seine Bücher, ebenso künstlerische Arbeiten wie die Installationen, haben oftmals ein Vorbild aus der Literatur. Ob B. F. Skinners *Walden Two* als Ideengeber für die Kommune und Suche nach Utopie in *Literally No Place* von 2002 oder Edward Bellamys *Looking*

Backward 2000 – 1888, das ein fiktionales Hin- und Herspringen zwischen den Zeiten reflektiert, wie in *Erasmus is Late* von 1995 – Gillicks London-Reiseführer als Zeitreise. Die Romane von Bellamy und Gabriel Tardes *Underground (Fragments of Future Histories)* mit einem überarbeiteten Text der 1904 veröffentlichten Übersetzung wurden von Gillick neu herausgegeben und so sind es vor allem Sozialutopien, die den Künstler interessieren. Doch weniger die in der Erzählung üblichen Beispiele einer auf die Zukunft hochgerechneten und projizierten Vision der vieldiskutierten Tradition utopischer Literatur als vielmehr die Randständigkeit der von ihm ausgewählten Utopien sind hierbei bemerkenswert. Welche Erkenntnis könnte Bellamys wieder aufgelegte Textfassung von 1998 für das zu Ende gehende 20. Jahrhundert leisten? Der Autor hat mit seinem 1890 verfassten Rückblick in das eigene 19. Jahrhundert aus einem von ihm entworfenen, fiktionalen 20. Jahrhundert eine Sozialkritik formuliert. Und welches Gedankenpotential birgt Gabriel Tardes Vision von 1896 von einer zukünftigen ästhetisierten Lebensgemeinschaft, die nach dem ökologischen Exodus im Jahr 2489 unter der Erde lebt, aus heutiger Sicht? Meist geht die Neuherausgabe auch mit einer Kritik des Künstlers an den fest gefügten Utopiemodellen einher, doch ist es jeweils eine radikale Denkfigur, die Liam Gillick mit seiner Neuherausgabe für heutige Fragen aktualisiert und zur Diskussion stellt.

„SHOULD THE FUTURE HELP THE PAST?"
VERZEITLICHTE GESCHICHTE UND UTOPIE

FLASH #1

Ein dunkelbrauner, uneben gewellter Teppich ist im gesamten vorderen Ausstellungsraum ausgebreitet und erinnert an eine imaginäre Landschaft oder an die Erdkruste eines noch unbenannten Planeten. Zur Raummitte hin erhebt sich ein kleiner Teppichhügel, auf dessen Spitze ein Brionvega „Cuboglass"-Fernseher steht, der eine Text-Animation mit einer durch den Computer verfremdeten Partitur alter Musik zeigt. Die Installation bildet einen Rahmen zu dem von Gillick zur Ausstellung neu herausgegebenen Buch Gabriel Tardes *Underground (Fragments of Future Histories)*. In der Galerie Micheline Szwajcer in Antwerpen hat der Künstler 2004 einerseits ein Setting für sein Buch installiert, das an die Zukunftsvision Tardes erinnert, das Leben nach einem Exodus in das Erdinnere zu verlagern und in Höhlen ein neues künstlerisches und philosophisches Leben zu führen. Andererseits hat Gillick im hinteren Raum mit seinen vier in leicht versetzter Höhe hängenden Plattformen in transparentem, braunem Plexiglas sowie einer geliehenen Arbeit des amerikanischen Konzeptkünstlers Allen Ruppersberg aus dem Lager der Galerie einen Ort der Verdichtung und Selbstreferenz geschaffen. Die Leere und Weite des vorderen Ausstellungsraumes, der nur mit Text und Sound das utopische Szenario Gabriel Tardes heraufbeschwört, erhält mit der zitierten Arbeit im hinteren Ausstellungsraum einen anderen Fokus: Parallel zu dieser metaphorischen Landschaft reflektieren die ebenfalls in vielen Medien angelegten Arbeiten Allen Ruppersbergs Themen wie Erinnerung und Gedächtnis, sind in diesem

Kontext auf Tarde bezogen und führen damit eine bewusste historische und kommentierende Ebene im Kunstkontext ein.

In der Ausstellung deutet sich an, was Tarde explizit formuliert: In der Utopie lässt sich ein neues, ästhetisiertes Leben auf historischer Basis verwirklichen, auch wenn der unterirdische Lebensraum keine Verbindung zu den Lebensbedingungen heutiger Zeit mehr aufweist. Da sich die überlebende Bevölkerung in *Underground* bei ihren künstlerischen Disziplinen am klassisch-antiken griechischen Ideal orientiert, ist die Erinnerung durch Überlieferung und Raumvorstellung der alten Welt ein wesentlicher Bestandteil für die neue Gesellschaft geworden. Aufschlussreich ist, dass in der antiken Mnemotechnik, die das natürliche Gedächtnis mit einer speziellen Lerntechnik durch ein artifizielles erweitert, die in Bildformeln festgehaltenen, zu erinnernden Inhalte oftmals bestimmten Orten eines gestaffelten Raumes zugeordnet werden. Das Verfahren geht auf den Griechen Simonides von Keos zurück, der während eines Gastmahls vor die Tür gerufen wurde, dadurch dem schicksalhaften Einsturz des Hauses und der Verschüttung der Gäste entkam und die unkenntlichen Opfer aufgrund der Sitzanordnung in seiner Erinnerung zu identifizieren vermochte.[2] Dass die Form des Erinnerns mit Räumen in Verbindung gebracht wird, hat eine lange Tradition, da sich, wie Aleida Assmann beschreibt, Gebäude-Metaphern der Memoria mit verschiedenen Gedächtnis-Formen verbinden. Als bekannteste Metapher des kulturellen Gedächtnisses beschreibt sie die Bibliothek (Wissen der Vergangenheit und Gegenwart) und den Tempel (Andenken für die Zukunft).[3]

Sozialutopien und damit verbunden die Bewertung vergangener und gegenwärtiger gesellschaftlicher Systeme stellen durch ihre Geschichtsschreibung ein häufig diskutiertes Thema in Gillicks Werk dar. Die Vielzahl der zitierten Utopien und eine kritische Revision von Gillicks Seite zeigt sein grundlegendes Interesse an Strukturen und Bewertungen zeitlicher Kategorien und ihrer räumlichen Ausprägungen, die letztlich Geschichte konstituieren. Der Historiker Reinhart Koselleck stellt seit dem 18. Jahrhundert eine Veränderung in der Geschichtswahrnehmung fest, da die Kategorien Raum und Zeit mehr und mehr aufeinander bezogen werden und dem Primat der vergangenen Historie das Bewusstsein für eine „neue Zeit" oder „Neuzeit" mit ihrer gegenwärtigen Geschichte entgegengesetzt wird. Zur Anthropologie geschichtlicher Zeiterfahrung hat Koselleck mit seiner Beobachtung einen zentralen Beitrag geleistet, dass sich seit Ende des 18. Jahrhunderts die Zeiterfahrung dynamisiert und die Geschichte verzeitlicht – dass sich die Zeitwahrnehmung „kraft der ablaufenden Zeit jeweils heute und mit wachsender Distanz auch in der Vergangenheit ändert, oder genauer gesagt: in ihrer jeweiligen Wahrheit enthüllt."[4] Sein Begriff der Verzeitlichung oder auch der „vergangenen Zukunft" beschreibt einen Aspekt der Zeitwahrnehmung, den Gillick mit diversen Arbeiten zur Erinnerung von Zukunft als wesentliches Potential für Denkmodelle erkannt und formuliert hat. Arthur Lovejoy, Georg Simmel und Reinhart Koselleck entwerfen einen Terminus, der nicht Heideggers Verzeitlichungsvorstellung, sondern einen anderen Begriff der

Verzeitlichung aufnimmt: Nicht die reine Zeitlichkeit lässt einen Inhalt zu einem historischen Ereignis werden, auch nicht das Verstehen des Inhaltes, sondern der Inhalt wird erst historisch, wenn er aufgrund des zeitlosen Verstehens verzeitlicht wird.[5] Das bedeutet, die zeitlichen Dimensionen Vergangenheit, Gegenwart und Zukunft werden qualitativ miteinander verwoben, so dass immer wieder der Beginn einer neuen Geschichte einlösbar wird. Damit ändert sich auch die gesamte Betrachtung der vergangenen Geschichte; Geschichte wird somit selbst zur zeitlichen Struktur, verzeitlicht. Die jeweils neue Zeit wird zum „[…] Indikator eines beschleunigten geschichtlichen Erfahrungswandels und seiner erhöhten bewusstseinsmässigen Verarbeitung."[6] Koselleck widmet sich dem Verzeitlichungsbegriff im Hinblick auf die Utopie; seine Erkenntnisse werden insbesondere für Bellamys utopischen Roman *Looking Backward 2000 – 1888*, aber auch für Gillicks *Erasmus is Late* relevant. Er beschreibt die Verzeitlichung der Utopie als Einbruch der Zukunft in die ehedem räumliche Utopie.

In einem seiner Essays über das Szenario widmet sich Gillick der Frage „Should the future help the past?" oder anders gesagt, der Verzeitlichung von Utopie. In seinem Text *ILL TEMPO. The Corruption of Time in Recent Art* weist er darauf hin, wie das Denken über die Zukunft diese bereits selbst zu verändern vermag.[7] Dieses Motiv stellt für Gillick ein wesentliches Potenzial für eine andere Wahrnehmung und ihren Einfluss auf das menschliche Handeln dar. Dabei unterstreicht er, dass das Zeitverständnis als Element visueller Praxis nicht nur für ihn, sondern auch für die aktuelle Kunstproduktion von Bedeutung ist.

Die Idee des Hin- und Herspringens zwischen den Zeiten wird in Gillicks Erzählung *Erasmus is Late* durch Erasmus Darwins Gespräch mit Figuren aus unterschiedlichen historischen Epochen vergegenwärtigt, während der Protagonist durch das georgianische London wandert. Dieser „Reiseführer" von 1995 bewegt sich zwischen 1810 und der nahen Zukunft von 1997 hin und her. In der Buchform selbst wird auch das gedankliche Vor- und Zurückblättern reflektiert und damit ein zeitloses Verstehen. Der Gedanke der „prevision", also der Vor-Vision, stellt bei Gillick einen Schlüsselbegriff dar, der keine reine Vorhersage bezeichnet, sondern das Beschreiben eines Ereignisses, bevor es eintrifft. Wie Kant formuliert, ist diese Vor-Vision der Einbildungskraft entsprungen, ein „Voraus-Sehen", das ein Begehren enthält und ein Zurückblicken auf das Vergangene, um das Künftige zu ermöglichen.[8] So entspricht Gillicks Vor-Vision bei Kant einer Mischung aus „Vorempfindung" („praesensio") und „Vorhererwartung" („praesagitio"). Die „prevision" lässt sich vor allem nachhaltig im filmischen und fiktionalen Bereich einsetzen (durch Rückblenden und Zeitsprünge etc.), indem sie als Thema selbst in das Geschehen eingeht, wie etwa in Form der Zeitreise. Insofern stehen die Fragestellung der Verzeitlichung und diejenige der „prevision" eng zusammen, da die filmischen und narrativen Strukturen in ähnlicher und spezifischer Weise umgesetzt werden können. In beiden Medien kann das Simultan-Bild von Raum und Text über die Technik der

Books are written in large typefaces because due to a lack of paper we have to write on slates, pillars and other parts of the interior architecture. It doesn't only make us write in a sober style, it also contributes to the taste of the surroundings. It also means that there are no daily newspapers anymore, to the great benefit of the eyes and the brain. It was unfortunate that in the past people could write what they wanted on paper. Nothing of serious value was written and all the ideas were piled indiscriminately on top of each other. Now, before engraving our ideas onto the rocks we have to think hard about what to write. Another problem among our primitive ancestors was tobacco. We no longer smoke because we can't. Public health is absolutely magnificent.

Verzeitlichung erzeugt werden. Der utopische Gedanke unterliegt zwar keinem festen, raumzeitlichen Ort, sondern fungiert hier wie auch in anderen Arbeiten Gillicks als Modell, hat eine normative Funktion für das gesellschaftliche Leben inne.

PRODUKTION UND RAUM DER DIFFERENZ

„The mental space left by the reduction of our needs is taken up by those talents – artistic, poetic and scientific which multiply and take deep root. They become the true needs of society. They spring from a necessity to produce and not from a necessity to consume."[9]

Ein Zitat Gabriel Tardes ist dem Haupttext von *Underground* in seinem neu edierten und herausgegebenen Buch von Gillick vorangestellt. Es ist der Begriff der Produktion, den Tarde als wesentliche Funktion der Gesellschaft hervorhebt. Sicherlich ist Tarde zur Zeit der Veröffentlichung seines Buches der Produktionsbegriff nach Karl Marx und Friedrich Engels bekannt; sie sehen die Produktion als ein das gesellschaftliche System konstituierendes Element an, um das herum sich Interessen und Macht kristallisieren. Tarde wendet sich jedoch im 5. Kapitel von *Underground*, in dem es um die Konstitution eines neuen quasi-religiösen Ästhetizismus geht, der die neue Gesellschaft konstituieren soll, explizit gegen die Ideen des Sozialismus. Als althergebrachte Visionäre haben es die Sozialisten laut Tarde nicht vermocht, ihre Vision eines neuen gesellschaftlichen Lebens durchzusetzen, da sie sich auf die Entwicklung des gewerblichen Lebens konzentrieren statt die Ideale eines wahren und ästhetischen Lebens zu fördern.[10] Tarde begreift sich selbst nicht als Teil des utopischen Sozialismus, obwohl sein Gesell-schaftsentwurf in der Tradition sozialistischer Utopie steht (seit Thomas Morus sich 1516 mit *Utopia* gegen die Feudalherrschaft und auf die antike Polis zurückbesonnen hatte). Stattdessen propagiert er ein unterirdisches, die Errungenschaften des klas-sischen Altertums reproduzierendes Leben, in welchem dem Produktionsbegriff vor allem in den Künsten eine wesentliche Rolle zukommt.

Ungewöhnlich an seiner Utopie ist die Rolle des Ästhetischen und der bildenden Künste innerhalb der Gesellschaft, auch wenn Tarde sie ganz im Geist des 19. Jahrhunderts auf einer restaurativen und reproduzierenden Ebene ansiedelt. In seinen Vorlesungen über Ästhetik hatte Hegel in der ersten Hälfte des 19. Jahrhunderts die Produktion bereits als geistige Tätigkeit des Menschen beschrieben, in der er sich selbst (sein Denken) nach aussen reproduziert, wie etwa im Kunstwerk, um eine neue Anschauung von sich zu gewinnen.[11]

Nun wird diese Formulierung von Liam Gillick bei einer Neuherausgabe des Buches dem Text als Schlüsselbegriff vorangestellt; damit liegt die Frage nahe, ob dieser Begriff

der geistigen und materiellen Produktion wieder eine Rolle spielt und inwiefern ihm aus der heutigen Sicht neue Funktionen zukommen.

Seine Überlegungen zu Veränderungsprozessen in der Gesellschaft und in ihrer Organisation führt Gillick zu einem neuen Projekt, mit dem er sich seit 2004 in einer Reihe von Ausstellungen und Vorträgen mit dem Obertitel *Construcción de Uno* auseinandersetzt und dessen Gedanken zeitnah in einem neuen Buch gebündelt werden könnte oder das als produktiver Prozess belassen wird.[12] Der Produktionsbegriff ist hier ebenfalls von Bedeutung. Der Text geht von Überlegungen zu einer Fabrik in Schweden aus, die kürzlich geschlossen wurde. Gillick untersucht darin, wie der Umgang sowie die Reaktion der Arbeiter auf die neue Situation aussehen und wie sie in ihrer nun anbrechenden, ungenutzten Zeit neue Arbeitsmodelle entwickeln. Den Entwurfstext hat der Künstler auf der Basis von Archivmaterial über neue Arbeitspraktiken in brasilianischen Fabriken verfasst, beruhend auf akademischen Schriften, die ihre Aufmerksamkeit auf progressive, schwedische Produktionsmodelle aus den Siebzigerjahren richten.

Gillicks Vortrag schwankt dabei ähnlich wie seine Texte zwischen grundsätzlichen gesellschaftlichen Fragestellungen und einem fiktionalen Plot, der die Weiterentwicklung der ehemaligen Angestellten, ihr separatistisches oder integratives Verhalten im Hinblick auf eine Gemeinschaft für die Formulierung neuer Modelle schildert. So erläutert er, wie Überlegungen zum fortschrittlichen Arbeitsmodell seiner experimentellen Auto-Produktionsstätte in der nicht-hierarchischen Dimension und das Aufsplitten in unendliche, flexible Produktionsprozesse einer Post-Beschäftigungsphase gewichen sind. Nach einer anfänglichen Existenzangst wie es in einer gesicherten Arbeitslosigkeit weitergehen könnte, entwickeln die Arbeiter neue Gedanken zu experimentellen Arbeitsformen und die Umverteilung, in die sie einbezogen wurden. Ihr neues Modell stellt eine Situation her, in der die Beschäftigten Teil einer Idee werden, die Gleichheit nicht zum Paradigma erhebt, sondern über die Idee reflektiert, eine „economy of equivalence" (Ökonomie der Gleichwertigkeit) herzustellen. Bei dieser Ökonomie geht es um Entsprechungen von Einheiten, die gegeneinander aufgewogen werden, wie etwa Energie, Zeit, Ökologie und Leistungsvermögen. Um wieder Teil des Produktionsprozesses zu werden, denken die ehemaligen Arbeiter in Gillicks Struktur über Produktionsverhältnisse und die Ursachen eines Kollapses innerhalb flexibler Arbeitsmethoden nach, den sie mit neuartigen Konzepten über Tauschwerte zu revolutionieren suchen.

Diese Ideen lassen direkt an Karl Marx' Auffassung vom konträren Verhältnis des Gebrauchswertes zum Tauschwert denken, bei der Kategorien wie etwa Arbeit und Arbeitszeit als Tauschwerte begriffen werden. Die von Gillick skizzierte „Ökonomie der Gleichwertigkeit" oder der Entsprechung mag im Detail der Gegenüberstellung von Wertigkeiten eine Ähnlichkeit aufweisen. Jedoch wird der Tauschwert bei Marx nach

den Gesetzen des Marktes, nach Angebot und Nachfrage bemessen. Bei Gillicks Ökonomie geht es um messbare Einheiten, die einander im Input und Output gegenübergestellt werden, aber vor allem zeigt er eine experimentelle Methode auf. Henri Lefebvre sieht in den beiden Begriffen ein dynamisches, dialektisches Verhältnis, da Gebrauch und Tausch für ihn wesentliche Kategorien des täglichen Lebens darstellen und die politische Besetzung des Raumes vorantreiben.[13] In Gillicks Projekt richten sich die Gedanken auf die alten „neuen" Modelle der Siebzigerjahre, wie flexible Arbeitszeiten und Produktionstechniken, die mit einer kurzen Rückkehr zu Standardpraktiken zu der möglichen Schließung der Fabrik und Produktionsstätte geführt haben.

Im Hinblick auf den Begriff der Post-Produktion, der einen neuen Prozess von Wertkategorien und aktiven Denkleistungen durchläuft, sind Lefebvres Fragen nach dem Werk, das Raum besetzt und diesen erzeugt oder nach dem Produkt, das Raum besetzt und in diesem zirkuliert, von Bedeutung. Denn Raum generiert sich selbst über das Verhältnis von Dingen (Produkten/Werken), aber auch über alle kommunikativen und gesellschaftlichen Faktoren, die zunehmend sichtbarer werden, obwohl es unübersichtlicher geworden ist, sie zu analysieren.[14] Dies ist nichts anderes, als Liam Gillick es in seiner Konzentration auf einen lokalen Ort beschreibt: Wie der Raum sich durch die strukturellen Entscheidungen anders generiert, aber auch durch die Dynamik einer neuen Gruppe von Architekten der eigenen Arbeit verändert, die grundlegend über neue Produktionsbedingungen reflektieren, die sich permanent aufsplitten und neu zusammenfügen. Lefebvre betont, dass gesellschaftlicher Raum das Konzept von Produktion infiltriert und in dieses Konzept als sein wesentlicher Teil eindringt.[15]

Die Themen des Projekts entwickelt Liam Gillick auch als eine Kritik an der sozioökologischen Debatte mit Fragen, inwiefern politische und gesellschaftliche Fortschrittsgedanken durch das Marketing ökologischer Modelle und Belange überschwemmt werden (ein Autohersteller könnte etwa großen Anspruch auf den ökologischen Wert seiner Produkte erheben). Es sind vier Entwicklungsmomente, die Gillick am Beispiel der gerade geschlossenen Fabrik erläutert: die Stagnation/Lähmung in der Post-Beschäftigungsphase; die Depression der vergeblichen Versuche, in der Vergangenheit Flexibilität und Modelle zu etablieren, die Rückkehr kurz vor der Schließung zur Wiederaufnahme der alten Produktionslinie mit allen althergebrachten Arbeitsabläufen; als Drittes nennt er ein gewisses „negatives Potential" das zwar Antrieb für Veränderung darstellt, aber letztlich diese im Kern nicht herbeiführen kann und eventuell auch wieder zu der Notwendigkeit führt, zu traditionellen Formen sozialer Revolution zurückzukehren; als letztes beschreibt er die Einführung einer Form der Tauschökonomie über eine konstante Revolution der Verhältnisse, die Produktion zu einem ständig in Bewegung befindlichen Austausch von abstrakten und konkreten Werten werden lässt. Er benennt folglich nichts anderes als vier Etappen möglicher Entwicklung nach einem grundlegenden Eingriff in ein lokales Produktionsmodell. Dabei spielen ebenso Bewegungen in der

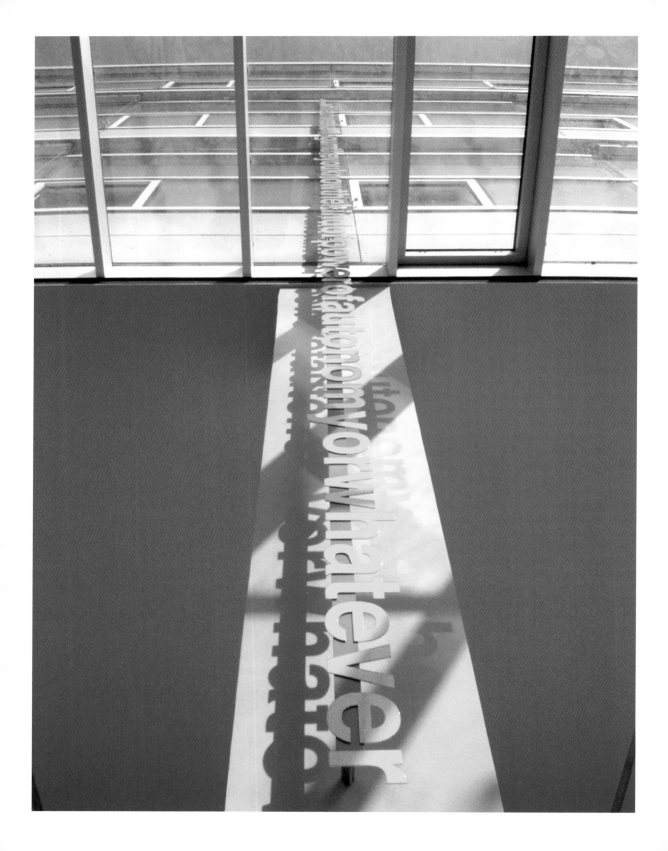

Gruppendynamik eine wesentliche Rolle wie auch Analysen des Potentials dieser temporären Gruppierungen und ihrer Folgen. Insofern scheint sich Gillicks Untersuchung zunächst nicht von einem Analysten gesellschaftlicher Prozesse zu unterscheiden, gäbe es nicht die fiktionalen Elemente und die Kunst als Ort der Reflexion und Darstellung.

Der Literaturwissenschaftler Fredric Jameson hat 1996 in verschiedenen Thesen den aktuell existierenden Marxismus präzise analysiert und dabei Aspekte herausgestellt, die Gillicks Ideen unterstützen. Jameson sieht durch das Reglement des Diskurses und durch anti-utopische Ängste vor Veränderung die ursprünglich sozialistische Idee der Freiheit gefährdet. Er formuliert als Vorschlag, diese Prozesse durch Diagnose zu benennen und einer radikalen Veränderung Raum zu geben. Revolution als marxistischer Gedanke, bei dem Theorie und Praxis eine Einheit bilden, heisst demnach, keine zerstückelte Reform durchzusetzen, die sich dann als illusorisch erweist, sondern im wörtlichen Sinne die Notwendigkeit eines Wechsels zu erkennen und diese in einem gewaltfreien Prozess gleichzeitig umzusetzen. Jameson betrachtet das Abkoppeln bestimmter Bereiche und das Weiterführen einer sozialen Veränderung in einem gemeinschaftlichen, veränderten System als notwendigen Schritt für einen grundlegenden Wechsel. So sieht er die aktuellen Themen wie Nicht-Beschäftigung, finanzielle Spekulation und kapitale Veränderungen der Gesellschaft auf einer abstrakten Ebene als zusammenhängende Kategorien an. Jameson favorisiert die Idee, am Negativen festzuhalten als einem Weg, neue unerwartete Möglichkeiten herauszubilden.[16] Im fiktionalen Plot ist das negative Potential als Auslöser für eine mögliche Entwicklung angelegt und begünstigt damit Gillicks Technik, aus den Analysen Denk- und Entwicklungsanstösse für Dynamisierungsprozesse herauszufiltern und diese als Urheber für die Veränderung von Mikroprozessen herauszustellen.

FLASH #2 Eine installierte, plakatierte Wand in roter Signalfarbe ist im Eingangsbereich des Palais de Tokyo in Paris installiert. Das Poster kündigt in Form eines T-Shirt-Designs mit nach oben gereckter, kämpferischer Faust die „Ökonomie der Gleichwertigkeit" an. Gillicks Ausstellung mit dem Titel *A Short Essay on the Possibility of an Economy of Equivalence* wird gleichzeitig in den angrenzenden Räumen gezeigt. Die Plakatwand öffnet den Blick auf eine farblich und räumlich gestaffelte Bergsilhouette aus flachen Stahlelementen in leuchtenden Farben und im hinteren Teil des Raumes auf eine Struktur aus verschiedenfarbigen Aluminiumstreben, die – einer Stahlskelettarchitektur ähnlich – der schematisierten Struktur eines Fabrikgebäudes entlehnt ist. Zwischen den Installationen ist die Fussbodenfläche mit schmalen Rampen zu den Installationen versehen und der Zwischenraum ist mit hundert Kilo rotem Glitter bestreut, der sich nach und nach in alle Ausstellungsbereiche trägt. Es sind zwei Pole, die den Rhythmus zwischen Arbeit und Freizeit herstellen: die ländliche Umgebung und die „Fabrik" als Ort, der den Arbeitsalltag strukturiert. Die Installationen schwanken zwischen einem konkreten Naturbild und der schematisierten Skizze eines Ortes der Arbeit. Die Orte

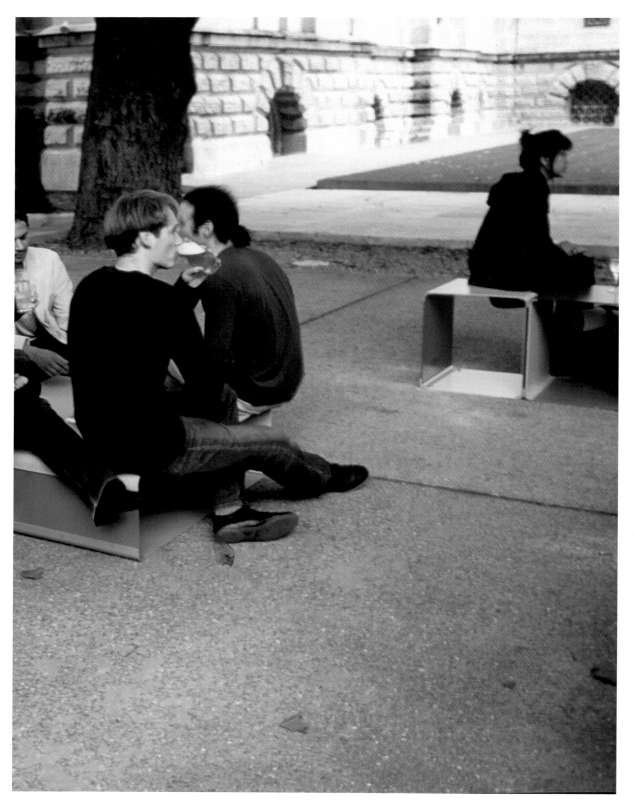

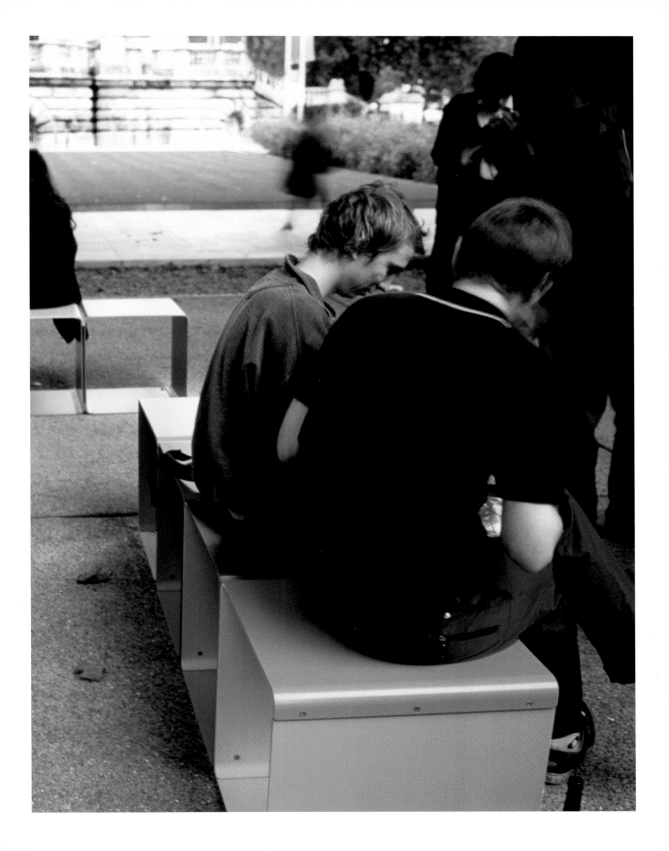

@kimstandingnowonaridge

des gesellschaftlichen Raumes unterscheiden sich sehr vom Naturraum, stellt Lefebvre fest. Sie sind nicht einfach beigeordnet, sondern überlagern sich, gehen eine Allianz ein oder können miteinander kollidieren.

Begleitend zu der Installation hat Gillick einen Leseraum eingerichtet sowie die museumspädagogische Gruppe des Palais de Tokyo eingeladen, ein Filmprogramm auszuwählen. In dieser Reihe wurde auch der Film *Week-end à Sochaux* (1971–72) der französischen Groupe Medvedkine aus Sochaux gezeigt. Diese Gruppe hat Anfang der Siebzigerjahre Filme über den Arbeitsalltag und Aufstand gegen die Verhältnisse in der Fabrik von Peugeot mit fiktionalen und dokumentarischen Elementen gedreht, auf die sich Gillick explizit in seinen Skripts zu *Construcción de Uno* bezieht.

Die Groupe Medvedkine formierte sich im Hinblick auf Chris Markers Interview-Film von 1968 *A bientôt j'espère* (Bis bald hoffentlich) über einen aufgegebenen Streik in der Textilfabrik Rhodiaceta von Rhône-Poulenc in Besançon, da der Gruppe die Sicht des Filmes zu distanziert von der Arbeiterumgebung war. Namensgeber des Filmkollektivs ist der sowjetische Filmemacher Alexander Medvedkine, der in den Dreissigerjahren einen Kinozug mit einer kompletten Ausstattung zur Filmproduktion und -projektion einrichtete. Er konnte mit diesem mobilen Raum vor Ort Filme schneiden und direkt vorführen. Die Gruppe setzte sich vorwiegend aus Arbeitern/ Arbeiterinnen der Fabriken in Besançon und später auch Sochaux zusammen; mit dabei waren die Filmemacher Chris Marker und zeitweise auch Jean-Luc Godard. Die Produktion eines Farbfilms in knapper Spielfilmlänge stellt für die Gruppe einen wesentlichen Aspekt dar. Dementsprechend gibt es auch einen Protagonisten, der von Fabrik zu Fabrik zieht und später den Arbeiterstreik organisiert sowie einzelne narrative Elemente wie die Einstellungstests von Peugeot und die Schilderung des Arbeitsalltags. Kombiniert werden diese Szenen mit Dokumentationsmaterial von einem Arbeiteraufstand und Interviews sowie mit filmischen Passagen, die – akustisch unterlegt durch eine Sprach-Soundcollage der Anlage, Fabrikumgebung und dem Arbeitsrhythmus – ein ästhetisch-abstraktes Porträt der Arbeitsstätte widmen.

Week-end à Sochaux zeigt mehrere Phasen, von der Anwerbung neuer Arbeiter/Arbeiterinnen, über die Arbeitsrationalisierungsmethoden, Reglementierungen in der Fabrik und die kollektiv organisierte Anerkennung der Vorstellungen und Wünsche seiner Protagonisten/ihrer Protagonistinnen. Fiktion und Dokumentation generieren hier eine eigene, rhythmisierte Filmsprache, die beschreibt, wie die staatliche Macht sucht, den gesellschaftlichen Raum der Arbeit zu dominieren und die natürlichen Widersprüche, die sich mit den Arbeitern und ihren Aktivitäten materialisieren, zu reduzieren (Lefebvre). Staatliche und unternehmerische Macht, arbeitnehmerische Ohnmacht und der daraus erwachsene Widerstand sind die Themen der Arbeiterbewegung der Siebzigerjahre, die Gillick ebenfalls als Folie und Material für sein Arbeiterszenario und die sich anschließende Umverteilung in Selbstorganisation verwendet. Sein Fokus richtet sich jedoch vor

allem auf progressive Modelle, die teils aus der Notwendigkeit anderer Konstellationen der Post-Beschäftigungsphase, teils aus einer Vision um einen neuen Produktionsbegriff heraus motiviert sind. Die Quelle dieser Veränderungen liegt auch in neuen Ansätzen der Siebzigerjahre; sie sind die Keimzelle für seine Analysen und gehen mit Beobachtungen über Ablösungen vom europäischen Sozialmodell der Nachkriegszeit einher.

So ist es die Frage nach den gesellschaftlichen Bedingungen, die auch Gillick beschäftigt: Wie verändert eine andere Form der Arbeitsorganisation den gesellschaftlichen Raum? Inwiefern findet eine Verräumlichung von Macht durch die Veränderung und Besetzung des ursprünglichen Produktionsortes statt? Die Vorherrschaft des Raumes ist für Lefebvre die privilegierteste Form, Raum mit Macht zu besetzen, was bedeutet, soziale Prozesse zu kontrollieren. Um abstrakten Raum als Werkzeug für die Vorherrschaft zu konterkarieren und um einer Ökonomisierung und Funktionalisierung der Stadt als profitabler Einheit entgegenzuwirken, formuliert der Raumtheoretiker Henri Lefebvre seine Theorie des Raumes der Differenz. Raum kann nicht entstehen, wenn er nicht durch Unterschiede hervorgebracht wird. So definiert er Unterschiede zwischen dem Erdachten und direkt Gelebten, den kleinsten und grössten Unterschieden und dazwischen den selbst verursachten und den exogen erzeugten Differenzen.

KONZEPT UND VORLÄUFIGE STRUKTUREN

Ein charakteristisches Motiv in Gillicks Szenarien, die vor den fertigen Büchern entstehen (ein Merkmal, das auch in dem Buch *Literally No Place* wieder auftaucht), ist die Dominanz des Konzepts vor dem fertig ausformulierten Text. Bislang hat er seine Bücher nach diversen Versuchen und Szenarien auch realisiert; nur bei diesem Konzept zu *Construcción de Uno* bleibt in der Schwebe, ob es nach verschiedenen Beschreibungen zwischen Fiktion und allgemeinen Betrachtungen des gesellschaftlichen Handelns noch eines Buches bedarf, was auch der Künstler gegen Ende seines Textes thematisiert. In der Skizzierung einer Reihe von Modellen, die beispielhaft wesentliche Elemente des gemeinschaftlichen Zusammenlebens benennen, zeigt sich ebensoviel, möglicherweise mehr Potential struktureller Auseinandersetzung als in der komplett ausgearbeiteten Fassung seines Projektes. Gillicks Konzepte konservieren den Status des Vorläufigen. „Provisional" (vorläufig) ist ein häufig von ihm verwendetes Stichwort, das immer auf eine mögliche Veränderung hinweist. So könnte die Hinwendung zum Vagen, Vorläufigen sich die Kritik des nicht vollständig ausformulierten Prozederes einhandeln; sie ist jedoch vielmehr eine Notwendigkeit für Gillick, an Veränderungen und Umbrüchen entlang ein Vokabular der Analyse und Fiktion zu formulieren, das Auslöser für Prozesse herausstellt. So ist die Wahl der Kapitelüberschriften in seinem 1997 publizierten und bislang umfangreichsten Buch *Big Conference Centre/Das grosse Konferenzzentrum* nicht von ungefähr an Schnittstellen des kommunikativen Austauschs orientiert:

Beschwichtigung, Kompromiss, Verhandlung, Konsens und Revision, die eine Drama-
turgie des Gesprächs zwischen Vertretern aus Politik oder Wirtschaft je nachdem zu
Instrumenten der Diplomatie oder staatstragenden Veränderungen werden lassen können.
Neben den kommunikativen Modellen ist der situative Kontext zu berücksichtigen,
der Umbruchsituationen mitgeneriert. Es sind somit Orte, die als Vorlage für Gillicks
Auseinandersetzung mit verschiedenen Phänomenen dienen (etwa das Haus des
Opiumessers Erasmus Darwin in *Erasmus is Late* oder das Konferenzzentrum des *Big
Conference Centre*), die wiederum Ideengeber für eine umfangreiche Werkgruppe von
Skulpturen und Installationen aus Sperrholz, Stoff und später Aluminium sowie trans-
luzentes Plexiglas sind, die in den Raum eingreifen, ihn mit einer Sequenz vorläufiger
Modelle strukturieren und als Hintergrund für Aktivitäten und spekulative Gedanken
funktionieren könnten.

Literally No Place als Synonym für den Nicht-Ort Utopia handelt von einer Kommune
als Gegenentwurf zur bestehenden Gesellschaft, markiert jedoch im Gegensatz zu den
anderen Plätzen die Abwesenheit eines sinnlich wie geistig erreichbaren Ortes oder
gesellschaftlichen Zustands. Das Motiv der Unerreichbarkeit zeigt sich in den Referenz-
arbeiten, die versuchen, Utopien zu beschreiben, wie auch in Gillicks Versionen. Seine
Aufmerksamkeit liegt jedoch vor allem auf der Kommunikation innerhalb der Kommune
(*Literally No Place*) zwischen Staatsvertretern des politischen Mittelgrunds (*Discussion
Island/Big Conference Centre*) oder auch zwischen den prägenden Persönlichkeiten
verschiedener Zeiten (*McNamara* und *Erasmus is Late*).

EN ABYME – PARALLELE STRUKTUR ALS INNERE REFLEXION

FLASH #3

Die schmalen, senkrecht nach oben ragenden Baumstämme verzweigen
sich zu ihrer Spitze hin in ein dichtes Netz aus Ästen. Dieses unübersichtliche
Dickicht eines winterlichen Waldes erschließt sich erst durch einen langen
Blick auf das, was einer stilisierten Reihung kleiner und grosser Bäume
ähnelt und damit dieselbe repetitive Struktur wiederholt. Das Logo, welches
Liam Gillick 1998 für den Frankfurter Kunstverein entworfen hat, richtet die
Aufmerksamkeit auf die Wahrnehmung und Sichtweise der Besucher. Zunächst
mutet es wie die Materialisierung des von Gilles Deleuze und Félix Guattari
beschriebenen Rhizoms an, bei denen mit einem Netz aus Wurzeln die
hierarchische Organisation von Wissen vergegenwärtigt wird. „Ein erster
Buchtyp ist das Wurzelbuch. Der Baum ist bereits das Bild der Welt, oder
vielmehr, die Wurzel ist das Bild des Weltbaumes. [...] Das Gesetz des
Buches ist das Gesetz der Reflexion: das Eine, das zwei wird.“[17] Bei näherer
Sicht besteht das Zeichen ganz einfach aus der unendlichen Wiederholung
derselben komplexen Form, die Wahrnehmung und Erkenntnis neu
herausfordert.

Das Logo für den Frankfurter Kunstverein stellt ein dichtes und frühes Beispiel einer Reihe von Arbeiten und Installationen dar, für die innere Reflexion ein zentrales Thema darstellt. Diese Serie ensteht vor allem seit 2000 im Zusammenhang mit seinem Buch *Literally No Place*, das Liam Gillick kurz vor seiner Übersichtsausstellung in der Whitechapel Art Gallery in London veröffentlichte. Der Text mit seinen beiden Untertiteln *Communes, Bars and Greenrooms* (Kommunen, Bars und Künstlergarderoben) sowie *Ethics, Conscience and the Revision of Form in the Built World* (Ethik, Bewusstsein und die Überarbeitung der Form in der gebauten Umwelt), spielt mit der Struktur dreier Elemente. Im ersten Untertitel werden drei verschiedene Orte, vielmehr Nicht-Orte (nach Marc Augé Übergangsorte ohne historische Einbindung) vorgestellt, die seine ursprünglich als Radiohörspiele geplanten Erzählungen situieren. Der zweite Untertitel verweist auf die im Text verhandelten Sujets, die wiederum den drei Orten zugeordnet werden können, „Ethik" (für das Gesellschaftliche), „Bewusstsein" (für die individuelle Wahrnehmung) und „Überarbeitung der Form" (für einen exemplarischen Übergangsort, an dem Ideen für neue Formen von Stadt und Gesellschaft generiert werden). Doch der zentrale Fokus liegt auf der Textstruktur: Es sind drei Erzähler, die drei Geschichten innerhalb der Kommune erzählen. Der Erste reflektiert über eine weitere Kommune, der Zweite über eine Bar und der Dritte über alle drei Szenarien. Dabei wird bewusst offengelassen, wie oft die Projektion der Erzählungen auf anderen Erzählebenen vorgenommen wird. Ein Motiv ist die Doppelung der Szenarien über diese verschiedenen Erzählebenen hinweg, so bei der „Kommune", in der die Rahmenhandlung von einer Mikrogeschichte gespiegelt wird. Ähnlich ist es bei der „Künstlergarderobe", die als Nicht-Ort oder Ort des Übergangs zwischen den Erzählebenen alle Orte noch einmal reflektiert und sich damit letztlich bis auf die Erzählebene des Autors rückbezieht.

Gillicks Installationen spielen ebenfalls mit der Denkfigur der Reflexion und inneren Spiegelung parallel zu seinen Texten. *Literally No Place* hat er während der von Barbara Vanderlinden und Jens Hoffmann kuratierten Ausstellung *Indiscipline* vorgestellt, mit einem improvisierten live präsentierten Skript als Versuch, ein Buch in Echtzeit mit wenig oder keinerlei Vorbereitung vorzutragen. So führen seine Ausstellungen wie *Literally No Place* bei der Galerie Air de Paris 2000 und *The Wood Way* von 2002 in der Whitechapel Art Gallery in London das gesamte Spektrum von Reflexion und ihrer Brechung in seinen Installationen aus transluzenten Raumteilern und Plattformen vor Augen. In Ausstellungen wie *Övningskörning* (*Driving Practice*) im Milwaukee Art Museum von 2004 war die Doppelung einer narrativen Struktur in frei hängenden Textversatzstücken aus Aluminium präsent als Skizzen erster Schritte seines Projektes *Construcción de Uno*. Das Prinzip innerer Spiegelung bedeutet, ein Bild- oder Textelement zu doppeln und auf verschiedenen Ebenen zu reflektieren. Die gespiegelten Text- oder Bildfiguren sollten dabei dieselbe Struktur aufweisen. Dieses strukturelle Prinzip, das *Mise en Abyme* genannt wird, stammt aus der Literaturtheorie und geht auf André Gides Buch *Tentative Amoureuse* zurück.[18] In einer Passage aus seinem *Journal* mit persönlichen

Aufzeichnungen denkt Gide über das Motiv der Doppelung nach und über die Wechselseitigkeit zwischen dem im Roman agierenden Subjekt und dem Thema, das vorgestellt wird. Zwischen dem realen und dem imaginierten Thema gibt es seines Erachtens eine indirekte Reflexion desselben Sujets. Zur Veranschaulichung vergleicht er die *Mise en Abyme* mit den Konvexspiegeln in niederländischen bildnerischen Darstellungen eines Hans Memling oder Quentin Massys, in denen der Spiegel oftmals einen imaginären Bildraum zeigt, diesen jedoch nicht direkt abbildet. Das eigentliche Thema erschliesst sich also erst durch die Reflexion. Zum Vergleich zieht Gide ein Verfahren aus der Heraldik heran, bei dem in einem Wappen oftmals dasselbe Emblem in einem Emblem dargestellt ist, das der Autor als *en abyme* eingesetzt bezeichnet. Jean Ricardou hat dieses Prinzip auf den französischen Nouveau Roman der Fünfzigerjahre angewendet als Geschichte in der Geschichte, um den Einfluss zu formulieren, den das Werk wiederum auf seinen Autor/seine Autorin nimmt, sowie die Beziehung, die der Autor/die Autorin zu seiner/ihrer Fiktion hat.[19] Er sieht den Text von André Gide auch als Verweis auf Victor Hugo, der explizit über eine doppelte Handlung geschrieben hat, bei der sich Ideen innerhalb einer grösseren und kleineren Dramenerzählung wie bei einem Echo wiederholen.[20] *Mise en Abyme* bedeutet demnach die unendliche Doppelung und Reflexion desselben Motivs auf verschiedenen Ebenen. Dies führt die Brechung einer einheitlichen Handlung und eine Differenz in der Wahrnehmung sowie eine zusätzliche Bedeutungsebene ein, die in der unendlichen Spiegelung wieder auf den Autor/die Autorin zurückweist.

Dieses Phänomen ist, abgesehen von einem Text des Kunstkritikers Craig Owens von 1978 über die unendliche Spiegelung in der Fotografie, bislang kaum in der Kunstgeschichte diskutiert worden.[21] Jedoch dient es als ein Werkzeug für die Analyse der Arbeit von Liam Gillick. Die Doppelung und die innere Reflexion eines Bildes, einer Erzählung oder eines Textes kann als sein Schlüsselthema bezeichnet werden. Der Künstler verhandelt dies durch paralleles Denken und den Aufbau paralleler Ebenen innerhalb seiner Arbeitsmethode. Seit den Neunzigerjahren ist das parallele Strukturieren ein Begriff in der Kunst; es wurde jedoch selten so explizit formuliert. Die Idee des Parallelen und inwiefern es mit unendlich gespiegelten Elementen zu tun hat, ist in einigen Ausstellungen beispielhaft angelegt. In seiner Analyse des Spiegelmotivs im fotografischen Prozess bezieht sich Owens auf Beispiele der Wiederholung aus der strukturellen Linguistik und klassischen Rhetorik, die zeigen, wie durch die Doppelung semantischer Wortsinn entsteht. Er überträgt diesen Prozess auf die fotografische Technik und reklamiert für das Foto die Fähigkeit, Bedeutung zu erzeugen unabhängig von der Struktur des Realen auf lichtempfindlichem Film. Die *Mise en Abyme* wird insofern als innere Spiegelung beschrieben, die nicht nur eine Fragmentierung des Motivs herbeiführt, sondern auf eine (von dem sichtbaren Thema des Textes oder Bildes unabhängige) innere Wirklichkeit verweist, die sich von der Vorstellung eines unendlich fortführbaren Vorgangs verselbständigt hat.

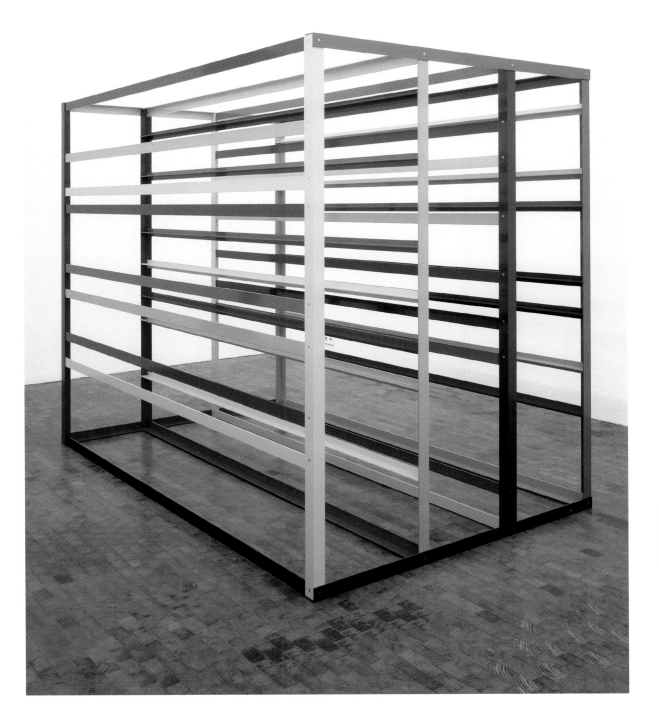

In seinen Installationen verwendet Liam Gillick Text in Form von einer unendlichen Kette aus Vinyl – oder Aluminiumbuchstaben, die ohne Pause zwischen den Buchstaben oder Wörtern aneinandergereiht werden. Die verwendeten Sätze können jedoch auch aus Kuben oder Kreisen aus pulverbeschichtetem Aluminium bestehen, die sich gegenseitig überlagern oder wiederholen: etwa in seiner *Consciens Lobby* von 2001, eine Auftragsarbeit, die er für Telenor in Oslo entworfen hat oder für seine Installation *Literally* (*structure and diagram*) im Museum of Modern Art, New York im Jahr 2003, *Idea Horizons* für den Flughafen Fort Lauderdale, Hollywood im Jahr 2002 und seine Ausstellung *Övningskörning* (*Driving Practice*) im Milwaukee Art Museum, 2004.

Bei Telenor, der norwegischen Telekommunikationsfirma, hat Gillick eine Arbeit für die Lobby des Gebäudes entworfen, zur Förderung der Kommunikation und des Ideenaustausches im Eingangsbereich des Firmensitzes. Auf den ersten Blick scheint der hängende, vielfarbige Kubus nur als gestalterisches Element den Raum zu strukturieren; der oft wiederholte Satz „Wittes, Learning and Studie"[22] wird jedoch zur memorierenden Botschaft, die nun den Ort bestimmt. Für das Museum of Modern Art in New York entsteht Gillicks durchlässige Kubenstruktur aus einem Schlüsselsatz von *Literally No Place*, gestaltet in einem gelb- und orangefarbenen Farbspektrum. „My step was light and I could feel the ball of each foot pushing the sand down from me as I walked." Dieser Satz ist ursprünglich aus B. F. Skinner's *Walden Two*[23] entlehnt: die verklärte Version eines alternativen Gesellschaftsmodells, die Gillick für seinen Text kritisch analysiert hat. Während Skinner am Schluss seines Textes die verheissungsvolle Zukunft einer parallelen Gesellschaft ausmalt, wird der Satz in *Literally No Place* zweimal verwendet und zum Auftakt einer problematischen Situation, in der die Mitglieder einer Kommune sich auf ihrem Rundweg befinden, während sie versuchen, die Kommune zu verlassen und sich dabei im wörtlichen und übertragenen Sinn im Kreis bewegen. In Gillicks Text hat der Satz die Funktion, den Wechsel zwischen verschiedenen Erzählebenen und Reflexionsebenen zu verdeutlichen, sowie den Wechsel zwischen den verschiedenen Erzählebenen und der Rahmenhandlung miteinander in Beziehung zu setzen. Im Museum of Modern Art scheint die Installation frei im Raum zu schweben, jedoch wirken die Textspiegelungen wie ein Fokus für Anfangs- und Endbetrachtungen und bilden einen Rahmen für den Parcours durch das Museum. Die Arbeit fungiert durch ihre Hängung oberhalb der Museumskasse wie ein Korrektiv im Ausstellungsraum.

Im Flughafen Fort Lauderdale in Hollywood wird die Idee eines Rasters für die gläserne Vorhangfassade mit langen, applizierten Textbändern in unterschiedlichen Grössen umgesetzt. Entsprechend Craig Owens Schlussfolgerung, dass der Spiegeleffekt in der Linguistik in seiner Bedeutung über den Wortsinn hinausweist, arbeitet Gillicks Fassadenentwurf *Idea Horizons* mit unendlich wiederholten und aneinandergereihten Wörtern, die mit den Konnotationen des Ortes spielen, auch wenn der Spiegeleffekt hier anders als in der Fotografie ist. Die Silben- und Wortwiederholungen scheinen

die Automatisierung derselben täglichen Abläufe des Ortes zu reflektieren. Durch den Einsatz unterschiedlicher Wiederholungen nehmen die Wortkombinationen eine Eigendynamik und ein bestimmtes Tempo auf, das eine Entsprechung für die Prinzipien von Geschwindigkeit und Bewegung an diesem Ort darstellt, wie zum Beispiel die Wortkombination „gliding by gliding by and gliding by."

Im Jahr 2004 hat Liam Gillick eine Installation aus hintereinander gestaffelten, frei hängenden Textelementen für einen langen Ausstellungsraum im Milwaukee Art Museum entworfen. Der Titel *Övningskörning (Driving Practice)* bezieht sich auf das Moment der Bewegung, das für die Konzeption dieser Installation eine zentrale Bedeutung hat – die Textzeilen erschliessen sich in der Bewegung durch den Raum erst nach und nach.

FLASH #4

Ein langer, offener Korridor mit einer durchfensterten Dachschräge an einer Seite. Die Skelettarchitektur aus weissen Wandpfeilern, die stufenweise zu Gewölbestreben werden, weist eine diaphane Struktur auf. Das weisse Gewölbe und der glänzende Marmorboden bieten kaum oder keine räumliche Orientierung für Durchreisende. Es scheint ein Nicht-Ort zu sein, der nur die Zwischenstation für andere Orte darstellt, wie die offenen Sitzbereiche in der Flughafen-Abflughalle. Nur die waagerechten Strukturen der schwarzen Textbänder sind unterhalb der Decke entlang des Korridors sichtbar, in einer horizontalen Linie gestaffelt und in der Luft frei schwebend, entzifferbar nur durch die Gehbewegung durch den Raum. Bezeichnen sie den Beginn einer Erzählung? Stellen sie den Widerhall einzelner Begriffe dar? Der reflektierende Boden wird zum gebrochenen Spiegel für den Text. Der Weg durch den Raum, Schritt für Schritt, vom Anfang bis zu dem Endpunkt generiert die Beschreibung eines Szenarios: „[...] an experimental factory – recent closure of the plant – primary activity produce objects – methods of production to alleviate the most destructive aspects of life on the production line".

Alle Wörter schliessen aneinander an, scheinen keinen Anfang und kein Ende zu haben. So wird die Installation zu einem *stream of consciousness*, zu einem inneren Monolog, ähnlich dem alltäglichen Gedankenstrom, der den Besucher begleitet. Es wird jedoch eine Ausrichtung der Arbeit deutlich: die allgemeine Reflexion über Produktionsbedingungen und Arbeitsabläufe in einer Fabrik. Der Korridor im Milwaukee Art Museum ist ein ungewöhnlicher Ausstellungsraum: Er wirkt wie ein Gang in einem Flughafen. Ob dort oder hier, die Arbeit könnte vor allem durch einen Besucherstrom funktionieren, der sich durch die Passage bewegt. Er wirkt als ein Raum, wie Marc Augé es beschrieben hat, in dem die Bewegung der Bilder den Betrachter dazu anregen, die Existenz einer Vergangenheit und den flüchtigen Eindruck einer möglichen Zukunft anzunehmen.[24] Augé beschreibt den Raum der doppelten und parallelen Bewegung für den Reisenden als einen Archetyp des Nicht-Ortes, in dem einzelne Eindrücke sich im Gedächtnis auftürmen und sich eine fiktionale Beziehung zwischen dem Blick des Reisenden und seiner Umgebung entwickelt. Insofern existiert der Korridor im Museum neben seiner Funktion als Übergangsbereich

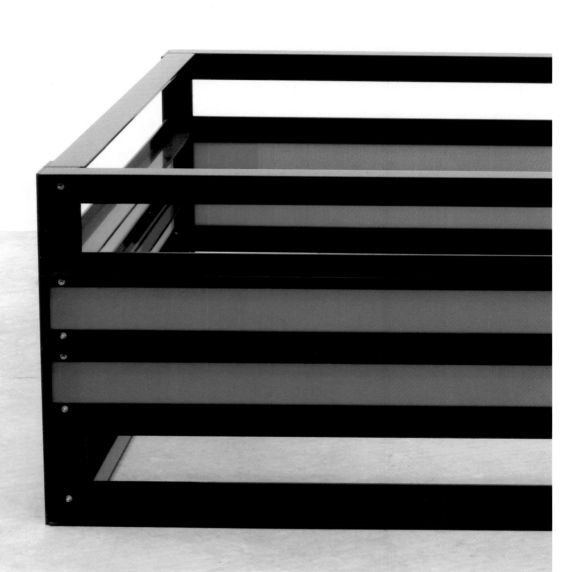

von einem Ausstellungsraum in den nächsten, durch den Menschen sich permanent bewegen, ausschliesslich durch die Gedanken und die Eindrücke des Reisenden, der den Ort in seiner einmaligen Ausprägung existent werden lässt.

Aus der Intervention im Ausstellungsraum wird durch Spiegelung ein doppelter Textfluss: eine Beschreibung oberhalb im Raum und ein unentzifferbarer Gedankenstrom auf dem Boden. Der Text erschliesst den Blick auf die Beschreibung eines industriellen Raumes. Somit wird das Unendliche des Nicht-Ortes durch die Idee eines faktischen Ortes kontrastiert. Beide Elemente werden vom Besucher in einem synchronen Moment erfasst.

Die Ambiguität des Blickes durch die Technik der *Mise en Abyme* in einem unendlich gespiegelten Raum oder in einer Erzählung findet ihre Definition in dem, was Liam Gillick „parallel structure" nennt. Dieser Begriff bezeichnet sowohl ein geistiges wie auch ein formales Prinzip und hat zunächst mit zwei eigenständigen und unabhängigen, aber doch miteinander in Beziehung stehenden Prozessen oder Szenarien zu tun; erst in der gemeinsamen Betrachtung der beiden Strukturen gibt jedes Prinzip über das andere Aufschluss und ermöglicht eine neue Lesart des jeweils anderen Bereichs. Das Konzept kann ebenfalls die Verlagerung zu einer anderen Ebene, Struktur, Handlung oder Erzählung bedeuten, die parallel zu dem rein gedanklichen Ausgangspunkt oder vielfachen Szenarien erzeugt wird. Für Gillick stellen parallele Prozesse ein formales, kontextuelles Werkzeug dar und damit eine andere Form des Denkens und eine andere Rezeptionsweise kultureller Produktion. Die Aufmerksamkeit richtet sich somit auf den Rezipienten/die Rezipientin und seine/ihre Fähigkeiten, zwei oder mehr unabhängige, aber chronologisch oder strukturell parallel angelegte Elemente mit einem Blick zu erfassen. Es handelt sich somit nicht um eine allgemeine Form des Vergleichs, da die Ebenen der Elemente hier unterschiedlich und unabhängig voneinander sind. Erst der Vorgang paralleler Betrachtung gibt Aufschluss sowie eine erweiterte Vorstellung des jeweils anderen Prinzips.

Gillick beschreibt paralleles Denken als einen Prozess und eine Anregung für die Visualisierung von Kunst, die sich nicht in geschlossenen Konstruktionen, sondern in vorläufigen Strukturen äussert.[25] Wenn Sinn im postmodernen Kunstwerk – wie Markus Brüderlin betont – aufgrund des Spannungsverhältnisses von „ästhetischer Erfahrung und diskursiver Reflexion" entsteht, ist ein Blick auf Gillicks nebeneinander angelegte Arbeiten aus Installationen und Büchern oder Skripts aufschlussreich.[26] Stephan Schmidt-Wulffen weist im Hinblick auf Gillicks unveröffentlichtes Drehbuch *Robert McNamara* von 1994 und die in derselben Zeit entstandenen Installationen als „parallel artworks" auf die Veränderung in der Wahrnehmung infolge einer gemeinsamen Betrachtung von Skript und Objekt hin. Aufgrund der Übernahme filmischer Lowtech-Produktionsmechanismen, erscheinen die Arbeiten, ob es sich um ein Trickfilm-Video, Skizzen oder Dias handelt, als Kollektiv, die eine allmähliche Leseweise zulassen. Gillick verwendet oft

den Begriff des Szenarios für Gedankenprozesse, auf der Basis simultaner Darstellung unterschiedlicher Wahrnehmung diskursiver Bereiche; die Grenzen zwischen Autor und Rezipient, Denken und Handeln, Objekt und Idee werden so in Frage gestellt.[27]

Insofern begünstigt die parallele Betrachtungsweise ein Feld für unendlichen, kommunikativen Austausch jenseits subjektivistischer Fixierung, wie Nicolas Bourriaud es formuliert: eine Bewegung in der Kunst, in der die Intersubjektivität das Substrat darstellt und das zentrale Thema die Begegnung zwischen Betrachter und künstlerischer Arbeit ist.

The Wood Way (Der Holzweg) ist der Titel einer zum Teil retrospektiv angelegten Ausstellung in der Londoner Whitechapel Art Gallery von 2002. Die Ausstellung bringt verschiedene Werkgruppen von Liam Gillick zusammen, die im Kontext des Buches *Discussion Island/Big Conference Centre* entstanden sind, aber auch einige Hinweise auf frühere und nachfolgende Projekte durch Wandtexte und die gleichzeitig entstandene Präsentation des Buches *Literally No Place* bei der Eröffnung der Ausstellung berücksichtigt. Der Titel stellt eine wörtliche Übersetzung der deutschen Redewendung „auf dem Holzweg sein" dar. Die direkte Verwendung einer deutschen Redewendung ist im Englischen erläuterungsbedürftig. So weist Iwona Blazwick in ihrer Einführung des Ausstellungskataloges darauf hin, dass das Einschlagen des falschen Weges im übertragenen Sinne ein Sich-Verlieren im Dickicht eigener Gedanken bedeutet. Der Titel beschreibt auch den klassischen Nicht-Ort, da eine solche Stelle nach Augés Definition keinen anthropologischen und keinen von menschlichen Beziehungen geprägten (relationalen) Ort darstellt, sondern stattdessen einen Übergangsort, an dem Entscheidungen (Aus-)Richtungen oder Gestaltungen im Denken und Handeln ändern können und der auch in produktiver Weise genutzt werden kann.

FLASH #5

Eine als durchlässiger Raumteiler konzipierte Holzstruktur, bestehend aus einander in Längsrichtung gegenüberstehenden Paneelen mit Plattformen und Projektionswänden auf jeder Seite, bildet einen verzweigten Pfad durch den Ausstellungsraum. Aufgrund der Unterteilung des Raumes in Längs- und Querrichtung entsteht ein Parcours mit einzelnen Nischen, der die Möglichkeit bietet, die Kunstwerke unterschiedlich zu gruppieren. Einen Durchblick auf die Texte aus Vinylbuchstaben auf den hinteren Wänden gibt es vor allem durch die transluzenten Plexiglaswände. Die Holzstruktur konzentriert die ausgestellten Werke auf die Raummitte. Einerseits kommt der Struktur eine trennende und gliedernde Funktion zu, andererseits gewährleistet sie, dass durch die Durchblicke unterschiedliche Sichtbezüge hergestellt werden, während die Binnenstruktur erhalten bleibt. Der Holzboden des Raumes ist mit Wodka, Wasser, glänzenden Silber- und Goldpartikeln gewischt worden. Die Ausstellung beginnt bereits im Foyer mit sechs Plattformen und weiteren formalen Veränderungen in Vortragssaal und Café durch Sitzbezüge, Wandtext und Deckengestaltung. Zwischen dem Eingangsbereich und dem Ausstellungsbereich hat der Künstler fast

unbemerkt eine zweiflügelige Glastür mit Holzrahmen auf einer Seite wie ein Nadelöhr eingefügt. Das Glas ermöglicht einen direkten Durchblick in den Ausstellungsraum und gewährt einen bewussten Zugang in einen anderen Raum, der in seiner ursprünglichen Architektur offen ist. Die Tür ist von Gillick 1997 ursprünglich während seiner Ausstellung im Le Consortium in Dijon im Zuge einer Veränderung des Zugangs zum Consortium renoviert worden. Als *Documentary Realization Zone 1# to 3# (Part)* scheint sie der gesamten Ausstellung einen Rahmen zu verleihen, obwohl sie eigentlich das verbindende Element zwischen einem Aussen und Innen der Präsentation darstellt. Der messingfarbene Türknopf unterstützt diesen Eindruck des Rahmens, da er als Konkavspiegel fungiert, der die Sicht auf die Ausstellung reflektiert. Eine Detailfotografie aus dem Katalog unterstreicht diese Lesart. Der Blick auf die Ausstellung mit seiner ungewöhnlichen Holzstruktur wird nun im Spiegel im Sinne der *Mise en Abyme* verdoppelt; ähnlich wie bei flämischen Interieurdarstellungen reflektiert der Spiegel mehr als nur die Sicht vom Eingang aus, sondern auch den Besucher und den Fotografen.

Der Holzweg lässt an die Anfangs- und Schlussschilderung in *Literally No Place* denken, in dem die Gruppe aus der Kommune sich auf einen langen Fussmarsch begeben hat. Haben sie sich zu Beginn des Buches im Dickicht verirrt, so hat sich die Situation am Ende des Buches in eine produktive Situation verwandelt, in der sie einen weiten Weg zurückgelegt haben. Ähnlich wie der Satz „My step was light…" Gillicks Text formal rahmt, verwendet er die Tür (Renovierung/Verlagerung), und so gibt es ein spielerisches Element in der je nach Position im Text unterschiedlichen Metapher des Satzes. Das Sich-Verlieren im Dickicht wird somit zu einem Bild für den Zustand des Mikrokosmos der Kommune.

Für die zum Teil retrospektiv angelegte Ausstellung ist das Element des Holzweges ein notwendiges Werkzeug als formaler Platzhalter für die ortsspezifischen Arbeiten, die ursprünglich für spezifische Kontexte entwickelt wurden; andererseits führt die Struktur eine doppelte Sicht auf die Dinge durch den entlehnten Begriff *The Wood Way* ein. Der Holzweg wird zum Leitmotiv eines Gedankenprozesses, bei dem die eigene Denkleistung von den Betrachtern selbst gefordert ist. Als Ausstellungsparcours, der den Durchblick aufgrund der Holzpaneelenstruktur immer wieder irritiert, reflektiert *The Wood Way* somit die faktischen und metaphorischen Ebenen dieses Begriffes und gleichzeitig seine Funktion als Struktur, als Vehikel für die Interpretation. Sein Motiv des Scheiterns wird zum produktiven Element, nicht die Sammlung definierter skulpturaler Formen durch die Institution selbst.

Der im Katalog im Detail abgebildete Türknauf der *Document Realization Zone* lässt mit seiner Spiegelung der Ausstellungssituation an Craig Owens Erkenntnis über das fotografische Bild denken, das Bedeutung unabhängig vom abgebildeten Objekt generiert. Insofern hat der Künstler mit seinen Eingriffen in Foyer, Café und Vortragsraum eine parallele Ebene eingeführt, die die Ausstellung zur Denkfigur werden lässt.

Das Bild als ein in der Reflexion unendlich weitergeführtes Motiv deutet neben der Doppelung und Spiegelung der Elemente auch auf die Brechung eines einheitlichen und kontinuierlichen Themas hin. In seinen Studien zur *Mise en Abyme* hat Fernand Hallyn diese Brechung *en abyme* mit dem Hinweis auf eine doppelte Erfahrung und doppelte Wahrheit beschrieben, bei der Reflexion sowohl als ein Zeichen für Geschlossenheit als auch für Diskontinuität auftritt.[28] Jean Ricardou sieht die innere Spiegelung als literarischen Kunstgriff oder ein Instrument an, das oft gegenläufig zum Text agiert und mit diesem in Konkurrenz tritt. Dies geschieht nicht durch die Wiederholung eines Textteils auf einer anderen Ebene, sondern über die Teilungen, die eine innere Spiegelung hervorrufen. Anhand des Romans *Passage de Milan* des französischen Autors Michel Butor beschreibt er, wie die Motive eine relative Autonomie erlangen und somit eine parallele Erzählung entsteht, die Ricardou mit einer Schichtung gleichsetzt, die jegliche Einheit der Erzählung durch das Schichten vieler metaphorischer Erzählungen aufbricht.[29] Dieses Aufbrechen einheitlicher Handlung und Schichten vieler paralleler Erzählungen nimmt auch Liam Gillick durch vielfache Teilung in Subgeschichten in *Literally No Place* vor. Er visualisiert diese Technik in der Ausstellung *The Wood Way* und erzeugt damit einen zentralen Aspekt der *Mise en Abyme*.

Eine ähnliche Brechung nur in räumlicher Hinsicht sieht Fernand Hallyn in der Übertragung der *Mise en Abyme* auf das Werk Hans Holbeins d. J. *Doppelbildnis Jean de Dinteville und Georges de Selve (Die Gesandten)* von 1533. Das Aufbrechen der Einheit oder des homogenen Raumes führt hier eine Veränderung des Werkes in ein Gefüge aus zwei unterschiedlichen, systematischen Räumen herbei. Die Zweiteilung findet in der Darstellung auf unterschiedlichen Ebenen statt. Über die perspektivische Konstruktion mit dem durch Anamorphose verzerrten Totenschädel in der Mitte des Bildes, der gegen die perspektivischen Gesetze zu verstossen scheint, werden die Besucher zu einer doppelten Betrachtung angehalten. Der zweite Blick erschliesst sich über die ursprüngliche Hängung des Bildes im Saal der Dinteville-Familie des Château de Polisy, in dem Holbeins Gemälde neben und oberhalb einer Tür an einer langen Mauer hing, so dass die Betrachter die doppelte Sicht und zwei gänzlich verschiedene Perspektiven auf dem Weg durch den Raum erfahren konnten. Erst aus einer starken Untersicht wird das anamorphotische Gebilde des Totenschädels in der Mitte des Gemäldes deutlich sichtbar und die anderen Bildelemente erscheinen verzerrt. Hallyn beschreibt die Funktion der Perspektive als Code für die bildnerische Darstellung, die jeweils die andere Sicht komplett ausschliesst und eine Sicht als Lebens- sowie Todesmetapher nahelegt.[30]

In der bildnerischen Darstellung fungiert der Totenschädel als *Mise en Abyme*. Es ist nicht einfach nur die Einführung eines weiteren Raumes, der sich innerhalb des grossen Bildraumes befindet und diesem von der Struktur her untergeordnet ist. Hier findet auch eine Analogie des optischen und emblematischen Prinzips statt: Die Anamorphose

des Totenschädels verzerrt und zerlegt die anerkannte Perspektive und so verhält sich das Prinzip des Todes zu demjenigen des Lebens. Hallyn sieht gerade die schräge und frontale Sicht vertauscht, da die frontale Sicht mit dem undechiffrierbaren, dekonstruierten Schädel der Todesdarstellung näherkommt und unser Vertrauen in (visuelle) Realitätssysteme irritiert. Hier wird die Todesmetapher zur Vergegenwärtigung eines anderen Blickwinkels im Bild, verdeutlicht durch die *Mise en Abyme*, in der der Tod nach Hallyn zur „abwesenden Präsenz und einer präsenten Abwesenheit" wird.[31]

Diese Aspekte der Brechung und Schichtung paralleler Erzählungen oder Darstellungen werden auch in Liam Gillicks Installationen und fiktionalen Texten deutlich. Das Schlüsselelement, das den Prozess der doppelten und gespiegelten Sicht herbeiführt, differiert oftmals, wie es die Verwendung des Totenschädels in Holbeins *Die Gesandten* vorführt. In Gillicks Fall kann es durch den Einsatz eines Wandtextes in einer Installation transluzenter Wandschirme und Plattformen erzeugt werden. In einigen Fällen geht es auch durch ein sichtbares Piktogramm, ein Thema im Text, eine Ausstellungsstruktur oder ein reflektiertes Bild im Spiegel. Es ist diese Technik der inneren Spiegelung, die einen gewissen Schwindel des Abgrunds hervorruft und bei dem die einzelnen Elemente eine Autonomie innerhalb ihrer eigenen, parallelen Ebene beanspruchen. Die *Mise en Abyme* führt einen Vorgang der Diskontinuität im Blick herbei, die nicht nur den eigenen Wahrnehmungsstandpunkt relativiert, sondern wieder und wieder die Referenzkette des Vorstellungsprozesses und damit der Raumbildung anstösst und damit neue Formen räumlicher Konzeptionen hervorbringt.

So sind es neben streng symmetrischen Elementen wie der Spiegelung und der parallelen Struktur, zugleich narrative Elemente innerhalb des Werkes. Allgemein gesellschaftliche Betrachtungen prognostischer Art wie auch metaphorische Motive, verleihen dem Werk Liam Gillicks eine eigentümliche Balance. Diese entwickelt sich über das strukturelle Interesse an gesellschaftlichen Verhaltensweisen und der Art ihrer Rückführung als Material in den Fluss der Geschichte und ihrer Verzeitlichung. All das geschieht Seite an Seite mit der Erzeugung einer permanenten Entwicklung raumbildender Prozesse und fiktionaler Visionen. Diese funktionieren wiederum als Vehikel traumwandlerischen Bewegens zwischen Vergangenem und Zukünftigem und somit für das Verstehen und Lesen der Konzepte innerhalb und jenseits des Werks.

Es mag sein, dass dieser Duktus als ein allgemeines Merkmal der Kunstproduktion der letzten fünfzehn Jahre wahrgenommen wird und als Verfahren erprobt wird, soziale Handlungsmodelle aufzuzeigen, diese im Bereich der Kunst zu reflektieren und damit einen Beitrag zu leisten, der dem analysierten Feld ausserhalb des Kunstdiskurses Prognostisches hinzufügt. In der Arbeit Liam Gillicks erschliesst sich das Potenzial dieser Prozesse besonders, als sein fiktives Gespräch zwischen dem Direktor des RAND-Institutes Herman Kahn und dem Verteidigungsminister unter John F. Kennedy, Robert

McNamara, in einem Reader über diese Epoche in der Geschichte als relevanter Beitrag erscheint. Gillick zeigt mit seinen Arbeiten, was Fiktion und spekulatives Wissen ausrichten und in anderen Feldern anstossen können, die sonst auf empirischer Basis erarbeitet werden; dies unterscheidet das Bild der künstlerischen Reflexion wesentlich von demjenigen des Analysten und Strategen. Das Hin- und Herbewegen zwischen fiktionalem und strukturellem Denken erzeugt hier aufs Neue einen Raum der Reflexion, der Wissen und Spekulation gegeneinander auslotet. In diesem wird beides einer Kritik und Revision unterzogen und dadurch werden sich ständig verändernde Möglichkeits-räume geschaffen.

ENDNOTES

1 Aleida Assmann, „Die Sprache der Dinge. Der lange Blick und die wilde Semiose", in: Hans Ulrich Gumbrecht und
 K. Ludwig Pfeiffer (Hg.), *Materialität der Kommunikation*, 1952, S. 237–51, insbes. S. 241 f.

2 Harald Merklin (Hg.), *Marcus Tullius Cicero, De oratore/Über den Redner*, lat./dt., Stuttgart 1976, S. 430.

3 Aleida Assmann, *Erinnerungsräume, Formen und Wandlungen des kulturellen Gedächtnisses*, München 2003, S. 160.

4 Reinhart Koselleck, *Vergangene Zukunft. Zu der Semantik geschichtlicher Zeiten*, Frankfurt am Main 1984, S. 327.

5 Georg Simmel, „Das Problem der historischen Zeit", in: Arthur Liebert (Hg.), *Philosophische Vorträge der
 Kantgesellschaft*, Berlin 1916, S. 12–13. Vgl. Arthur Lovejoy, *The Great Chain of Being*, Cambridge, Massachusetts 1950,
 S. 242, 244 ff. und Reinhart Koselleck, *Zeitschichten. Studien zur Historik*, Frankfurt am Main 2000, S. 78 f.

6 Koselleck, *Vergangene Zukunft*, S. 320.

7 Liam Gillick, „ILL TEMPO. The Corruption of Time in Recent Art", in: Ders., *Five or Six*, 1999, S. 21.

8 Immanuel Kant, „Anthropologie in pragmatischer Hinsicht", 1. Buch § 35, in: Walter Kinkel (Hg.), *Immanuel Kant,
 Sämtliche Werke*, Bd. IV, Leipzig 1920, S. 91–92.

9 Gabriel Tarde, *Underground (Fragments of Future Histories)*, updated by Liam Gillick, Brüssel/Dijon 2004, S. 7.

10 Tarde, *Underground*, S. 68.

11 Georg Wilhelm Friedrich Hegel, *Vorlesungen über die Aesthetik*, 1. Band, Stuttgart 1953, S. 379 f.

12 Vorlage von Liam Gillick, Skript zum Buch sowie Vortrag vom 07.05.06 und überarbeitete Version vom Dezember 2005.

13 Henri Lefebvre, *The production of space*, Oxford 1991, S. 356 f.

14 Lefebvre, *Space*, 1991, S. 73, 83.

15 „[...] here we see the polyvalence of social space is ‚reality' at once formal and material. Though a product to be used,
 to be consumed, it is also a means of production; networks of exchange and flows of raw materials and energy fashion
 space and are determined by it. Thus this means of production, produced as such, cannot be separated either from the
 productive forces, including technology and knowledge, or from the social division of labour which shapes it, or from
 the state and the superstructures of society." Lefebvre, *Space*, 1991, S. 85.

16 Fredric Jameson, „Five Theses on actually Existing Marxism", in: Michael Hardt und Kathis Weeks (Hg.), *The Jameson
 Reader*, Oxford 2001, S. 164–71.

17 Gilles Deleuze, *Shortcuts*, Berlin 2001, S. 45 ff.

18 André Gide, *Journal. 1889–1939*, Paris 1948, S. 40.

19 Jean Ricardou, *Problèmes du nouveau roman*, Paris 1948, S. 40; Christian Angelet, „La Mise en Abyme selon le
 ‚Journal' et la ‚Tentative Amoureuse' de Gide", in: Fernand Hallyn (Hg.), *Onze études sur la Mise en Abyme*, Romanica
 Gandensia, vol. XVII, Gent 1980, S. 13.

20 Ricardou, *Nouveau roman*, S. 61.

21 Craig Owens, „Photography en Abyme", Scott Bryson, Barbara Kruger, Lynne Tillmann & Jane Weinstock (Hg.), *Beyond
 recognition. Representation, Power, and Culture*, London 1992, S. 17.

22 Der Text dieser Arbeit setzt sich aus verschiedenen Sprachen zusammen, einer Mischung aus Englisch, Altenglisch und
 Französisch und reflektiert drei Hauptformen des Englischen vor der Vereinheitlichung der englischen Sprache in
 Johnsons Wörterbuch. Diese Textpassage ist ein Zitat aus Thomas Mores *Utopia* von 1518.

23 Burrhus Frederic Skinner, *Walden Two*, New York/Hampshire 1948, S. 284.

24 Marc Augé, *Non-places: Introduction to an anthropology of supermodernity*, London/New York 1995, S. 87.

25 Liam Gillick, „The Semiotics of the Built world", in: Ausstellungskatalog *Liam Gillick. The Wood Way*, Whitechapel Art
 Gallery, London 2002, S. 83, 84.

26 Markus Brüderlin, „Beitrag zu einer Ästhetik des Diskursiven. Die ästhetische Sinn- und Erfahrungsstruktur
 postmoderner Kunst", in: Jürgen Stöhr (Hg.), *Ästhetische Erfahrung heute*, Köln 1996, S. 287.

27 Stephan Schmidt-Wulffen, „Gillicks Konjunktiv", in: Ders. (Hg.), *Perfektimperfekt*, Freiburg im Breisgau 2001, S. 249–54.

28 Fernand Hallyn, „Introduction", in: Ders. (Hg.), *Onze études sur la Mise en Abyme*, Romanica Gardensia, vol. XVII, Gent
 1980, S. 6.

29 Ricardou, *Nouveau Roman*, S. 85.

30 Fernand Hallyn, „Holbein: La mort en abyme", in: Ders. (Hg.), *Mise en Abyme*, S. 166.

31 Hallyn, „Holbein", in: Ders. (Hg.), *Mise en Abyme*, S. 181.

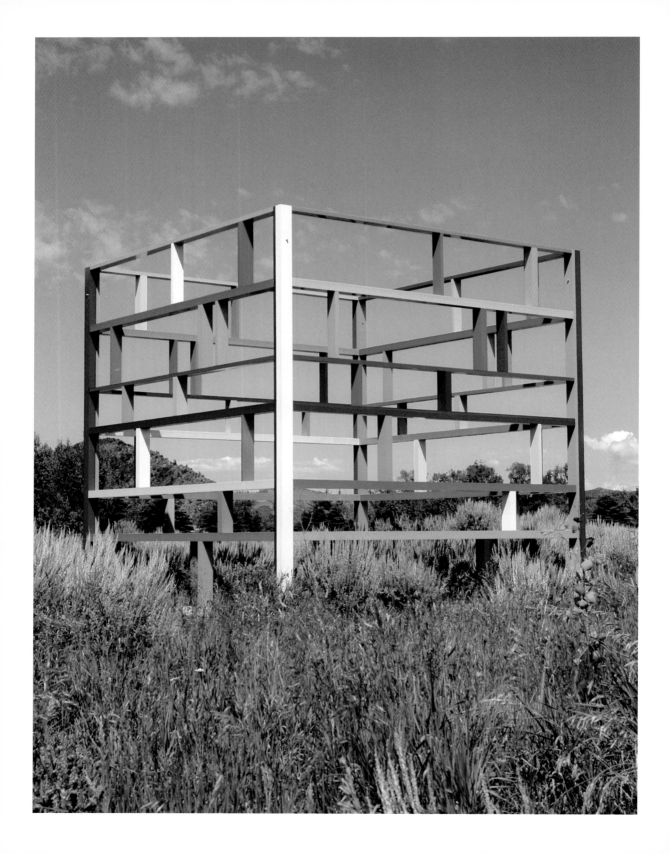

Image Archive

UNDERGROUND (TRAILER FOR A BOOK), 2004
Brionvega Cuboglass television, DVD, brown
office carpet

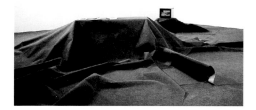

An improvised landscape of brown carpet fills the room. Various plinths, boxes, and the flight case that contains the Brionvega Cuboglass television, are used to create the support for this varied landscape. The television shows a DVD comprised of fragments from the book UNDERGROUND (FRAGMENTS OF FUTURE HISTORIES), 2004 (Brussels/Dijon, Les Maîtres de Forme Contemporains, Les Presses du Réel). Transparent layers of text float across the screen. The film is accompanied by a sound track of rearranged Early Music, primarily sourced from Italian composers. The sources for the soundtrack are midi files derived from the original scores that have been reworked using Cubase software. The book UNDER-GROUND is an updated version of the original 1904 translation of FRAGMENT D'HISTOIRE FUTURE by Gabriel Tarde. The introduction is by Maurizio Lazzarato. The updating process both accelerates the narrative flow of the text and calls into question the embedded values revealed in the original translation. Lazzarato's introduction examines the broad themes of the text, globalization, ecological catastrophe, and the final days in what is now Iraq, as the last people on earth await their fate in a concrete bunker.

UNDERGROUND (FRAGMENTS OF FUTURE HISTORIES),
Galerie Micheline Szwajcer, Antwerp, Belgium, 2004

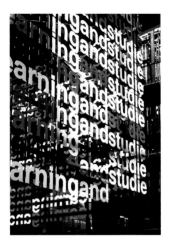

CONSIENS LOBBY, 2001
Water- and laser-cut text, vinyl text, and
painted aluminum panels

A large powder-coated aluminum framework hangs low in the lobby of the Telenor building on the site of
the old Oslo Airport. The complete work also includes a series of painted aluminum forms bonded to
the glass walls of the lobby, and a text on the ceiling of the open atrium space. The work functions in
three distinct ideological ways. At ground level the visitor is faced with abstract hard-edged forms that
have been applied to the glass. Just above head height the text cube carries a phrase written before
the unification of modern English language. "Wittes, Learning and Studie" reveals a combination of Old
English, modern English, and the original French spelling of the modern word Study. The phrase is derived
from the book LITERALLY NO PLACE, 2002 (London, Book Works). On the ceiling a more extensive
quotation expresses a more precise statement. THE DISCHARGE OF MY CONSIENS ENFORCETH ME
TO SPEAK SO MUCHE. This quote is directly from the trial of Thomas More, author of UTOPIA, and
reflects the aspects of the book LITERALLY NO PLACE that examine how conscience and ethics reveal
themselves in the built world.

Permanent work for Telenor, Oslo, Norway, 2001

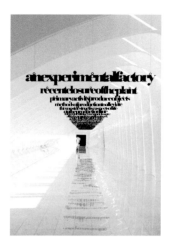

ÖVNINGSKÖRNING (DRIVING PRACTICE), 2004
Water-cut, powder-coated aluminum, 30 texts

A series of texts hanging in one of the two main side-corridors of the Milwaukee Art Museum. As a whole the texts outline the background story of a potential text project provisionally titled CONSTRUCCIÓN DE UNO, 2004 onwards. The text refers to an experimental factory, recently closed, where the workers return to their original workplace and over time start to develop a new improvised form of economic and ecological production. The book is in a permanent state of suspension, but the research behind it and the process of discussion towards it has generated a number of projects. The underpinning of the project is a reassessment of the notion of production methods in developed European social democracies, and what happens when these experimental models of production come to an end. A great deal of the research into this project is derived from Brazilian academic papers on the subject of Swedish experimental and socially conscious working practices in the 1970s.

ÖVNINGSKÖRNING (DRIVING PRACTICE),
Milwaukee Art Museum, Milwaukee, Wisconsin, USA 2004

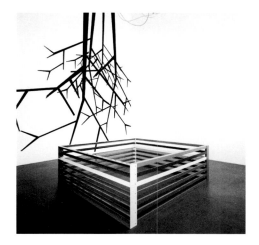

SIGNAGE FOR A FUTURE SOCIAL CENTRE, 2005
Vinyl graphic

REVISION CORRAL, 2005
Powder-coated aluminum

Two works from an exhibition, that refer to the developing ideas around the project CONSTRUCCIÓN DE UNO. This developing project has led to a number of works that could be viewed as functional nominative structures for fading or disrupted concepts such as the idea of the social center. This is a parallel connection; the work does not function as a guide or illustration of the developing ideas. Rather it has been produced in a state of distraction while thinking about the conditions of a revised social structure. CONSTRUCCIÓN DE UNO concerns a group of people in a Northern European country who return to their recently closed factory out of habit and boredom. Their area is unaffected by post-industrial blight, but the former employees are conscious of a specific loss. Following a period of directionless improvisation with the signage and equipment left behind in the factory, they start to develop structural games in order to develop a better model of production. The work here—signage, seating, low screens, and a corral—refer to the earliest days following the closure of the place. A manipulation of materials that happen to surround them in order to produce a new series of framing devices around which to commence their thinking takes space. The work also makes a conscious reference to the language of workshop-based, semi-industrial modernist art production.

FACTORIES IN THE SNOW, Galerie Meyer Kainer, Vienna, Austria, 2005

THE CURRENT CONSTRUCTED BY THE FACTORY
ONCE IT HAS STOPPED PRODUCING CARS, 2005
Powder-coated aluminum

A structure conceived while thinking about the elements needed to develop the project CONSTRUCCIÓN DE UNO: "Over time they completely reconfigure the working space of their new activities. They write on the walls and create diagrams on the floor that reveal the passage of their thoughts, false start, and developments. More windows are opened up in the space to create new vistas and bring them closer to the exterior spaces that now make them anxious and should be kept as a view not an experience. Some people work all night and if you are driving past the factory you might see them through the windows, involved in long discussions and lengthy expositions of their ideas. They attempt to find a way to create a total transfer of all objects and ideas in such a way as to ensure that nothing is depleted or diminished, but everything is different."

FACTORIES IN THE SNOW, Galerie Meyer Kainer, Vienna, Austria, 2005

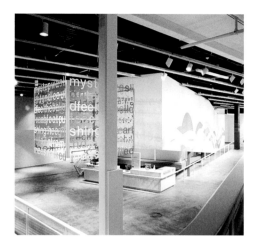

LITERALLY (DIAGRAM), 2003
Paint on wall

LITERALLY (STRUCTURE), 2003
Water-cut aluminum, powder-coated aluminum

A wall design that refers to the desert landscape described in the book LITERALLY NO PLACE. The desert is the zone of the commune within the text. It is also the landscape walked by the characters in the project who leave their commune on a circuitous route in order to talk and reassess the ideological and political implications of the place. The wall graphic can also be understood as an abstracted depiction of a Middle-Eastern desert landscape, the work having been completed as the war in Iraq loomed.

A text cube functioning somewhere between a sign for a non-event and an announcement of intentions (a reflection of the way things could be and a meeting point). A piece of formalized rhetoric in relation to a wall diagram (note the use of the word diagram rather than drawing—the diagram is the abstraction of a location or setting that echoes an environment where there are still options in terms of direction and development). Something designed for a lobby. A work intended as a backdrop. The text refers to Thomas More's UTOPIA and B.F. Skinner's applied neo-Utopian vision WALDEN TWO, towards the completion of my own compressed book, LITERALLY NO PLACE, 2002. The large text cube designates a foyer as a place to consider the way ethical shifts leave their trace in the built world. WALDEN TWO provides a glimpse of poetry—a moment that synthesizes the contradictory value systems circling around the book: "MY STEP WAS LIGHT AND I COULD FEEL THE BALL OF EACH FOOT PUSHING THE EARTH DOWN FROM ME AS I WALKED." A visitor to Skinner's behavioralist Utopia stops for a moment to consider the implications of what he has witnessed and how things should proceed personally and socially in relation to the idea of the commune.

LITERALLY, MoMA, New York, USA, 2003

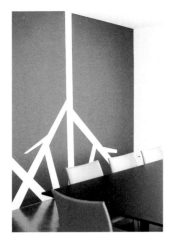

LOCKED DISTANCE DEVICE, 2005
Paint on wall

One of 12 wall designs, each located in a separate private dining room of BSI in Lugano. The wall designs are supplemented by a series of aluminum structures in the foyer. The designs range from geometric patterns to the tree-like image here. The tree-like image recurs in the work and is also seen in THE TRIAL OF POL POT, 1998; the design for the logo of the Frankfurter Kunstverein; and the exhibition at Meyer Kainer in 2005. The graphic is one of the few moments in the work that comes close to a representative image. The tree-like form is derived from Deleuze but also indicates the notion of the stage set or backdrop. The form implies a continual splitting of narratives within the work into parallel strands of inter-related ideas over time.

Permanent work for BSI, Lugano, Switzerland, 2005

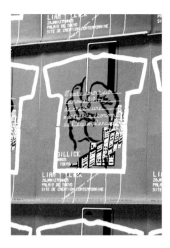

POSTER FOR AN EXHIBITION
(with M/M, Paris), 2005
Screenprint

The original poster for the exhibition A SHORT ESSAY ON THE POSSIBILITY OF AN ECONOMY OF EQUIVALENCE was designed by the in-house graphic department of the Palais de Tokyo. The original poster displayed a rather literal understanding of the factory references within the work on show. The original poster also demonstrated an affinity with political poster design from the late 1960s and more recently from Latin America. M/M took the original poster design and corrupted it graphically, rendering the original design unclear. They cut up and rearranged the text and included two new elements: the diagram of a t-shirt and a clenched fist holding a credit card between two fingers. In this way, M/M complicated the nostalgic image that made up the original poster, and inserted graphic renditions of doubt and compromise. For the exhibition, a whole wall was covered in the posters, overwhelming the effect of the official posters, which were located outside the exhibition venue.

A SHORT ESSAY ON THE POSSIBILITY OF AN ECONOMY
OF EQUIVALENCE, Palais de Tokyo, Paris, France, 2005

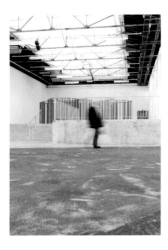

A DIAGRAM OF THE FACTORY ONCE THE
FORMER WORKERS HAD CUT EXTRA
WINDOWS IN THE WALLS, 2005
Painted steel

THE HOPES AND DREAMS OF THE WORKERS AS
THEY WANDERED HOME FROM THE BAR, 2005
Red glitter

This exhibition related to the research project CONSTRUCCIÓN DE UNO, the outline of which was being written in parallel to the exhibition structure. One starting point for the research was a commission in the mid-1990s to propose a renovation for the town square of Kalmar in Sweden, in collaboration with Danish architect Jeppe Aagard Andersen. While the proposal did not prevail, it began a relationship with the city, which continues in the text through research into the experimental Volvo factory that was originally located in Kalmar.

The book and the exhibition structure involve thinking about how to behave once a factory has closed and conditions of labor have devolved into a post-productive situation. The assumption behind the project is that the former "producers" choose to return to their place of work and re-start the construction of ideas rather than car-sized objects. One of their first tasks is to remodel the building itself, cutting more windows in the facades. Another is to construct a mountain landscape to view from those windows, and on their long walks home from the bars. These two works show "red snow" in the form of red glitter, an evocative image from the history of labour struggle. And in the background a schematic representation of the factory itself, now reduced to open structure rather than enclosed form.

A SHORT ESSAY ON THE POSSIBILITY OF AN ECONOMY
OF EQUIVALENCE, Palais de Tokyo, Paris, France, 2005

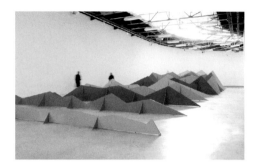

THE VIEW CONSTRUCTED BY THE FACTORY
AFTER IT STOPPED PRODUCING CARS, 2005
Painted steel

A notional mountain landscape that is fabricated from the same grade steel traditionally used for car production. The structure could be considered the first task of a group of workers returning to a now abandoned car factory and finding a use for the remaining materials. During their working time, windows were cut into the factory walls to give a beautiful view of the unobtainable landscape. Once redundant, the worker's return to their former work place as a place to talk and hang-out is marked by their self-consciousness of their former situation. They make the landscape while considering what to do next. The work also refers to a specific history of primarily North-American fabricated steel sculpture. The work reveals the story of semi-contented former factory workers once they have exhausted their productive play in their former site of work. Their days are consumed attempting to evaluate new models of production towards an economy of equivalence, where one unit of input, whether intellectual or physical, can produce one unit of output. Their economic and social models seem to improve and become more and more elegant as the book progresses, until we realize that it is they who have become the drained element in the process.

A SHORT ESSAY ON THE POSSIBILITY OF AN ECONOMY
OF EQUIVALENCE, Palais de Tokyo, Paris, France, 2005

FOUR LEVELS OF EXCHANGE, 2005
Powder-coated aluminum

Four large text structures are installed on the pillars of the new Lufthansa building at Frankfurt Airport.
Each text refers directly to the development of the book CONSTRUCCIÓN DE UNO and specifically
the element of the project where a group of former factory workers creates a series of equations in an
attempt to resolve relations of production in a post-productive environment. The texts are as follows:
ONE UNIT OF ENERGY ONE UNIT OF OUTPUT; TWO IDEAS TWO ACTIONS; THREE UNITS OF INPUT
THREE UNITS OF STABILITY; FOUR UNITS OF DECISION FOUR UNITS OF OPERATION.

Lufthansa Headquarters, Frankfurt am Main, Germany

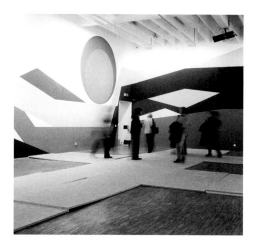

DEDALIC CONVENTION
Wood, paint, cinema lighting

An attempt to lure a group of people to Salzburg in order to check something. A cross-border rumor visualized without a clear focus. The project was in two stages. The first involved the use of a loose convention format (in both the political and musicological senses) at the MAK in Vienna, both in support of its semi-functional present status and as a way to create the conditions whereby it might be possible to develop a site for a very specific performative audience. An attempt to create a situation through the use of a number of environmental tools where it might be possible to detect a background echo and pulse that can set into motion the play with a lost geneology between the experimental music situation in Turin in the late 1960s and our contemporary matrix of visual and acoustic production. A series of devices that might allow shadows and parallel lines of communication to re-attach. A tracing of legacies that were never intended to be locked down. A project directed towards a group of people who don't know they are the point of attraction. The second stage of the project, with Gary Webb, was an attempt to lure the group Daedalus to Salzburg for a public moment of presentation or private reflection and research in light of the rumors set into action in Vienna. Artists involved in the project included: Julie Ault, Matthew Brannon, Trisha Donnelly, Stefan Kalmar, Gabriel Kuri, Scott Olson, Philippe Parreno, Pia Ronicke, Markus Weisbeck, Gary Webb, Nathan Carter, and Geraldine Belmont.

DEDALIC CONVENTION/DU UND ICH, Salzburger
Kunstverein, Austria, 2001

THE CONTENT CONSTRUCTED WITHIN
THE FACTORY ONCE IT HAS STOPPED
PRODUCING CARS, 2005
Powder-coated aluminum

A structure conceived while thinking about the elements needed to develop the project CONSTRUCCIÓN DE UNO: "This is somehow a critique of ecology and socio-ecological discourse in general. What I am talking about is what happens with an excess of ecology and when ecological concerns overwhelm all modern models of political and social progressiveness. This may be the subplot to this potential book. By super-focusing on an exchange of things they forget older models of progressive collectivism, or how to keep re-inventing relations in terms of collective behavior. All in favor of an over-determined sense of ecological collapse that transcends personal agency."

FACTORIES IN THE SNOW, Galerie Meyer Kainer, Vienna,
Austria, 2005

LOGO FOR THE FRANKFURTER KUNSTVEREIN, 2000
Various uses and forms

Following a competition among architects, designers, and artists to propose a new logo for the Frankfurter Kunstverein, this design was chosen. The tree-like form had previously appeared in a different design and configuration during the project THE TRIAL OF POL POT at Le Magasin, Grenoble, in 1998. The logo was adapted and applied to all aspects of the Kunstverein's work by Frankfurt-based design group Surface, and Markus Weisbeck in particular.

Frankfurter Kunstverein, Frankfurt am Main, Germany

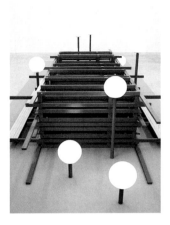

QUARTER SCALE MODEL OF A SOCIAL
STRUCTURE FOR A PLAZA IN GUADALAJARA,
2005
Painted wood, lighting

The function and scale of the work is indicated in the title. The full-size structure is constructed from
painted steel and located in the center of a plaza in a newly developed area of Guadalajara in Mexico.
The work is a meeting place and a site for discussion. The seating is lit by a number of globes at different
heights. The red color of the work matches that used in the project EDGAR SCHMITZ at the Institute
of Contemporary Arts, London, 2005. The project is a literal extension of earlier interests in the potential
for creating sites for discussion. In this case the work has a use value that has not been predetermined
by the commission but is provided on the insistence of the artist. The project is an attempt to find a
complex form for a non-site that echoes the diagram of a building while also being reminiscent of a corral
structure or barricade. The work thereby reveals itself to be derived from diagrammatic politicized form.

AS YOU APPROACH THE EDGE OF TOWN THE LIGHTS
ARE NO SOFTER THAN THEY WERE IN THE CENTRE,
Casey Kaplan, New York, USA, 2005

BUFFALO STRUCTURE, 2005
Powder-coated aluminum

A series of painted aluminum "hurdles" located on a private estate. The work is designed to reveal itself slowly within the landscape and constructed specifically for the location. The work was produced at the same time as a permanent commission for the exterior of the Albright Knox Art Gallery, also in Buffalo. The structure reveals a critical interest in the legacy of painted metal sculpture and the way such work shifts meaning and potential when produced while reconsidering notions of production in a post-industrial environment such as Buffalo. The work is literally a series of obstructions rather than a clearly defined and self-contained minimal form. As such it echoes the apparently paradoxical aspects of other work which involves the use of a combination of Plexiglas and aluminum, the materials of advertising, shop fronts, as well as riot shields, bullet-proof screens, and renovation.

Private commission, Buffalo, New York, USA

HOME OFFICE, LONDON, 2002–2005
Mixed media

A number of areas of the exterior structure of the building were identified by the architects in collaboration with the artist as potential sites for a major installation. These included the canopy over the front elevation of the central building. Glass "slots" form parts of the glazing for the two side buildings. Additionally, glass "vitrines" at the ground level of the buildings were proposed along with the area of the central facade above the main entrance to the building. Initially it was proposed to provide kiosks for general unspecified use at each corner of the central block; these were eventually rejected and in their place the areas were left aside for potential freestanding artworks to play off the integrated structures proposed. Some elements, notably the brise-soleil above the main entrance and the use of the same pattern as a decorative device on the window slots, were developed in such close collaboration with the architects that it would be impossible to attribute clear authorship to the work. It was always intended that this project would be incredibly integrated in terms of the artist/participants in the development of the building. This was the case. The main elements developed by the artist were a colored glass canopy; a brise-soleil above the main entrance; frit patterns on glass slots of the side buildings; colored glass "fins" in the vitrines of the side buildings, and two sets of polished stainless steel structures that appear as if embedded in the landscaping at either ends of the main building. Involvement in the project was conditional on being involved in all aspects of the building.

Home Office, London, UK

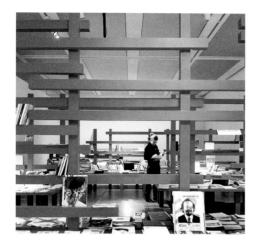

EDGAR SCHMITZ (with Edgar Schmitz), 2005
Painted wood, projections, sound, complete
collection of Revolver Archiv

Two projects at the same time, one layered on top of the other. The Revolver Archiv in relation to Liam
Gillick and Edgar Schmitz. Liam Gillick and Edgar Schmitz in relation to the Revolver Archiv. A series
of structures that involve doubling and reversal—the personalization of the content of an exhibition and
an attempt to display an informative archive that is a record of prolific publishing activity. In order to
proceed when faced with the nearly 3,500 items that make up the Revolver Archiv, Liam Gillick decided
to invite Edgar Schmitz to collaborate on the development of the project. As a London-based, German-
speaking critic and artist, Schmitz could address the shape and content of the project, both in terms of
the archive and his ability to react to Gillick's work over the last few years. After working for some time,
Gillick proposed echoing the fact that the archive is the content of the publishing house by making
"Edgar Schmitz" the content of the framing structure. Edgar becomes both the title and the content of
the project. He has worked on how to operate within the archive and the ICA in terms of the various
flows and potentials that they generate, while Liam Gillick has created the physical structures within the
main gallery and corridor. So we are confronted by two structures layered on each other, each function-
ing in a doubled and reactive way. Just to complicate things further, a new work by Christopher Wool,
in collaboration with Josh Smith, acts as a mute sign and announcement of this meeting of structures.
Within the gallery, a complex of bright red wooden structures divides the space. Each element incorpo-
rates an open vertical framework with a bench/shelf system that can be used to display the archive,
and as a place to sit and read. A projected loop derived from the Fassbinder film THIRD GENERATION
plays continually in the space, providing extra light to read by and an activated moment within the
space. A mutated soundtrack relating both to and from the film plays on specially designed speakers in
the corridor space. The speakers are arranged in a form that echoes the footprint of the structures in
the main gallery. The project as a whole, in relation to the Revolver Archiv, aims to create an implicated
space where it might be possible to reflect on multiple forms of production and content in a state of
distraction.

EDGAR SCHMITZ, Institute of Contemporary Arts, London,
UK, 2005

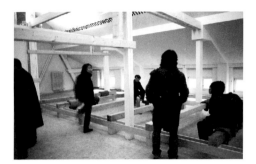

NEGOTIATED DOUBLE, 2001
Wood, cloth, vinyl text, etched signage

A multi-purpose space constructed in the roof area at the top of the main building of Kunstwerk in Berlin. The structure was commissioned for the Berlin Biennial in 2001 and was conceived to provide a place for discussions and screenings for the duration of the project. Unlike other spaces in similar exhibitions the structure was designed to offer fixed seating combinations rather than accentuating a loose notion of flexibility. The form of the work echoed the existing beams in the roof area of Kunstwerk and the structure therefore had a parasitical and integrated relationship to the building itself. The work was completed with a text derived from Pierre Bourdieu on the relationship between the corporate and cultural spheres. One half of the text was located in the discussion area of Kunstwerk while the phrase was completed as an etched metal text on the building directory-board in the lobby of the Allianz Building in Treptow.

Berlin Biennial, Berlin, Germany, 2001

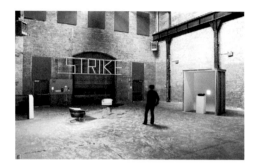

DISPERSED DISCUSSION STRUCTURE, 2006
Silver glitter, whiskey

A combination of whiskey and silver glitter mixed in a bucket and used to wash the floor of the space just prior to the opening of the exhibition GREY FLAGS at the Sculpture Center. The mixture was applied using a rag. The work rapidly dispersed during the opening of the exhibition but was occasionally replenished during the project. The work shows which areas of the space have been "cleaned" and ensures that the exhibition potentially permeates every area of the building.

GREY FLAGS, Sculpture Center, New York, USA, 2006

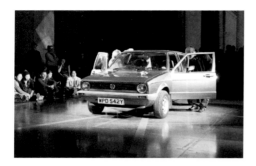

CONSTRUCCIÓN DE UNO (A PREQUEL), 2006
Screen, Volkswagen Golf Mk I, actors, lighting,
sound system

YOU ARE IN SEARCH OF WORK, I AM GOING TO BRING IT TO YOU.
WHAT WORK?
THE MOST BEAUTIFUL...
THE MOST NOBLE...
FOR THE GREATEST GLORY OF YOUR FAMILY...
FOR THE GREATEST GLORY OF YOUR HOMELAND... YOUR NATION.
YOU ARE GOING TO BUILD... AUTOMOBILES...

Presented as a film in real time, the performance takes the form of a repeated scenario derived from the
classic documentary by Groupe Medvedkin, WEEK-END À SOCHAUX from 1971. A section of the film
was transcribed in which the participants stage a mock recruitment speech to encourage people to
come and work in the Peugeot factory in Sochaux, France. Finding a translated copy of the text in the
back of a Volkswagen Golf, three actors improvised various scenarios around the text. Keeley Forsyth,
Ian Hart, and Maxine Peake performed at Tate Britain. Each actor is familiar from British television and
film. The main body of improvised performance was followed by an extensive credit sequence. The
credits included the entire transcribed translated text and was set to a new version of "Temptation" by
New Order, re-recorded for the performance.

TATE TRIENNIAL, Tate Britain, London, UK, 2006

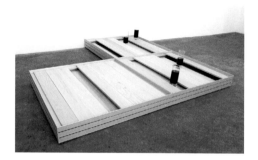

LITERALLY NO PLACE BAR/FLOOR, 2000
Anodized aluminum, oak, large glass, Pepsi,
nine units

Work related to the text ERASMUS IS LATE, 1995 (Book Works, London), introduced the notion of the provisional or prototype into the production of contingent objects and structures within an exhibition context. The notion of the multiple-function object was revisited in this work, in which the structure functions both as a bar, a floor, and logically as a bar floor. The work has the potential to be reworked in any permutation of nine units, and large glasses of Pepsi should accompany any presentation of the work. The structure precedes the use of the title LITERALLY NO PLACE as a book title, and refers to the dynamic no-place of the bar or bar floor. Literally no place is one interpretation of the word "utopia."

LIAM GILLICK, Casey Kaplan, New York, 2005

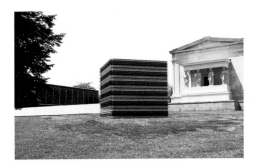

STACKED REVISION STRUCTURE, 2005
Powder-coated aluminum

A large free-standing cube located at what was originally the front of the Albright-Knox Art Gallery in Buffalo, New York. When Gordon Bunshaft's modernist addition to the museum was completed in 1962, the main entrance was shifted to the city side of the building and away from the parklands which now seem shielded by the museum. A number of modernist painted metal sculptures are located at the "new" front of the museum, which faces the road. For the exhibition EXTREME ABSTRACTION, a new work was commissioned to join these older works. It was decided to re-engage with the former facade of the building and place a complex constructed cube structure in a visual space between the original building and Bunshaft's addition. The title alludes to an examination of notionally middle-ground issues of social and political representation as they are controlled within a post-consensus culture.

EXTREME ABSTRACTION, Albright-Knox Art Gallery, Buffalo,
New York, USA, 2005

INVERTED RESEARCH TOOL
(with Edgar Schmitz), 2006
Printed banners

A quotation from the updated version of the book UNDERGROUND (FRAGMENTS OF FUTURE HISTORIES), 2004. The text is printed onto a gray background on a large banner that runs down through the central open space of the Van Abbemuseum Library. By the bottom of the banner, the material is white. The bottom of the banner is used as a screen for a program of films selected by Edgar Schmitz. Outside the museum two more banners replace the typical museum banners; the exterior works carry the same text, inverted and reversed. In addition, a bookmark was produced which carried the film program on one side and the text on the other. The work was a direct comment on the world of self-referential aestheticism proposed as a metaphorical model for all humanity in Gabriel Tarde's original science fiction novel FRAGMENT D'HISTOIRE FUTURE, 1897. The work was included in the project ACADEMY, which reflected upon the role of the museum and its relation to critical educational models.

ACADEMY, Van Abbemuseum, Eindhoven,
Netherlands, 2006

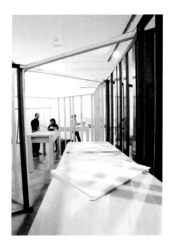

A DIAGRAM OF THE FACTORY ONCE
THE FORMER WORKERS HAD CUT EXTRA
WINDOWS IN THE WALLS, 2005
Painted steel

The same work from the exhibition at the Palais de Tokyo was intended for an exhibition at La Casa Encendida in Madrid in late 2005. An important aspect of the new exhibition was the fact that the work was designed specifically for the Palais de Tokyo, with no attempt made to check whether it would fit into La Casa Encendida. The work did fit in its allotted room, with 5 cm to spare on each side. The work was modified for the exhibition by the removal of some more "walls" and the inclusion of a café run by the museum, with free coffee and beer. Additionally, a special dispensation permitted smoking in the exhibition. Free copies of a newspaper format catalogue about the project was also available to be read within the space.

A SHORT ESSAY ON THE POSSIBILITY OF AN ECONOMY
OF EQUIVALENCE, La Casa Encendida, Madrid, Spain, 2005

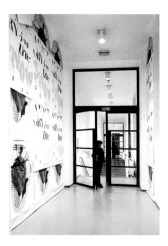

MALAGA POSTER (with M/M, Paris) 2005
Screenprints

A combination of posters from a now-published book of text works by the artist, rendered into graphic form by the Paris-based design agency M/M. The posters formed a wall of images on the way into the exhibition in Madrid. The works acknowledged the fact that there was another exhibition of the artist's work in Spain at the same time as the Madrid exhibition—in the city of Malaga. The Malaga exhibition brought together a large number of works by the artist in which text forms the primary means of communication. In Malaga all the works were presented in the same simple Helvetica Bold typeface, removed from their original context; the book of the exhibition offered images and information that re-connected some of the works with their original function. The Madrid poster presentation offered a leakage of information from one institutional structure into another; but by taking over the aesthetic presentation of that fact, M/M ensured that there was no immediate confusion between the two projects, rather a third form of presentation emerged that, right at the entrance to an exhibition, called into question the direction and authority of both projects.

A SHORT ESSAY ON THE POSSIBILITY OF AN ECONOMY
OF EQUIVALENCE, La Casa Encendida, Madrid, Spain, 2005

TELLING HISTORIES, 2003
MDF, paint, carpet, text, archive

A project with Maria Lind at the Kunstverein München. The exhibition structure made public the archive of the Kunstverein alongside a conference on and investigation of three important historical exhibitions at the Kunstverein. The project as a whole was an attempt to consciously encompass and to actively discuss the mediation of contemporary art. It was an effort to acknowledge the crisis of traditional curating, but also to offer examples for debate, by reflecting on and critically assessing historical and actual models of art institutions, individuals, and/or organizations that deal with production and circulation of art and ideas in an experimental and flexible way. The three exhibitions under examination were: POETRY MUST BE MADE BY ALL! TRANSFORM THE WORLD! from 1970, DOVE STA MEMORIA (Where is Memory) by Gerhard Merz from 1986, and EINE GESELLSCHAFT DES GESCHMACKS (A Society of Taste) by Andrea Fraser from 1993. Mabe Bethônico made a long-term analysis of the archive and the specific exhibitions this was accompanied by, as well as the specifically designed space and participation in the various discussions and the conference in relation to the project. In addition Søren Grammel organized a series of TALK SHOWS during the structure.

TELLING HISTORIES, AN ARCHIVE AND THREE CASE
HISTORIES (with Mabe Bêthonico and Liam Gillick),
Kunstverein München, Munich, Germany, 2003

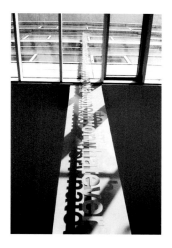

NEGOTIATED/DOUBLED, 2003
Powder-coated aluminum

Two texts, one in English and the other in German. The text carries two phrases with the words run together. The sentences are derived from a text by Pierre Bourdieu on the relationship between the corporate sphere and the cultural sphere. The text has been rendered into what might be called "pubetarian" English. The introduction of qualifiers such as "whatever" into the text locates it both in time and in the context of a school: umneouhliberalismkindofyouknowpromotessortofcommercialisationuhitstrengthensumtheyouknowcommercialkindofuhpole ...
... whileuhweakeningumtheyouknowthekindofpowerofautonomyorwhatever
The first half of the English text is located on the exterior of the school and the second half descends into the main hall through a glass roof. The same text, in German, is located along one wall of the main hall. Additionally a large non-functioning clock is located on the soffit at the rear of the building. The clock has been permanently stopped at two minutes before the end of school.

Permanent work for the Bundesschulzentrum, Kirchdorf, Austria

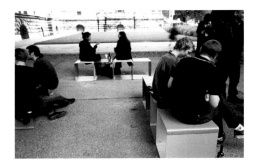

ANNLEE YOU PROPOSES
(STRUCTURE AND FILM), 2001
CGI animation, powder-coated aluminum
structures, lighting

The work involves two related elements. First a film involving the Anime character Annlee, and secondly a lit seating area on the designated sculpture court. The animated film was presented on the windows of the Stirling addition to Tate Britain, a postmodern building that inadvertently contributed to the creation of Tate Modern by using up all the available spare space at the Millbank site. At the time of the exhibition it could be said that the building was "out of fashion." One aspect of the projected film and seating area was to make it possible to look at the building again. The Annlee film uses a female character "saved" by Pierre Huyghe and Philippe Parreno from a short life in the fictional context of a Japanese magazine. The film here reflects on the peculiar status of the character in relation to her new suspended existence. The seating area comprises a number of seats, benches and shelf like structures all constructed from the same aluminum forms painted in different colors. The seating is supplemented by a lighting system.

ANNLEE YOU PROPOSES, Tate Britain, London, UK, 2001

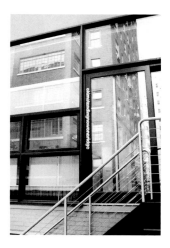

STAND NOW ON A RIDGE, 2003
Stainless steel text, vinyl text

The work was originally exhibited at Casey Kaplan in New York in the form of two rows of black vinyl text. The work forms a call and response. In the gallery, the phrase "Sit now on a ridge" was repeated along a single wall. Below it ran a form of response, "OK, I'm sitting now on a ridge." This text was also repeated. In the form shown here, the work was adapted for a private house in New York. Inside the house, the phrase "Sit now on a ridge" is repeated three times in a transparent, softly glittering vinyl text. Fixed to the rear of the house is the new response, "OK, I'm standing now on a ridge." The work was originally conceived in the build-up to the war in Iraq and could be considered a critique of the tendency of dominant cultures to nominate a space of occupation, and then go and occupy it without thinking through all the consequences of this action.

EXTERIOR DAYS, Casey Kaplan, New York, USA, 2003

POETRY MUST BE MADE BY ALL!
TRANSFORM THE WORLD! 2004
Anodized aluminum, Plexiglas

Sheets of Plexiglas sandwiched between two layers of anodized aluminum plate. The work is fixed together with irregularly placed fixings that screw the layers tightly together. The title of the work is a direct reference to the exhibition of early Soviet era art that had traveled from the Moderna Museet in Stockholm to the Kunstverein München in 1969, triggering a crisis at the Academie and the Kunstverein over the role of the Academie's professors during the Nazi period. The work here can be regarded as a sample or tool, which contains the components used in other works, but reduces the aesthetic potential of the colored Plexiglas by keeping it hidden or protected by the two enclosing sheets of aluminum.

Edition for Texte zur Kunst, Berlin, Germany, 2004

GUIDE, 2004
Silkscreen prints

The work comprises five screenprints, each using up to 15 layers of ink. Each print shows a different day of the working week. Each day is printed in German and should be exhibited out of order. The edition should be kept together and not distributed separately, however individual prints maybe displayed on their own, or in different locations in the same building. The work is a "guide" to the working week (there is no Saturday or Sunday). The use of the days of the week, displayed out of order, is a direct reference to the developed thinking towards the project CONSTRUCCIÓN DE UNO which, among other things, focuses on the rise of flexibility as a concept within the workplace.

Edition for Galerie Sabine Knust, Munich, Germany

REORGANISING THE SIGNAGE AGAIN, 2005
Powder-coated, water-cut aluminum

One of a number of hanging texts in the exhibition that directly refer to a constructed image from the developing scenario CONSTRUCCIÓN DE UNO. The text here directly describes that act that leads to the development of a new set of signage for a now-closed experimental factory. Once the former workers have cut new holes in the walls of the factory they proceed to reorganize the signage in the building. They play many games with the words in order to create a new language to describe their own workplace. With some of the signage they write about what they are doing, creating a self-conscious revelation of their new post-work condition. Later in the narrative they abandon such activities in favor of attempting to develop a new economy of equivalence, where instead of trying to resolve labor relations they look to balance out all forms of production and consumption.

PRESENTISM, CORVI-MORA, London, UK, 2005

QUATTRO, 2005
Powder-coated aluminum

A private commission for an exterior work. The dimensions of the work were suggested by the future user of the structure. The title of the work refers to the number of "screens" bound together to form the work. The work should be considered as a direct commentary upon the legacy of late-modern formalism in relation to post-Tayloristic working practices.

Private commission, Esther Schipper, Berlin, Germany

YOU CAN'T ORGANISE A CERTAIN FORM OF
SOCIAL ORGANISATION, 2002
Anodized aluminum, Plexiglas

A discussion platform that completely fills a dining and working space in a private house in Dublin. The
work should be considered in relation to the ideas that developed around the book DISCUSSION ISLAND/
BIG CONFERENCE CENTRE, 1998 (Orchard Gallery, Derry/Kunstverein Ludwigsburg). The work designates
a site where it might be possible to think about the implications of an extended scenario concerning,
among other things, the struggle between planning and development and the way things are decided in
a post-consensus context. The opaque Plexiglas used in the work is a later development and shows an
evolution in the work from the earliest discussion platforms that all made use of transparent Plexiglas.

Private commission, Dublin, Ireland. Corvi-Mora, London, UK

UNANIMOUS STRUCTURE, 2005
Powder-coated aluminum, opaque Plexiglas

A low, square form construction that relates to a sequence of low screens. The work first appeared in an exhibition at Casey Kaplan in 2005 and refers explicitly to the development of progressive industrial working practices in decentered locations. The exhibition examined the interplay between built structures and theoretical constructs. Together the works combined experimental and improvisational structures with pragmatic social proposals. The arrangements of screens and other works in the exhibition moved in-and-out of conceptual focus, creating close-up views and wide panoramas, both literally and metaphorically.

AS YOU APPROACH THE EDGE OF TOWN THE LIGHTS ARE NO DIMMER THAN THEY WERE IN THE CENTRE, Casey Kaplan, New York, USA, 2005

DE ANTEMANO POR FAVOR, 2003
(with Gabriel Kuri)
White paint on window

The work was produced for the windows of a temporary space in Mexico City. The work comprises a text that has been masked on a window. Once the window has been roughly covered by hand in white paint, the mask is removed, leaving clear spaces where the letters had been. The work both veiled the exhibition in the space and offered a partial glimpse of the work inside. As with earlier work in Dijon where the door of Le Consortium was blanked out during the project THE MORAL MAZE, the work highlighted the contingent quality of both the exhibition and the space within which it was taking place. The exhibition as a whole combined precise formal structures with a sequence of improvised works made in collaboration with Gabriel Kuri.

POR FAVOR, GRACIAS, DE NADA, Kurimanzutto,
Mexico City, Mexico, 2003

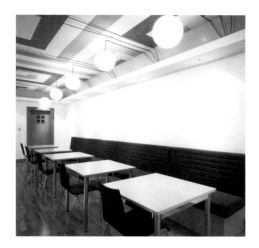

ADJUSTMENT FILTER, 2002
Mixed media

A complete renovation of the café at the Whitechapel Gallery. The work includes a painted design on the ceiling; the renovation of the windows; a wall text; new seating, tables, and a complete repainting of the space. The work was intended to extend the scope and timescale of the Whitechapel exhibition. The café is often used by people working at the gallery as a meeting point. The design was specifically intended to draw the exhibition into the café and test some of the ideas that are made explicitly in the earlier writing. The book LITERALLY NO PLACE, 2002, was published at the same time as the exhibition, and made available to be read in the café.

THE WOOD WAY, Whitechapel Art Gallery, London, UK, 2002

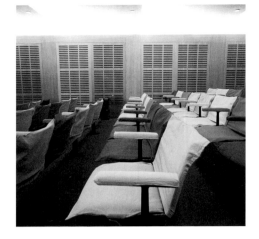

PROTOTYPE CONFERENCE ROOM
(with joke by Matthew Modine
arranged by Markus Weisbeck), 1999
Cloth

The auditorium of the Whitechapel Art Gallery was adjusted in order to extend the exhibition THE WOOD WAY. Custom-made seat covers were fitted over the existing auditorium seating. The resulting work used an existing auditorium as a site to rework a structure originally built for the Frankfurter Kunstverein in 1999. The only element remaining from the original work was the idea of colored seating. The joke originally installed in Frankfurt was in this case moved to the Whitechapel café.

THE WOOD WAY, Whitechapel Art Gallery, London, UK, 2002

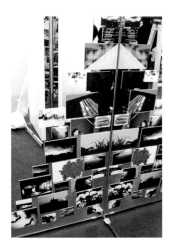

FITTING ROOM, 2004 (with Sean Dack)
Stickers on mirrors

The design of two fitting rooms at the Dior Homme Shanghai store. The work comprised two completely mirrored rooms, each with a low bench. A number of stickers were produced bearing various imagery by Sean Dack. The stickers were arranged on the mirrors in order to create a repeated progression of images. The work is a self-conscious reference to the practice of leaving stickers on changing-room mirrors in less particular locations. Here the processing of the street, found in the designs of Hedi Slimane, is echoed in the approach to the design of the dressing rooms.

DIOR HOMME, Shanghai, China, 2004

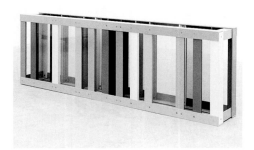

LONG FOREST, 2005
Powder-coated aluminum, transparent Plexiglas

A screen that combines multi-colored aluminum with transparent Plexiglas. The work is similar in form to the screens and platforms that were developed around the book DISCUSSION ISLAND/BIG CONFERENCE CENTRE. This later work has been produced under different conditions, while developing and researching CONSTRUCCIÓN DE UNO. The title refers to the notion of the rural factory or non-urban productive environment. The form of the work's vertical elements echoes the factory facade model developed for the exhibition at the Palais de Tokyo earlier in 2005.

Casey Kaplan, New York, USA, 2005

MULTIPLE REVISION STRUCTURE, 2006
Glazed ceramic

A sequence of 50-cm-diameter ceramic forms that can be stacked. The work makes use of every color available at the workshop that produced the plates. The intended function of the work remains undefined. The work has the deliberate appearance of a series of machine-produced objects, although each element was manufactured by hand. The resulting complication of reading and form is intended to highlight certain tensions within the history of applied modernism—the legacy of objects that were designed for mass production only remaining in small scale output for a small "market."

UNDISCIPLINED, Attese Biennial Of Ceramic Arts, Attese, Italy, 2006

RATED DISCUSSION STRUCTURE, 2006
Gold glitter

A combination of golden glitter and vodka. This work, along with others using glitter, involves cleaning the chosen floor by hand, with the mixture of glitter and alcohol. The work marks the space, showing evidence of what has been "cleaned," and creates an overall unifying effect on the room being used. The work tends to disperse quite rapidly depending on foot traffic. The work may therefore be reapplied by the user of the work as often as necessary. The works originally relate to imagery from the book DISCUSSION ISLAND/BIG CONFERENCE CENTRE, a text that attempts to image how things are still decided in a post-consensus or post-collective socio-political environment.

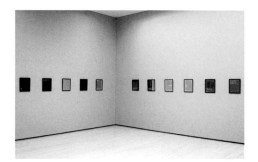

ANOTHER 2004 AGAIN, 2005
Inkjet prints, black frames

Having considered the possibility of a direct, physical, and lasting intervention into the structure of the Museum, it was decided instead to work as normal. This appears to be a peculiar statement in relation to the operation of an artist. But in this case it meant setting aside an increasing awareness of the efforts made by the Museum to constantly rethink its position in relation to the city and the wider multiple publics and visitors to the place. Rather than subsume the work into the judgement processes of the place or offer a simple, yet inevitably marginalized physical "improvement," it was decided to opt for a sweeping approach—a reworking of the interface of the Museum. A partial graphic reassessment of one year's output from the institution. As with many other projects the result is cool and "lite" rather than pointed and "other." The place has been reconsidered in its role as a high-cultural institution—and imaged accordingly. The look of the output of the place has been clarified and we are faced with another 2004 again. The result is intended to provide a space between the actual output of the Museum and a reconsideration of where we might find the space to move forwards once more when we can see all of the activities clearly laid out.

The Baltimore Museum of Art, Baltimore, USA, 2005

GLARUS CALENDER, 1999–2000
Color photographs

A calender and sequence of photographs derived from the work PAIN IN A BUILDING produced for an exhibition at the Kunsthaus Glarus in 1999. The images in the work were taken at Thamesmead in South London, one of the locations for the film CLOCKWORK ORANGE. A return to that site was intended as a check to see if the location could still be used for a potential film. Therefore the process involved making a site visit and location scout. The calender that produced in relation to this work spanned the months directly leading up to and following the year 2000. The work therefore highlights issues also covered in the books UNDERGROUND (FRAGMENTS OF FUTURE HISTORIES), 2004, and EIN RÜCKBLICK AUS DEM JAHRE 2000 AUF 1997 (with Matthew Brannon), 1998.

Kunsthaus Glarus, Glarus, Switzerland, 1999

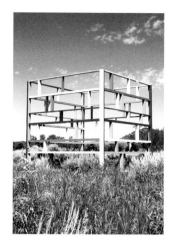

NINETEENFORTYSIXXISYTROFNEETENIN, 2004
Powder-coated aluminum

A large scale structure originally installed on the grounds of the Aspen Institute in Aspen, Colorado. The work has since been moved to land close to the original site. The work was installed to mark the founding of the Aspen Institute, hence the title, which refers to the year in which the Institute (designed by Herbert Bayer) commenced operation.

Aspen Art Museum, Aspen, Colorado, USA

Biography
Bibliography

LIAM GILLICK
FACTORIES IN THE SNOW

Born 1964, Aylesbury, UK
Lives and works in London and New York.

EDUCATION
1983/84 Hertfordshire College of Art.
1984/87 Goldsmiths College, University of London, BA (Hons.)

AWARDS
1998 Paul Cassirer Kunstpreis, Berlin.
2002 Turner Prize Nomination, London.

ONE-PERSON EXHIBITIONS
12/1989 *84 Diagrams*, Karsten Schubert Ltd, London.
01/1991 *Documents* (with Henry Bond), Karsten Schubert Ltd, London.
03/1991 *Documents* (with Henry Bond), A.P.A.C., Nevers.
12/1991 *Documents* (with Henry Bond), Gio' Marconi, Milan.
08/1992 *McNamara, Hog Bikes and GRSSPR*, Air de Paris, Nice.
06/1993 *Documents* (with Henry Bond), CCA, Glasgow.
11/1993 *An Old Song and a New Drink* (with Angela Bulloch), Air de Paris, Paris.
06/1994 *McNamara*, Schipper & Krome, Cologne.
09/1994 *Documents* (with Henry Bond), Ars Futura, Zurich.
11/1994 *Liam Gillick*, Interim Art, London.
05/1995 *Ibuka!* (Part 1), Air de Paris, Paris.
06/1995 *Ibuka!* (Part 2), Künstlerhaus Stuttgart.
09/1995 *Ibuka!*, Emi Fontana, Milan.
11/1995 *Part Three*, Basilico Fine Arts, New York.
12/1995 *Documents* (with Henry Bond), Kunstverein Elsterpark, Leipzig.
03/1996 *Erasmus is Late 'versus' The What If? Scenario*, Schipper & Krome, Berlin.
04/1996 *Liam Gillick*, Raum Aktueller Kunst, Vienna.
04/1996 *The What If? Scenario*, Robert Prime, London.
06/1996 *Documents* (with Henry Bond), Schipper & Krome, Cologne.
01/1997 *Discussion Island*, Basilico Fine Arts, New York.
02/1997 *Discussion Island—A What if? Scenario Report*, Kunstverein, Ludwigsburg.
03/1997 *A House in Long Island*, Forde Espace d'art contemporain, L'Usine, Geneva.
05/1997 *Another Shop in Tottenham Court Road*, Transmission Gallery, Glasgow.
07/1997 *McNamara Papers, Erasmus and Ibuka Realisations, The What If? Scenarios*, Le Consortium, Dijon.
10/1997 *Reclutamento!*, Emi Fontana, Milan.
02/1998 *Liam Gillick*, Kunstverein in Hamburg.
04/1998 *Up on the twenty-second floor*, Air de Paris, Paris.
04/1998 *When Purity Was Paramount*, British Council, Prague.
05/1998 *Big Conference Center*, Orchard Gallery, Derry.
06/1998 *Liam Gillick*, Robert Prime, London.
07/1998 *Révision: Liam Gillick*, Villa Arson, Nice.
09/1998 *When do we need more tractors?*, Schipper & Krome, Berlin.
11/1998 *The Trial of Pol Pot* (with Philippe Parreno), Le Magasin, Grenoble.
11/1998 *Liam Gillick*, c/o Atle Gerhardsen Oslo.

06/1999 *Liam Gillick*, Kunsthaus Glarus.
07/1999 *Liam Gillick*, Rüdiger Schöttle, Munich.
09/1999 *"David"*, Frankfurter Kunstverein, Frankfurt am Main.
01/2000 *Applied Complex Screen*, Hayward Gallery, London.
02/2000 *Liam Gillick*, Galleri Charlotte Lund, Stockholm.
03/2000 *Liam Gilllick*, Schipper & Krome, Berlin.
03/2000 *Consultation Filter*, Westfälischer Kunstverein, Münster.
04/2000 *Schmerz in einem Gebäude*, Fig 1, London.
05/2000 *Woody*, CCA, Kitakyushu.
09/2000 *Literally No Place*, Air de Paris, Paris.
10/2000 *Renovation Filter, Recent Past and Near Future*, Arnolfini, Bristol.
11/2000 *Liam Gillick*, Casey Kaplan, New York.
01/2001 *Firststepcousinbarprize*, Galerie Hauser & Wirth & Presenhuber, Zurich.
02/2001 *Liam Gillick*, Javier Lopez, Madrid.
04/2001 *Liam Gillick*, Corvi-Mora, London.
09/2001 *Annlee You Proposes*, Tate Britain, London.
10/2001 *Dedalic Convention*, Salzburger Kunstverein, Salzburg.
04/2002 *The Wood Way*, Whitechapel Art Gallery, London.
06/2002 *Light Technique*, Galerie Meyer Kainer, Vienna.
07/2002 *Liam Gillick*, Rüdiger Schöttle, Munich.
01/2003 *Hills and Trays and...*, Schipper & Krome, Berlin.
01/2003 *...Punctuated Everydays*, Max Hetzler, Berlin.
04/2003 *Por Favor Gracias de Nada* (with Gabriel Kuri), Kurimanzutto, Mexico City.
05/2003 *Exterior Days*, Casey Kaplan, New York.
09/2003 *Communes, Bars and Greenrooms*, The Powerplant, Toronto.
09/2003 *Projects 79: Literally*, The Museum of Modern Art, New York.
11/2003 *A Film, A Clip and a Documentary* (with Sean Dack), Corvi-Mora, London.
02/2004 *Construcción de Uno*, Javier Lopez, Madrid.
04/2004 *A Group of People*, Air de Paris, Paris.
06/2004 *Liam Gillick*, Aspen Art Museum, Aspen.
09/2004 *Övningskörning (Driving Practice)*, Milwaukee Art Museum.
09/2004 *Underground (Fragments of Future Histories)*, Galerie Micheline Szwajcer, Antwerp.
01/2005 *222nd Floor*, Galerie Eva Presenhuber, Zurich.
01/2005 *A Short Essay on the Possibility of an Economy of Equivalence*, Palais de Tokyo, Paris.
02/2005 *Another 2004 Again*, The Baltimore Museum of Art, Baltimore.
05/2005 *Presentism*, Corvi-Mora, London.
09/2005 *Factories in the snow*, Galerie Meyer Kainer, Vienna.
09/2005 *McNamara Motel*, CAC, Malaga.
10/2005 *A Short Essay on the Possibility of an Economy of Equivalence*, La Casa Encendida, Madrid.
11/2005 *As you approach the edge of town the lights are no softer than they were in the centre*, Casey Kaplan, New York.
01/2006 *We are Medi(evil)*, Angela Bulloch and Liam Gillick, Cubitt, London.
01/2006 *Briannnnnn & Ferryyyyyy*, Liam Gillick and Philippe Parreno, Kunsthalle Zürich, Zurich.

LIAM GILLICK
BIOGRAPHY

11/2006 *Literally Based on H. Z.*, Kerlin Gallery, Dublin.

11/2006 *The State itself as a super commune*, Esther Schipper, Berlin.

COLLABORATIVE PROJECTS

09/1992 *The Speaker Project*, ICA, London.

12/1992 *Instructions*, Gio' Marconi, Milan.

05/1995 *Faction*, Royal Danish Academy of Arts, Copenhagen.

06/1995 *Stoppage*, CCC, Tours.

07/1995 *Stoppage*, Villa Arson, Nice.

01/1999 *Oldnewtown*, Casey Kaplan, New York.

07/2000 *itsapoorsortofmemorythatonlyrunsbackwards*, Goldsmiths College, Creative Curating, London.

09/2001 *Dedalic Convention* (with Annette Kosak), MAK, Vienna.

10/2001 *Dedalic Convention/Du und Ich* (with Annette Kosak and Gary Webb), Salzburger Kunstverein, Salzburg.

03/2002 *Dark Spring* (with Nicolaus Schafhausen and Markus Weisbeck), Ursula Blickle Stiftung, Kraichtal-Unteröwisheim.

09/2003 *Telling Histories*, Kunstverein München, Munich.

11/2004 *Rider: Law and Creativity Briannnnn & Ferryyyyy* (with Philippe Parreno), Lund Konsthall, Lund.

09/2005 *Briannnnn & Ferryyyyy* (with Philippe Parreno), Vamiali's, Athens.

12/2005 *Edgar Schmitz*, ICA, London.

2006 Unitednationsplaza, Berlin.

PUBLIC PROJECTS

1999 BIC Technologiezentrum, Leipzig.

2001 Telenor, Oslo.

2002 Deka Bank, Frankfurt am Main.

2002 Alcobendas, Madrid.

2002 Bundesschulzentrum, Kirchdorf/Krems.

2002 Mercat, Alicante.

2002 Olenick Corporation, New Jersey.

2003 Fort Lauderdale/Hollywood International Airport, Broward County, Florida.

2003 *British Land*, Regents Place, London.

2003 *Headache, phone card, soda, donuts, stereo*, London Underground/Frieze Art Fair, London.

2003–5 Home Office, London.

2004 Museum in Progress, Rolling Boards, Vienna.

2004 Swiss Re, London.

2005 Dior Homme, Shanghai (with Sean Dack).

2005 BSI, Lugano.

2006 Maharam, Chicago.

RECORDED WORKS

1995 *Stoppage*, CCC, Tours/Villa Arson, Nice.

2001 *Liam Gillick Meets Scott Olson in Japan*, Whatness, Frankfurt am Main.

2002 *Wood (part of Void)*, CCA, Kitakyushu.

2002 *Capital, Bottrop Boy* (CD).

2002 *Ekkehard Ehlers & Joseph Suchy/Liam Gillick, En/Off*, Frankfurt am Main.

LIVE EVENTS

2006 *Construcción de Uno*, Tate Britain, London.

BOOKS

1991 *Technique Anglaise* (with Andrew Renton), London, One-Off Press/Thames & Hudson

1995 *Erasmus is Late*, London, Book Works.

1995 *Ibuka!*, Künstlerhaus Stuttgart.

1997 *Discussion Island/Big Conference Centre*, Derry/Ludwigsburg, Orchard Gallery/Kunstverein Hamburg.

1999 *Five or Six*, New York, Lukas & Sternberg.

2002 *Literally No Place*, London, Book Works.

2004 *Underground (Fragments of Future Histories)*, Brussels/Dijon, MFC/Les presses du réel.

2004 *Anna Sanders Films Identity Spot, Liam Gillick and Sean Dack*, Onestar Press, Paris.

2006 *Malaga—An album of Covers, Liam Gillick and M/M*, Paris, Brussels, Two Star Books.

2006 *Le Montrachet, Liam Gillick and Heather McGowan*, Los Angeles, Rocky Point Press.

2007 *Proxemics*, JRP|Ringier/Les presses du réel.

SELECTED GROUP EXHIBITIONS

12/1990 *The Multiple Projects Room*, Air de Paris, Nice.

07/1991 *No Man's Time*, CNAC, Villa Arson, Nice.

09/1991 *Air de Paris à Paris*, Air de Paris, Paris.

12/1991 *The Multiple Projects Room*, Air de Paris, Nice.

04/1992 *Tatoo*, Air de Paris/Urbi et Orbi, Paris/Daniel Buchholz, Cologne/Andrea Rosen, New York.

05/1992 *Molteplici Culture* (selected by Giorgio Verzotti), Folklore Museum, Rome.

05/1992 *Lying on top of a building the clouds look no nearer than they had when I was lying in the street*, Monika Sprüth, Cologne/Esther Schipper, Cologne/Le Case d'Arte, Milan.

06/1992 *Manifesto* (curated by Benjamin Weil), Daniel Buchholz, Cologne/Castello di Rivara, Torino/Wacoal Arts Centre, Tokyo/Urbi et Orbi, Paris.

06/1992 *Etats Spécifiques*, Musée d'art moderne, Le Havre.

10/1992 *12 British Artists*, Barbara Gladstone/Stein Gladstone, New York.

11/1992 *Group Show*, Esther Schipper, Cologne.

12/1992 *ON*, Interim Art, London.

01/1993 *Territorio Italiano* (curated by Giacinto di Pietrantonio), Milan.

01/1993 *Claire Barclay, Henry Bond, Roderick Buchanan, Liam Gillick, Ross Sinclair* (curated by Tom Eccles), Gesellschaft für Aktuelle Kunst, Bremen.

02/1993 *Travelogue* (curated by Jackie McAllister), Hochschule für Angewandte Kunst, Vienna.

02/1993 *Los Angeles International*, Esther Schipper at Christopher Grimes, Los Angeles.

07/1993 *Wonderful Life*, Lisson Gallery, London.

07/1993 *Group Show*, Esther Schipper, Cologne.

07/1993 *The London Photo Race*, Friesenwall 120, Cologne.

07/1993 *Futura Book*, Air de Paris, Nice.

07/1993 *Points de Vue*, Galerie Pierre Nouvion, Monaco.

09/1993 *Manifesto* (curated by Benjamin Weil), Hohenthal und Bergen, Munich.

9/1993 *Backstage* (curated by Stephan Schmidt-Wulffen & Barbara Steiner), Kunstverein in Hamburg.

10/1993 *Two out of four dimensions*, Centre 181, London.

11/1993 *Dokumentation über, Arbeiten von*, Esther Schipper, Cologne.

11/1993 *Unplugged* (curated by Nicolas Bourriaud), Cologne.

01/1994 *Don't Look Now* (curated by Joshua Decter), Thread Waxing Space, New York.

02/1994 *Backstage*, Kunstmuseum Luzern.

02/1994 *Surface de Réparations* (curated by Eric Troncy), FRAC Bourgogne, Dijon.

02/1994 *Cocktail I*, Kunstverein in Hamburg.

03/1994 *Public Domain* (curated by Jorge Ribalta), Centro' Santa Monica, Barcelona.

05/1994 *Grand Prix* (curated by Axel Huber), Monaco.

05/1994 *Rue des Marins*, Air de Paris, Nice.

05/1994 *Mechanical Reproduction* (curated by Jack Jaeger), Galerie van Gelder, Amsterdam.

06/1994 *WM/Karaoke* (curated by Georg Herold), Portikus, Frankfurt am Main.

06/1994 *Other Men's Flowers* (curated by Joshua Compston), Hoxton Square, London.

09/1994 *Miniatures*, The Agency, London.

10/1994 *Das Archiv*, Forum Stadtpark, Graz.

10/1994 *Lost Paradise* (curated by Barbara Steiner), Kunstraum, Vienna.

10/1994 *Surface de Réparations 2*, FRAC Bourgogne, Dijon.

12/1994 *The Institute of Cultural Anxiety* (curated by Jeremy Millar), ICA, London.

01/1995 *Möbius Strip*, Basilico Fine Arts, New York.

01/1995 *Bad Times* (curated by Jonathan Monk), CCA, Glasgow.

02/1995 *In Search of the Miraculous*, Starkmann Library Services, London.

06/1995 *The Moral Maze*, Le Consortium, Dijon.

06/1995 *Collection fin XXeme*, FRAC Poitou-Charentes, Angoulême.

07/1995 *Summer Fling*, Basilico Fine Arts, New York.

07/1995 *Karaoke* (curated by Georg Herold), South London Art Gallery.

07/1995 *Ideal Standard Summertime*, Lisson Gallery, London.

09/1995 *Reserve-Lager-Storage*, Oh!, Brussels.

09/1995 *Filmcuts*, Neugerriemschneider, Berlin.

10/1995 *New British Art*, Museum Sztuki, Lodz.

10/1995 *Brilliant* (curated by Richard Flood), Walker Art Center, Minneapolis.

11/1995 *Trailer* (curated by Barbara Steiner), Mediapark, Cologne.

01/1996 *Co-operators*, Southampton City Art Gallery, Southampton.

01/1996 *Traffic* (curated by Nicolas Bourriaud), CAPC, Bordeaux.

02/1996 *Kiss This* (curated by Jeremy Deller), Focalpoint Gallery, Southend.

03/1996 *March à l'ombre*, Air de Paris, Paris.

04/1996 *Departure Lounge*, The Clocktower, New York.

04/1996 *Everyday Holiday*, Le Magasin, Grenoble.

04/1996 *Der Umbau Raum*, Künstlerhaus Stuttgart.

05/1996 *Dinner* (organised by Giorgio Sadotti), Cubitt Gallery, London.

06/1996 *Some Drawings From London*, Princelet Street, London.

06/1996 *Nach Weimar* (curated by Nicolaus Schafhausen and Klaus Biesenbach), Landesmuseum, Weimar.

07/1996 *How Will We Behave?*, Robert Prime, London.

08/1996 *Escape Attempts*, Globe, Copenhagen.

10/1996 *Life/Live*, Musée d'Art moderne de la Ville de Paris.

10/1996 *Such is Life*, Serpentine Gallery, London/Palais des Beaux-Arts, Brussels/Herzliya Museum of Art.

11/1996 *Itinerant Texts*, Camden Arts Centre, London.

11/1996 *Lost For Words*, Coins Coffee Store, London.

11/1996 *All in One*, Schipper & Krome, Cologne.

11/1996 *A Scattering Matrix* (curated by Jane Hart), Richard Heller Gallery, Los Angeles.

11/1996 *Found Footage*, Tanja Grunert & Klemens Gasser, Cologne

11/1996 *Glass Shelf Show*, ICA, London.

12/1996 *Supastore de Luxe*, Up & Co., New York.

12/1996 *Limited Edition Artist's Books Since 1990*, Brooke Alexander, New York.

01/1997 *Life/Live*, Centro Cultural de Belém, Lisbon.

03/1997 *Temps de Pose*, *Temps de Parole*, Musée de l'Echevinage, Saintes.

03/1997 *Des Livres d'Artistes*, L'école d'art de Grenoble.

04/1997 *Ajar*, Galleri F15, Jeløy.

04/1997 *Enter: audience, artist, institution* (curated by Barbara Steiner), Kunstmuseum Luzern.

05/1997 *Space Oddities*, Canary Wharf Window Gallery, London.

05/1997 *Moment Ginza* (co-ordinated by Dominique Gonzalez-Foerster), Le Magasin, Grenoble.

05/1997 *I Met A Man Who Wasn't There*, Basilico Fine Arts, New York.

06/1997 *504* (curated by John Armleder), Kunsthalle Braunschweig.

06/1997 *Documenta X*, Kassel.

07/1997 *Enterprise*, ICA, Boston.

09/1997 *Group Show*, Robert Prime, London.

09/1997 *Ireland and Europe*, Sculptors Society of Ireland, Dublin.

09/1997 *Group Show*, Vaknin Schwartz, Atlanta.

10/1997 *Heaven—a Private View*, P.S.1, Long Island City.

11/1997 *Hospital*, Galerie Max Hetzler, Berlin.

11/1997 *Kunst. Arbeit*, Südwest-LB, Stuttgart.

12/1997 *Other Men's Flowers*, The British School at Rome.

12/1997 *Maxwell's Demon*, Margo Leavin, Los Angeles.

12/1997 *Work in Progress and or Finished*, Ubermain, Los Angeles.

12/1997 *Group Show*, Air de Paris, Paris.

12/1997 *Group Show*, Schipper & Krome, Berlin.

02/1998 *Liam Gillick, John Miller, Joe Scanlan,* Raum Aktueller Kunst, Vienna.

02/1998 *Fast Forward*, Kunstverein in Hamburg.

02/1998 *Artist/Author: Contemporary Artists' Books*, American Federation of Arts touring show,

Weatherspoon Art Gallery, Greensboro/The Emerson Gallery, Clinton/The Museum of Contemporary Art, Chicago/Lowe Art Museum, Coral Gables/Western Gallery, Bellingham/University Art Gallery, Amherst.

03/1998 *Interactive, An Exhibition of Contemporary British Sculpture*, Amerada Hess, London.

04/1998 *A to Z* (curated by Matthew Higgs), The Approach, London.

05/1998 *Construction Drawings* (curated by Klaus Biesenbach), P.S.1, Long Island City.

05/1998 *Arena—Sport und Kunst Ausstellung*, Galerie im Rathaus, Munich.

06/1998 *Inglenook* (curated by Evette Brachman), Feigen Contemporary, New York.

06/1998 *In-significants*, varied locations, Stockholm.

06/1998 *Kamikaze*, Galerie im Marstall, Berlin.

06/1998 *London Calling*, The British School at Rome & Galleria Nazionale d'Arte Moderna, Rome.

06/1998 *Fuori Uso '98*, Mercati Ortofrutticoli, Pescara.

07/1998 *Videostore* (organized by Nicolas Tremblay and Stéphanie Moisdon), Brick and Kicks, Vienna.

07/1998 *UK—Maximum Diversity*, Galerie Krinzinger, Bregenz/Vienna.

07/1998 *The Erotic Sublime*, Galerie Thaddaeus Ropac, Salzburg.

08/1998 *Entropy* (curated by Wilhelm Schürmann), Ludwig Forum, Aachen.

09/1998 *Places to Stay 4 P(rinted) M(atter)*, Büro Friedrich, Berlin.

09/1998 *Weather Everything* (curated by Eric Troncy), Galerie für Zeitgenössische Kunst, Leipzig.

09/1998 *Odradek* (curated by Thomas Mulcaire), Bard College, New York.

09/1998 *Mise en Scène*, Grazer Kunstverein.

10/1998 *Minimal-Maximal*, Neues Museum Weserburg, Bremen/Kunsthalle, Baden-Baden/CGAC, Santiago de Compostela.

10/1998 *Ghosts*, Le Consortium, Dijon.

11/1998 *Dijon/Le Consortium.coll*, Centre Georges Pompidou, Paris.

11/1998 *Cluster Bomb*, Morrison/Judd, London.

12/1998 *The Project of the 2nd December*, Salon 3, London.

12/1998 *Projections*, De Appel, Amsterdam.

12/1998 *1 + 3 = 4 × 1*, Galerie für Zeitgenössische Kunst, Leipzig.

01/1999 *Konstruktionszeichnungen*, Kunst-Werke, Berlin.

01/1999 *Pl@ytimes*, Ecole supérieure d'art de Grenoble.

01/1999 *Xn*, Maison de la culture, Chalon.

01/1999 *Continued Investigation of the Relevance of Abstraction*, Andrea Rosen Gallery, New York.

03/1999 *Nur Wasser*, Neumühlen, Hamburg.

03/1999 *12 Artists, 12 Rooms*, Galerie Thaddaeus Ropac, Salzburg.

04/1999 *Air de Paris: works by AND/OR informations about*, Grazer Kunstverein.

05/1999 *Tang, Turner and Runyon*, Dallas.

05/1999 *Plug-ins*, Salon 3, London.

05/1999 *Etcetera*, Spacex Gallery, Exeter.

05/1999 *Out of Sight—A cross-reference exhibition*, Büro Friedrich, Berlin.

07/1999 *Essential Things* (curated by Guy Mannes Abbott), Robert Prime, London.

07/1999 *Laboratorium*, Antwerpen Open, Antwerp.

07/1999 *In The Midst of Things*, University of Central England, Bourneville.

07/1999 *Le Capital* (curated by Nicolas Bourriaud), Centre Régional d'Art Contemporain, Sète.

08/1999 *The Space is Everywhere*, Villa Merkel, Esslingen.

09/1999 *Objecthood OO*, Athens.

09/1999 *Tent*, Tent, Rotterdam.

09/1999 *dConstructivism: Life into Art*, Brisbane Convention and Exhibition Centre.

09/1999 *Shopping*, FAT, London.

09/1999 *Fantasy Heckler* (curated by Padraig Timoney), Tracey, Liverpool Biennial.

09/1999 *Art Lovers* (curated by Marcia Fortes), Tracey, Liverpool Biennial.

09/1999 *Transmute* (curated by Joshua Decter), MCA, Chicago.

10/1999 *New York/London*, Taché-Levy, Brussels.

10/1999 *Get Together/Art As Teamwork*, Kunsthalle, Vienna.

10/1999 *1999 East Wing Collection*, Courtauld Institute of Art, London.

10/1999 *Jonathan Monk*, Casey Kaplan, New York.

10/1999 *705 Wings of Freedom* (curated by Uwe Wiesner), Berlin.

10/1999 *Officina Europa*, Bologna.

10/1999 *Une histoire parmi d'autres*, collection Michel Poltevin, FRAC Nord-Pas de Calais.

11/1999 *Space*, Schipper & Krome, Berlin.

01/2000 *29th International Film Festival*, Rotterdam.

01/2000 *Continuum 001* (curated by Rebecca Gordon Nesbitt), CCA, Glasgow.

01/2000 *Stortorget i Kalmar*, Statens Konstråds Galleri, Kalmar.

02/2000 *Media City 2000*, Seoul.

03/2000 *Group Show*, Casey Kaplan, New York.

03/2000 *Wider Bild Gegen Wart. Positions to a political discourse*, Raum Aktueller Kunst, Vienna.

03/2000 *14 + 1*, Feichtner & Mizrahi, Vienna.

03/2000 *Decompressing History* (curated by Lars Bang Larsen), Galleri Enkehuset, Stockholm.

04/2000 *Viva Maria III*, Galerie Admiralitätsstraße, Hamburg.

04/2000 *British Art Show 5*, Touring Exhibition, Edinburgh, Southampton, Cardiff, Birmingham.

05/2000 *Dire Aids, Art in the Age of Aids*, Promotrice delle Belle Arti, Torino.

05/2000 *Working Title*, Stanley Picker Gallery, Kingston University.

05/2000 *Prefiguration of the Museum of Contemporary Art, Tucson (AZ), Collection JRP*, Fri-Art, Fribourg.

05/2000 *What If/Tänk Om*, Moderna Museet, Stockholm.

06/2000 *Interplay, selected works from the Museum and private collections*, The National Museum of Contemporary Art, Oslo.

06/2000 *Group Show*, Paula Cooper Gallery, New York.

07/2000 *Intelligence*, Tate Britain, London.

07/2000 *Future Perfect*, Centre for Visual Arts, Cardiff.

07/2000 *Haut de Forme et Bas Fonds*, FRAC Poitou-Charentes, Angoulême.

07/2000 *Vicinato 2*, Fig. 1, London.

07/2000 *Vicinato 2*, Neugerriemschneider, Berlin.

07/2000 *Werkleitz*, Tornitz.

09/2000 *Wilder Bild Gegenwart, Positions to a Political Discourse*, Nieuw Internationaal Cultureel Centrum, Antwerp.

09/2000 *Perfidy*, La Tourette, Éveux.

09/2000 *Protest and Survive*, Whitechapel Art Gallery, London.

10/2000 *e-mona*, The Museum of New Art, Detroit.

10/2000 *Aussendienst*, Kunstverein in Hamburg.

10/2000 *Indiscipline*, Roomade, Brussels.

11/2000 *Que saurions-nous construire d'autre? (What else could we build?)*, Villa Noailles, Hyeres.

11/2000 *Casa Ideal*, Museo Alejandro Otero, Caracas.

11/2000 *More Shows About Buildings and Food*, Lisbon.

11/2000 *Perfidy*, Kettles Yard, Cambridge.

11/2000 *How do you change an apartment that has been painted brown? Certainly not by painting it white*, Institute of Visual Culture, Cambridge.

11/2000 *Ausstellung der Jahresgaben*, Westfälischer Kunstverein, Münster.

11/2000 *Group Show*, Corvi-Mora, London.

12/2000 *Future Perfect*, Cornerhouse, Manchester.

01/2001 *Century City*, Tate Modern, London.

02/2001 *Demonstration Room: Ideal House*, Apex Art, New York.

03/2001 *Histoire de coeur, collection Michel Poitevin*, Fondation Guerlain, Les Mesnuls.

03/2001 *There's gonna be some trouble, a whole house will need rebuilding*, Rooseum, Malmö.

03/2001 *Stop and Go*, FRAC Nord—Pas-de-Calais, Dunkerque.

03/2001 *Future Perfect*, Orchard Gallery, Derry.

04/2001 *Minimal-Maximal*, City Museum of Art, Chiba/National Museum of Art, Kyoto/City Museum of Art, Fukuoka.

04/2001 *Nothing*, Northern Gallery for Contemporary Art, Sunderland/Contemporary Art Centre, Vilnius/ Rooseum, Malmö.

04/2001 *Contemporary Utopia*, Museum of Modern Art, Riga.

04/2001 *Berlin Biennale*, Kunst-Werke, Berlin.

04/2001 *Collaborations with Parkett: 1984 to Now*, The Museum of Modern Art, New York.

05/2001 *International Language, Grassy Knoll Productions*, various sites, Belfast.

05/2001 *A New Domestic Landscape*, Javier Lopez, Madrid.

06/2001 *The Wedding Show*, Casey Kaplan, New York.

07/2001 *Geometry and Gesture*, Galerie Thaddaeus Ropac, Salzburg.

07/2001 *Biennale de Lyon*, Musée d'Art Contemporain, Lyon.

07/2001 *A Timely Place, Or, Getting Back to Somewhere*, London Print Studio.

07/2001 *Strategies against Architecture*, Fondazione Teseco, Pisa.

07/2001 *Stéphane Dafflon/Liam Gillick/Xavier Veilhan*, Le Spot, Le Havre.

07/2001 *The Communications Department*, Anthony Wilkinson Gallery.

07/2001 *Ambiance Magasin*, Meymac Centre d'art Contemporain.

07/2001 *Beautiful Productions: Parkett*, Whitechapel Art Gallery, London.

09/2001 *Demonstration Room: Ideal House*, NICC, Antwerp.

09/2001 *Yokohama 2001*, Yokohama Triennale, Yokohama.

09/2001 *Everything Can Be Different*, Jean Paul Slusser Gallery, University of Michigan School of Art, Ann Arbor.

10/2001 *Rumor City*, Raffinerie, Brussels.

10/2001 *Animations*, P.S.1, Long Island City.

10/2001 *Parallel Structures*, South Bank Corporation, Brisbane.

11/2001 *9e Biennale de l'Image en Mouvement*, Centre pour l'image contemporaine, Saint-Gervais, Geneva.

11/2001 *Rumour City*, TN Probe.

11/2001 *En/Of*, Schneiderei, Cologne.

11/2001 *Ingenting*, Rooseum, Malmö.

11/2001 *I love Dijon*, Le Consortium, Dijon.

11/2001 *...if a double-decker bus crashes into us to die by your side such a heavenly way to die and if a ten ton truck kills the both of us to die by your side the pleasure and the privilege is mine...*, Air de Paris, Paris.

01/2002 *Urgent Painting*, ARC, Musée d'Art moderne de la Ville de Paris.

01/2002 *Reflexions*, Sprüth Magers, Munich.

01/2002 *Passenger: The Viewer as Participant*, Astrup Fearnley Museum, Oslo.

01/2002 *Nothing*, Mead Gallery, Warwick.

01/2002 *Minimal Maximal*, National Museum of Contemporary Art, Seoul.

02/2002 *Do It*, Museo de Arte Carrillo Gil, San Angel.

02/2002 *J'en ai pris des coups mais j'en ai donné aussi*, Galerie Chez Valentin, Paris.

02/2002 *Art & Economy*, Deichtorhallen Hamburg.

03/2002 *Everything Can Be Different*, University of Memphis, Tennessee.

03/2002 *Void*, Rice Gallery, Tokyo/CCA Kitakyushu.

03/2002 *Annlee You Proposes*, Mamco, Geneva.

04/2002 *Startkapital*, K21, Düsseldorf.

04/2002 *Parallel Structures*, Gertrude Contemporary Art Spaces, Fitzroy.

04/2002 *Private Views*, Printed Space, London.

05/2002 *The Ink Jetty*, Neon Gallery, London.

05/2002 *Inframince*, Cabinet Gallery, London.

05/2002 *Happy Outsiders from Scotland and London*, Zacheta, Warsaw/Katowice City Gallery.

06/2002 *The Object Sculpture*, The Henry Moore Institute, Leeds.

06/2002 *Without Consent*, CAN, Neuchâtel.

06/2002 *The Movement Began with a Scandal*, Lenbachhaus, Munich.

06/2002 *JRP Editions*, Raum Aktueller Kunst, Vienna.

06/2002 *Collected Contemporaries*, Moderna Museet, Stockholm.

06/2002 *Summer Cinema*, Casey Kaplan, New York.

07/2002 *Multiples X*, London Print Studio.

08/2002 *No Ghost Just a Shell*, Kunsthalle Zürich, Zurich.

09/2002 *Société Perpendiculaire: La Tapisserie*, FRAC Provence-Alpes-Côte-d'Azur.

09/2002 *Collections*, ZKM, Karlsruhe.

09/2002 *Strike*, Wolverhampton Art Gallery.

09/2002 *The Unique Phenomena of a Distance*, Magnani, London.

10/2002 *The Galleries Show: Contemporary Art in London*, Royal Academy of Arts, London.

10/2002 *Turner Prize*, Tate Britain, London.

10/2002 *Relational Aesthetics from the 1990s*, San Francisco Art Institute.

10/2002 *This Play 31*, La Colección Jumex, Mexico City.

10/2002 *L'image habitable—versions B,C,D,E*, Mamco, Geneva.

11/2002 *Lap Dissolve*, Casey Kaplan, New York.

11/2002 *It's Unfair*, Museum De Paviljoens, Almere.

12/2002 *Gleitsicht*, Krypta 182, Bergisch Gladbach.

12/2002 *No Ghost Just A Shell*, Institute of Visual Culture, Cambridge.

12/2002 *No Ghost Just A Shell*, San Francisco Museum of Modern Art.

01/2003 *Perfect Timeless Repetition*, c/o Atle Gerhardsen, Berlin.

01/2003 *No Ghost Just A Shell*, Van Abbemuseum, Eindhoven.

01/2003 *Ill Communication*, DCA, Dundee.

01/2003 *Re-Produktion 2*, Georg Kargl, Vienna.

01/2003 *JRP Editions*, Galerie Edward Mitterand, Geneva.

02/2003 *Animations*, Kunst-Werke, Berlin.

02/2003 *Breathing the Water*, Galerie Hauser & Wirth & Presenhuber, Zurich.

03/2003 *This Was Tomorrow*, New Art Centre Sculpture Park, Salisbury.

03/2003 *The Air is Blue*, Barragan House, Mexico City.

04/2003 *JRP Editions*, Galería Javier López, Madrid.

04/2003 *The Moderns/I moderni*, Castello di Rivoli, Torino.

04/2003 *Glamour*, British Council, Prague.

04/2003 *Imperfect Marriages*, Galerie Emi Fontana, Milan.

04/2003 *20th Anniversary Show*, Sprüth Magers, Cologne.

05/2003 *Typofgravy*, Cell, London.

05/2003 *Cool Luster*, Collection Lambert, Avignon.

05/2003 *Form Specific*, Moderna Galerija, Ljubljana.

05/2003 *Tirana Biennale 2*, Tirana.

06/2003 *3D*, Friedrich Petzel, New York.

06/2003 *Social Facades and Others*, Lenbachhaus, Munich.

06/2003 *25th International Biennial of Graphic Arts*, Ljubljana.

06/2003 *Utopia Station*, Venice Biennale.

07/2003 *Honey I rearranged the collection*, Greengrassi/ Corvi-Mora, London.

8/2003 *Abstraction Now*, Künstlerhaus Wien, Vienna.

9/2003 *How to learn to love the bomb and stop worrying about it*, National Chamber of Art Industries, Mexico City.

10/2003 *Wittgenstein: Family Likenesses*, Institute of Visual Culture, Cambridge.

10/2003 *Adorno 100*, Frankfurter Kunstverein, Frankfurt am Main.

11/2003 *A Nova Geometria*, Galeria Fortes Vilaça, São Paulo.

11/2003 *Everything Can Be Different*, Maryland Institute College of Art, Baltimore.

11/2003 *Bad Behaviour: Works from the Arts Council Collection*, Yorkshire Sculpture Park.

03/2004 *Singular Forms (Sometimes Repeated), Art from 1951 to the Present*, Guggenheim Museum, New York.

03/2004 *Establishing Shot*, Artist's Space, New York.

03/2004 *100 Artists See God* (curated by John Baldessari & Meg Cranston), The Contemporary Jewish Museum, San Francisco.

03/2004 *The Drawing Project*, Vamiali's, Athens.

03/2004 *Before the End* (curated by Stéfanie Moisdon and Olivier Mosset), Le Consortium, Dijon.

04/2004 *How to learn to love the bomb and stop worrying about it*, Central de Arte en WTC, Guadalajara.

04/2004 *Tonight* (curated by Paul O'Neill), Studio Voltaire, London.

04/2004 *Russian Doll*, MOT, London.

05/2004 *Across the Border*, MDD—Museum Dhondt-Dhaenens, Deurle.

05/2004 *9 Mütter XX04*, Mütter Museum, Philadelphia.

05/2004 *Drunken Masters*, Galeria Fortes Vilaça, São Paulo.

05/2004 *Sadie Hawkins Dance*, Southfirst, Brooklyn.

06/2004 *Artists' Favourites*, ICA, London.

06/2004 *Emotion Eins*, Ursula Blickle Stiftung/Frankfurter Kunstverein.

06/2004 *Em Jogo*, CAV, Coimbra.

06/2004 *Czech Made*, Display, Prague.

06/2004 *Off the Record/Sound Art*, ARC Musée d'Art moderne de la Ville de Paris.

06/2004 *Open*, Arcadia University Art Gallery, Glenside.

07/2004 *Marks in Space*, Usher Gallery, Lincoln.

07/2004 *Black Friday: Exercises in Hermetics*, Galerie Kamm, Berlin.

07/2004 *Strike*, Basekamp, Philadelphia.

08/2004 *The Trailer Special Project*, Curzon Cinemas, London.

08/2004 *100 Artists See God* (curated by John Baldessari & Meg Cranston), Laguna Art Museum, Laguna Beach.

09/2004 *Trailer*, Man in the Holocene, London.

09/2004 *Nothing Compared to This: Ambient, Incidental and New Minimal Tendencies in Current Art*, CAC, Cincinnati.

10/2004 *Utopia Station*, Haus der Kunst, Munich.

11/2004 *100 Artists See God* (curated by John Baldessari & Meg Cranston), ICA, London.

11/2004 *Dicen que finko o miento. La ficción revisada*, Central de arte, Guadalajara.

12/2004 *Poul Kjaerholm*, Sean Kelly, New York.

01/2005 *Exit—Ausstieg aus dem Bild*, ZKM, Karlsruhe.

01/2005 *The Furniture of Poul Kjaerholm and selected artwork*, Sean Kelly and R 20th Century, New York.

01/2005 *New Cohabitats*, Galerie Ghislane Hussenot, Paris

01/2005 *Goodbye 14th Street*, Casey Kaplan, New York.

03/2005 *Good Titles for Bad Books*, Kevin Bruk, Miami.

03/2005 *The Strange, Familiar and Unforgotten*, Galerie Erna Hecey, Brussels.

04/2005 *Group Exhibition*, Air de Paris, Paris.

04/2005 *Anna Sanders Films*, Cinema Svetozor, Prague.

04/2005 *Supernova*, Bunkier Sztuki, Kraków.

05/2005 *Icestorm*, Kunstverein München, Munich.

05/2005 *La La Land*, The Project, Dublin.

05/2005 *Post Notes*, Midway Contemporary Art, Minneapolis.

05/2005 *Bidibidobidiboo*, Works from Collezione Sandretto Re Rebaudengo, Torino.

06/2005 *100 Artists See God* (curated by John Baldessari
 & Meg Cranston), Contemporary Art Center of Virginia,
 Virginia Beach.
07/2005 *I Really Should**, Lisson Gallery, London.
07/2005 *Go Between*, Kunstverein Bregenz.
07/2005 *Nach Rokytnik*, MUMOK, Vienna.
07/2005 *Extreme Abstraction*, Albright Knox Art Gallery, Buffalo.
09/2005 *100 Artists See God*, Albright College Freedman Art
 Gallery, Reading.
09/2005 *General Ideas: Rethinking conceptual art 1987–2005*,
 CCA Wattis, San Francisco.
09/2005 *Etc.*, Le Consortium, Dijon.
09/2005 *Passion beyond reason*, Wallstreet 1, Berlin.
09/2005 *En Route: Via another route*, Trans-Siberian Railway.
09/2005 *Snow Black*, Yvon Lambert, New York.
09/2005 *Reception*, Büro Friedrich, Berlin.
10/2005 *Rundlederwelten*, Martin Gropius Bau, Berlin.
10/2005 *Ambiance*, K21, Düsseldorf.
10/2005 *Strictement Confidentiel*, CIAP, Ile de Vassiviere.
11/2005 *Thank You for the Music*, Sprüth Magers, Munich.
11/2005 *Im Bild Sein*, Galerie der HGB-Leipzig.
12/2005 *The Party*, Casey Kaplan, New York.
12/2005 *Minimalism and after*, Daimler Chrysler Collection, Berlin.
01/2006 *A person alone in a room with coca-cola coloured
 walls*, Grazer Kunstverein.
01/2006 *Cinéma(s)*, Le Magasin, Grenoble.
01/2006 *Fondos da Colección CGAC: Entre o proceso e a
 forma*, CGAC, Santiago de Compostela.
01/2006 *Slow Burn*, Galerie Edward Mitterand, Geneva.
02/2006 *Broken Surface*, Galerie Sabine Knust, Munich.
02/2006 *100 Artists See God* (curated by John Baldessari &
 Meg Cranston), Cheekwood Museum of Art, Nashville.
04/2006 *Ordnung und Verführung*, Haus Konstruktiv, Zurich.
04/2006 *Bühne des Lebens—Rhetorik des Gefühls*, Kunstbau
 München, Munich.
04/2006 *A short history of performance Part 4*, Whitechapel Art
 Gallery, London.
04/2006 *Back and Forth*, Stiftung Wilhelm Lehmbruck Museum,
 Duisburg.
05/2006 *Grey Flags*, Sculpture Center, New York.
06/2006 *Thank You for the Music (London Beat)*, Sprüth Magers
 Lee, London.
07/2006 *Undisciplined*, Attese Biennale of Ceramic Arts, Attese.
07/2006 *Crystallizations*, Andreas Murkudis Temporary, Munich.
07/2006 *Summer Academy*, Shedhalle, Zurich.
07/2006 *Turtle*, Chelsea Space, London.
07/2006 *Dirty Words*, Galeria Pedro Cera, Lisbon.
07/2006 *Abstraction Now*, Wilhelm-Hack-Museum, Ludwigshafen.
09/2006 *Modus*, Neue Kunsthalle, St. Gallen.
09/2006 *Academy*, Van Abbemuseum, Eindhoven.
09/2006 *Projektion*, Kunstmuseum, Lucerne.
09/2006 *How to improve the World*, Hayward Gallery, London.
10/2006 *Eye on Europe: Prints, Books and Multiples 1960 to
 now*, MoMA, New York.
11/2006 *If I can't dance, I don't want to be part of your
 revolution*, De Appel, Amsterdam.
12/2006 *Grey Flags*, CAPC, Bordeaux.

SELECTED REVIEWS

1991 Rose Jennings, "Documents: Karsten Schubert Ltd,"
 City Limits, February 7–14.
 Michael Archer, "Documents: Karsten Schubert Ltd,"
 Artforum, March.
 Ian Jeffrey, "Bond & Gillick," *Art Monthly*, March, 144.
 Clifford Myerson, "Documents & Details," *Art Monthly*,
 April, 145.
 Liam Gillick, "The Placebo Effect," *Arts*, May.
 Carolyn Christov-Bakargiev, "Someone Everywhere,"
 Flash Art, Summer.
 Tim Hilton, "Composition with Old Hat," *Guardian*,
 August 14.
 "Frontlines: No Man's Time," *Artscribe*, September.
 Jean Yves Jouannais, "Villa Arson," *Art Press*, 162,
 October.
 Giorgio Verzotti, "No Man's Time," *Artforum*, November.
 Michael Archer, "Audio Arts Issues and Debates I,"
 Audio Arts.
 Andrew Wilson, "Technique Anglaise," *The Art
 Newspaper*, November.
 Eric Troncy, "No Man's Time," *Flash Art International*,
 December.
 Meyer Raphael Rubinstein, "Technique Anglaise," *Arts*,
 November.
 Michael Archer, "Technique Anglaise," *Artforum*, December.
1992 Giacinto di Pietrantonio, "Bond & Gillick, Gio' Marconi,"
 Flash Art Italia, February/March.
 Maureen Paley interviewed by David Brittain, *Creative
 Camera*, 313.
 Giacinto di Pietrantonio, "Bond & Gillick, Gio' Marconi,"
 Flash Art, April.
 Henry Bond & Liam Gillick, "Press Kitsch," *Flash Art
 International*, 165, July/August.
 Eric Troncy, "London Calling," *Flash Art International*,
 165, July/August.
 Giorgio Verzotti, "News From Nowhere," *Artforum*,
 July/August.
 Elisabeth Lebovici, "L'art piege à l'anglaise,"
 Liberation, July 7.
 Mark Thomson, "États Spécifiques," *Art Monthly*, July/
 August.
 Robert Pinto, "Molteplici Culture," *Flash Art
 International*, October.
 Francesco Bonami, "Twelve British Artists," *Flash Art
 International*, November.
 Peter Schjeldahl, "Twelve British Artists," *Frieze*, Issue
 7, November/December.
1993 Amedeo Martegani, "Liam Gillick," *Flash Art Italia*,
 January.
 David Lillington, "ON," *Time Out*, January 13.
 Jutta Schenk-Sorge, "Zwölf Junge Britische Künstler,"
 Kunstforum, 120.
 Interview with Liam Gillick, *Flash Art International*,
 January.
 Frederick Ted Castle, "Occurances-NY," *Art Monthly*,
 February.

Eric Troncy, "Wall Drawings & Murals," *Flash Art International*, May.

Nicolas Bourriaud, "Modelized Politics," *Flash Art*, Summer.

David Lillington, "True Brit," *Time Out*, July 28.

Ray McKenzie, "Views from the Edge, *Scottish Photography Bulletin*, October.

Henry Bond and Liam Gillick, *The List*, July 2–15.

James Odling-Smee, "Wonderful Life," *Art Monthly*, October.

Mat Collings, "Art Break," *Observer*, October 17.

Liam Gillick, "A Guide to Video Conferencing Systems and the Role of the Building Worker in Relation to the Contemporary Art Exhibition (Backstage)," *Documents*, No. 4, October.

1994 Benjamin Weil, "Backstage," *Flash Art International*, January/February.

Liam Gillick/Ken Lum, "Global Art," *Flash Art International*, January/February.

Radio Interview, Lucerne, February.

Mark James, "Freeze," BBC 1, *Omnibus*, February 22.

Nathalie Bouley, "Les Parcours d'illusions...," *Le Bien Public*, February 23.

Roland Topor, "Surface de Réparations," *Art & Aktoer*, February, No. 5.

Nicolas Bourriaud, "Au Moment du Penalty," Globe, February 9–15.

Nicolas Bourriaud, "Surface de Réparations," *Art Press*, No. 190.

Eric Troncy, "Suface de Réparations," *Omnibus*, June.

Fritz Billeter, "Schnörkel und Schleifchen," *Tages-Anzeiger*, February 28.

"Arte Guerrero," *El Pais*, March 14.

Olga Spiegel, "Fotographos de Londres...," *La Vanguardia*, March 14.

Christian Besson, "Surface de Réperations," *Flash Art International*, May–June.

Helena Papadopoulos, "Don't Look Now," *Flash Art International*, May–June.

Simon Grant, "World Cup Football Karaoke," *Art Monthly*, September.

"Paradies Verloren," *Die Presse*, October 22.

"Verdoppelt, durchleuchtet," *Kleine Zeitung (Graz)*, October 12.

Brigitte Borchhardt-Birnbaumer, "Ein neues Ausstellungsmodell," *Wiener Zeitung*, October 14.

Wolfgang Zinggl, "Tee trinken mit Künstlern," *Falter*, October 28.

"Schipper & Krome," *Neue Bildende Kunst*, November.

Mark Currah, *Time Out*, December.

1995 Franz Niegelhell, "Sammeln und Speichern," *PAKT*, January.

Michael Hauffen, "Das Archiv," *Kunstforum*, January.

Justin Hoffman, "Das Archiv," *Artis*, February–March.

"Möbius Strip," *Zapp Magazine*, Issue 4.

Arno Gisinger, "Das Archiv," *Eikon*, April.

Liam Gillick, "The Insitute of Cultural Anxiety," *Blueprint*. "Project (Jake & Dinos Chapman)," *Art & Text*, May.

Nicolas Bourriaud, "Pour une esthétique relationnelle," *Documents*, No. 7.

Sabine Maida, "Sur un air de Darwin," *Paris Quotidien*, May 15.

Philippe Parreno, "Une exposition serait-elle un cinéma sans caméra?," *Liberation*, May 27.

Liam Gillick, "Künstlerporträts," *Neue Bildende Kunst*, June–August.

Liam Gillick, "When Are You Leaving?," *Art & Design*, May.

Eric Troncy, "Liam Gillick," *Flash Art International*, Summer.

Sabine Krebber, "Romantisch und Verwundbar," *Stuttgarter Nachrichten*, July 1.

"Forget about the ball and get on with the game," (with Rirkrit Tiravanija), *Parkett*, 44, Summer.

Adrian Searle, "Karaoke," *Time Out*, July 26.

Sarah Kent, "Ideal Standard Summertime," *Time Out*, July 26.

Philip Sanderson, "Ideal Standard Summertime," *Art Monthly*, September, No. 189.

"Erasmus is Late," *La Repubblica*, September 15.

Christoph Blase, "Ibuka!," *Springerin*, Issue 4.

Martin Maloney, "Grunge Corp," *Art Forum*, November.

Jeffrey Kastner, "Brilliant?," *Art Monthly*, December/January.

Lynn McRitchie, "Brilliant," *Financial Times*.

Karmel, "Liam Gillick," *The New York Times*, December 8.

Stuart Servetan, "Liam Gillick," *New York Press*, December 6–18.

Anne Doran, "Part Three," *Time Out*, December 13–20.

Matthew Collings, "My Brilliant Repartee," *Modern Painters*, Winter.

Peter Herbstreuth, "Leipzig: Fotografie im Kunstverein Elsterpark," *Das Kunst-Bulletin*, 12.

1996 Iain Gale/Georgina Starr, "Where does British Art go from Here?," *Independent*, January 2.

Neal Brown, "Ideal Standard Summertime," *Frieze*, 26, January/February.

Adrian Dannat, "Brilliant," *Flash Art*, January/February.

Simon Ford, "Myth Making," *Art Monthly*, March, 194.

Michael Archer, "No Politics Please We're British," *Art Monthly*, March, 194.

John Tozer, "Co-operators," *Art Monthly*, March, 194.

Rainald Schumacher, "Liam Gillick," *Springerin*, January.

Matthew Ritchie, "Liam Gillick: Part Three," *Performing Arts Journal*.

Georg Schöllhammer, "Kuratiert von:," *Springerin*, March.

Brigitte Werneburg, "Das Virus heißt Political Correctness," *TAZ*, March 9/10.

Barbara Steiner, "If...If...If... a lot of possibilities," *Paletten*, No. 223.

Philippe Parreno, "McNamara—A film by Liam Gillick," *Paletten*, No. 223.

Andreas Spiegl, "Traffic—CAPC," *Art Press*, No. 212, April.

Hans Knoll, "Parallelwelten und frottierte Schilde," *Der Standard*, April 18.

Johanna Hofleitner, "Ausgestellt in Wien," *Die Presse*, April 19.

Liam Gillick, *Der Standard*, May 2.

Lynne McRitchie, "Brilliant," *Art in America*, May.

Simon Ford, "Der Mythos vom Young British Artist," *Texte zur Kunst*, No. 22, May.

Martin Herbert, "Liam Gillick," *Time Out*, May 15–22.

Liam Gillick, "The Corruption of Time (Looking Back at Future Art)," *Flash Art*, May/June, No. 188.

Godfrey Worsdale, "Liam Gilllick," *Art Monthly*, June, No. 197.

Juan Cruz, "Some Drawings from London," *Art Monthly*, July/August, No. 198.

Lars Bang Larsen, "Traffic," *Flash Art*, Summer, No. 189.

Barbara Steiner, "Traffic," *Springerin*, Band II, Heft 2.

Verena Kuni, "Der Umbau-Raum," *Springerin*, Band II, Heft 2.

Jennifer Higgie, "Liam Gillick," *Frieze*, Issue 30.

Carl Freedman, "Some Drawings From London," *Frieze*, Issue 30.

Barbara Steiner, "Film as a method of Thinking and Working," *Paletten*, No. 224.

Marie de Brugerolle, "Renaissance du Magasin," *Art Press*, October, No. 217.

Elisabeth Lebovici, "Grand déballage d'art britannique," *Liberation*, October 10.

Jelka Sutej Adamic, "Liam Gillick," *Delo*, October 11.

Angela Vettese, "Giovani Inglesi Aspettano Godot," *Il Sole*, October 13.

Michael Krome, "Liam Gillick," *Kunstzeitung*, No. 3, November.

"La crème anglaise s'expose à Paris," *Le Figaro*, November 26.

Robert Fleck, "Die Wahren Helden sind die Väter," *Art*, December.

Pierre Restany, "New Orientations in Art," *Domus*.

1997 Peter de Jonge, "The Rubell's in Miami," *Harper's Bazaar*, February.

Jesse Kornbluth, "Is South Beach Big Enough for Two Hotel Kings?," *The New York Times*, February 16.

"Die Zukunft als Künstlerisch-humanes Spielkonzept," *Ludwigsburger Kreiszeitung*, February 22.

Überliefertes Aufbrechen, *Neue Luzerner Zeitung*, April 12.

"Enter—Audience, Artist, Institution" Ausgestellt, *Luzern Heute*, April 12.

Gregory Volk, "Liam Gillick at Basilico Fine Arts," *Art in America*, June.

Dominique Nahas, "I met a man who wasn't there," *Review*, July/August.

Elizabeth Mangini, "I met a man who wasn't there," *The Exhibitionist*, August/September.

"Documenta X", *The Guardian, The Financial Times, Art Forum, Kunstforum, Art Monthly*.

Zeigam Azizov, "Liam Gillick and his Parallel Activities," *Omnibus*, October.

Nadine Gayet-Descendre, "Nouvelle vie pour P.S.1," *L'Oeil*, No. 490, November.

Ann Doran, "School's In," *Time Out New York*, November 6–13.

Marc-Olivier Wahler, "Habiter un lieu d'art," *Das Kunst-Bulletin*, December.

Eric Troncy, "We're people this dumb before television: Interview with Liam Gillick," *Documents sur l'art*, No. 11.

Christoph Tannert, "Zwischen Hospital und Hotel," *Berliner Zeitung*, December 20.

Brigitte Werneburg, "The Good Beuys," *TAZ*, December 20.

Tanja Fielder, "Auf dem Pappbett endet Sehnsucht," *Morgenpost*, December 16.

Schwarzwaldklinik, *Ticket*, December 11.

1998 Susanne Gaensheimer, "In Search of Discussion Island—About the Book *Big Conference Centre*, by Liam Gillick," *Index*, No. 22, February.

Karl Holmqvist, "Hospital," *Flash Art*, March/April.

David Musgrave, "A to Z," *Art Monthly*, May.

Jade Lingaard, "Le Plexiglas philosophal," *Aden*, May 6–12.

Jorn Ebner, "Dickes Make-up, dünnhäutige Kunst," *Frankfurter Allgemeine*, July 11.

Laura Moffatt, "Liam Gillick," *Art Monthly*, July/August.

"Inglenook," *Village Voice*, July 21.

Ken Johnson, "Inglenook," *The New York Times*, July 24.

Eric Troncy, "Liam Gillick/Villa Arson," *Les Inrockuptiples*, Summer.

Christoph Blase, "Liam Gillick," *Blitz Review*.

Christian Huther, "Agiler Krisenmanager," *Main-Echo*, September 9.

Christian Huther, "Der Krisenmanager," *Der Tagesspiegel*, September 9.

"Paul Cassirer Kunstpreis," *Berliner Morgenpost*, September 30.

Morning Edition, *NPR New York*, October 3.

Kerstin Braun, "Wie bildende Kunst Theater reflektiert," *Neue Zeit*, October 9.

Anders Eiebakke & Bjønnulv Evenrud, "Liam Gillick," *Natt & Dag*, December/January.

Berit Slattum, "Kommuniserende britisk samtidskunst," *Klassekampen*, December 9.

1999 "Salon 3," *Flash Art*, January/February.

Heinz Schütz, "Steirischer Herbst '98," *Kunstforum*, January/February, No. 143.

Holland Cotter, "Changes Aside," *The New York Times*, February 12.

Roberta Smith, "Continued Investigation of the Relevance of Abstraction," *The New York Times*, February 12.

Catsou Roberts, "Ouverture de Salon 3," *Art Press*, No. 243, February.

Thomas Wolff, "Na Logo," *Frankfurter Rundschau*, March 31.

Sue Spaid, "Conceptual Art as Neurobiological Praxis," *Village Voice*, April.

Andrea K. Scott, "Conceptual Art as Neurobiological Praxis," *Time Out*, April.

Andreas Denk, "Nur Wasser läßt sich leichter schneiden," *Kunstforum*, May/June.

Silke Hohmann, "Transparenz als Prinzip," *Journal Frankfurt*, June.

Ronald Jones, "A continuing investigation into the relevance of abstraction," *Frieze*, Issue 47, Summer.

Britta Polzer, "Kunst," *Annabelle*, June.

Interview with Liam Gillick, *Radio DRS 2*, June 29.

Claudia Kock Marti, "Viereck und Kosmos," *Die Südostschweiz/Glarner Nachrichten*, July 2.

Edith Krebs, "Er ist ein Jongleur," *Tages-Anzeiger*, July 3.

"Liam Gillick," *Neue Zürcher Zeitung*, July 9.

Martin Engler, "Verspätetes Millennium," *Frankfurter Allgemeine*, July 21.

Jonathan Jones, "In the Midst of Things," *The Guardian*, August 3.

Daniel Kurjakovic, "Szenarien zwischen Gestern und Morgen," August 5.

Eva Grundl, "Erklärt Kunst die Welt," *Südkurier*, August 12.

"In the Midst of Things," *The Big Issue*, August 16.

Elisabeth Wetterwald, "XN," *Parachute*, July/August/September, No. 95.

Duncan McLaren, "Better Than Chocolate," *The Independent on Sunday*, September 5.

"In Richtung Buchmesse," *Hannover Anzeiger*, September 9.

Gabriele Nicol, "Kubricks London zeigt seine karge Trostlosigkeit," *Offenbach-Post*, September 17.

"Kubrick in Himmel," *AZ Mainz*, September 18.

Nikolaus Jungwirth, "Erzengel Spielberg, Gott Kubrick und eine blutige Maria," *Frankfurter Allgemeine*, September 21.

Christian Huther, "Wenn der liebe Gott glaubt, er sei Kubrick," *Mainz Echo*, September 23.

Christian Huther, "Raumfantasien rund um Stanley Kubricks Filme," *Frankfurter Morgenpost*, September 23.

"Liam Gillick macht alles selbst," *Rhein-Zeitung*, October 6.

"Liam Gillick," *Süddeutsche Zeitung*.

Asprey/Jacques Documentary, *Channel 4*.

"Britische Kunst wie fürs Wohnzimmer," *Focus*, October 25.

Michael Hierholzer, "Ein Gerüst für die Stoffe der Phantasie," *Frankfurter Allgemeine*, November 3.

"What is art today?," *Beaux Arts Magazine*, December.

2000 "A Colourful Century," *Vogue Italia*, January.

Ann Donald, "Real things from a virtual world," *Glasgow Herald*, February 28.

Alex Hetherington, "Continuum 001," *The List*, February 17.

Elizabeth Mahoney, "Terribly PC," *Scotland on Sunday*, February 20.

Elizabeth Mahoney, "Brief encounters with the shape of things to come," *The Scotsman*, February 23.

Sarah Lowndes, "Continuum 001," *Metro*, February 25.

Michael Hauffen, "Liam Gillick: Consultation Filter," *Springerin*, 2.

Jonathan Jones, "Liam Gillick," *The Guardian*, March 7.

Samantha Ellis, "Pain in a building," *Evening Standard*, March 6.

Jörg Heiser, "Disco/Discontent," *Frieze*, March.

Michael Wilson, "Applied Complex Screen," *Art Monthly*, March.

Milou Allerholm, "Form vävs ihop med politik," *Dagens Nyheter*, March 21.

Petra Noppeney, "Mysteriöse Multiplexplatten," *Westfälischer Nachrichten*, March 25.

Liam Gillick, "Achtung, diese Stadt wird Normal," *Frankfurter Allgemeine*, March 27.

Manuel Jennen, "Ein Pferd ist ein Pferd ist ein Pferd," *Münster Zeitung*, March 25.

Marcus Lütkemeyer, "Ratespiel aus Kunststoff," *Münster Zeitung*.

Beate Naß, "Plexiglas in der Decke," *Münster Zeitung*.

Nina Mehta, "Continuum 001," *Art Monthly*, 235, April.

"What If?," *Contemporary Visual Arts*, Issue 28.

Nicolas Siepen, "Der Kern zerstreut sich," *Frankfurter Allgemeine*, April 3.

François Hers, "L'aventure, des nouveaux commanditaires," *Beaux Arts*, April.

Daniel Birnbaum, "What If?, preview," *Artforum*, May.

Robert Garnett, "Sheep and Goats, postcard from Paris," *Art Monthly*, 236, May.

Adrian Searle, "Life Through a Lense," *The Guardian*, May 4.

Ingeborg Cienfuegos, "Konst på gränsen," *Aftonbladet*, May 5.

Erika Josefsson, "Konstnärer tar för sig av Arkitektur och Design," *Metro Stockholm*, May 6.

Gilda Williams, "Because a fire was in my head, South London Gallery," *Art Monthly*, 235, May.

Clemens Poellinger, "Shopping som konst," *Svenska Dagbladet*, May 8.

Milou Allerholm, "Rum med Samplade Känslor," *Dagens Nyheter*, May 13.

Hans Hedberg, "Estetiskt vaktombyte utan udd," *Svenska Dagbladet*, May 13.

Peter Cornell, "Sköna hem på Moderna," *Expressen*, May 13.

Lars Vikström, "Utställning med alltför få Tanker," *Arbetet Ny Tid*, May 21.

Crispin Ahlström, "Tänk Om Är Ingen Fullträff," *Göteborgs Posten*, May 29.

Ronald Berg, "Demokratie aus dem Computer," *Zitty Magazin*, 7.

Adrian Searle, "Thick and Thin," *The Guardian*, July 8.

Johan Schloemann, "Bau mir einen Schuhladen," *Frankfurter Allgemeine*, July 24.

Egna Tolkningar, "En Svalt Sofistikerad Uppvisning," *Norrländska Socialdemokraten*, August 2.

Thomas Olsson, "Moderna Museet Tänker Om," *Ystads Allehanda*, August 5.

Charlotte Bydler, "Man Känner sig Nästan Läcker," *Aftonbladet*, August 5.

Thomas Olsson, "Moderna Museet Tänker Om," *Bohusläningen med Dals Dagblad*, August 5.

Alison Green, "Future Perfect," *Art Monthly*, 239, September.

Marianne Silen, "Konst, Arkitektur och Design," *Byggindustrin*, September 1.

Duncan McLaren, "Better than Chocolate," *The Independent on Sunday*, September 5.

Gordon Burn, "Art imitating Death," *The Guardian*, September 17.

Michael Wilson, "New British Art: Intelligence," *Art Monthly*, 239, September.

Rachel Withers, "Preview," *Artforum*, September.

"Liam Gillick," *Architect Builder Contractor and Developer*, September.

Amber Cowan, "Liam Gillick," *The Times*, October 7.

Anna Gunnert, "Tänk Om pa Moderna Museet," *Konsttidningen*, October 9.

"Liam Gillick," *Vogue (British)*, October.

Ina Blom, What If?," *Frieze*, 54.

"Liam Gillick," *Wallpaper*, October.

"Liam Gillick," *Artclub Magazine*, Autumn.

"Liam Gillick," *AN Magazine*, November.

Rachel Campbell Johnston, "Five Best Exhibitions Nationwide," *The Times*, November 4.

Andrew Mead, "Called into Question," *The Architects Journal*, November 8.

"Liam Gillick," *Flux*, October/November.

David Musgrave, "Liam Gillick," *Art Monthly*, 241, November.

Amelia Bate, "Liam Gillick," *Epigram*, November.

John Tremblay, "Top Ten," *Art Forum*, November.

"Liam Gillick," *Tatler*, November.

Charlotte Evans, "Brum sees the best in British art," *Sutton Coldfield Observer*, November 24.

Dean Inkster, "Défence de la Lecture, Le Procès de Pol Pot," *Art Press*, Special No. 21.

Jennifer Higgie, "Future Perfect," *Frieze*, Issue 55.

David Vincent, "Part of a bigger picture," *Wolverhampton Express and Star*, December 2.

Michael Wilson, "Liam Gillick," *Untitled*, December.

Nigel Prince, "Future Perfect," *Untitled*, December.

Neil Mulholland & David Musgrave, "Intelligence," *Untitled*, December.

Daniel Birnbaum, "What If?," *Artforum*, December.

Liam Gillick, "Voice Choices," *Village Voice*, December 1.

Ken Johnson, "Liam Gillick," *The New York Times*, December 8.

Tony Godfrey, "Liam Gillick," *Burlington Magazine*, December.

Max Andrews, "Liam Gillick," *Contemporary Visual Arts*, Issue 32.

Ingela Lind, "Konst i Krock med Kommersen," *Dagens Nyheter*, December 26.

2001 Maria Bonacossa, "Liam Gillick," *Tema Celeste*, January.

Roy Exley, "Liam Gillick," *Art Press*, January.

Andris Grinbergs, "Musdienu Utopija," *Sestdiena*, January 6.

"Spekulative Architektur—Liam Gillick," *Neue Zürcher Zeitung*, January 31.

"Color Ordenado," *El Periodico del Arte*, February.

Michael Archer, "Liam Gillick," *Art Forum*, March.

"Liam Gillick," *Galeria Antiquaria*, March.

Jose Luis Loarce, "Liam Gillick," *Lapiz*, No. 171, March.

Javier Hontoria, "Liam Gillick," *El Mundo-El Cultural*, March 14.

Anda Busevica, "Divi no trisdesmit diviem," *Diuc*, March 23.

"Liam Gillick," *Arte y Parte*, No. 31, March.

Ieva Rupenheite, "Latvijas robeza ar Zabriski," *Diuc*, March 31.

Christophe Domino, "Liam Gillick," *France Culture*, April.

Elizabeth Kley, "Liam Gillick," *Art News*, April.

Dan Fox, "Fig. 1," *Frieze*, April.

"Musdienu Utopija," *Studija*, April/May.

Maira Admine, "46 dienas Riga figures musdienu utopija," *Dienar Bizaess*, April 5.

Ieva Kalnina, "Ieraudzit musdienu utopiju," *Jauna Anuze*, April 5.

Paul Clark, "Liam Gillick," *Evening Standard*, April 17.

Janis Borgs, "Kede gulaszupa," *Diena*, April 17.

Adrian Searle, "Empty Promises," *The Guardian*, April 24.

Andrea Carrasco, *Exhibition in a Box*, April 25.

Aeneas Bonner, "Quantum murals on Ormeau Road," *Irish News*, April 28.

David Bussel, "Liam Gillick," *ID*, May.

Louisa Buck, "London," *The Art Newspaper*, May.

Matin Durrani, "Belfast Confused by Mystery Questions," *Physics World*, June.

Sassa Trülzsch, "Der Gerissene Faden: Rhizom," *Kunstforum*, June/July.

Anjana Ahuja, "Try to answer that, mate," *The Times*, June 4.

Dominic Eichler, "Berlin Biennale 2," *Frieze*, issue 61.

Jan Wilhelm Poels, "Art Works," *Frame*, July–August.

Dave Beech, "The Communications Department," *Art Monthly*, issue 249, September.

Stephen Bury, "A Timely Place," *Art Monthly*, issue 249, September.

Annie Fletcher, "Verwarring als Primaire Conditie," *Metropolis M*, August–September.

Fisun Günar, "Building Concepts," *What's On*, September 5–12.

"Netzwek als Schräges Kunstwerk," *Kurier*, September 18.

Doris Krump, "Freejazz in der Grauzone," *Der Standard*, September 26.

Johanna Hofleitner, "Diskursorientiert," *Die Presse*, October 5.

Ernst P. Strobl, "Es grünt so grün unter der Sonne," *Salzburger Volkszeitung*, October 18.

"A Question. Answers from:," *Frieze*, November–December.

"Raumgefühl," *Salzburger Nachrichten*.
Jonas Ekeberg, "Bokstavelig talt superkult," *Dagens Naeringsliv*, November 3.
Lena Lindgren, "Skriften på veggen," *Dagens Naeringsliv*, November 23.
Arve Rød, "Samvittighetens Mellomrom," *Billedkunst*, No. 6, December.
"Auf schrägem Boden," *Neue Kronen Zeitung*, November 23.
Karin Pernegger, "Dedalic Convention," *Camera Austria*, No. 76.
Jonas Ekeberg, "Farvel Utsmykking," *Dagens Naeringsliv*, December 31.

2002 "Strategies Against Architecture," *Collezioni Edge*, Winter/Spring.
Kristine Drakeer, "Kunst som merkevare," *Dagens Naeringsliv*, January 7.
Edgar Schmitz, "Liam Gillick: Annlee You Proposes," *Kunstforum*, January–March.
Roberta Smith, "The Armory Show, Grown Up and in Love with Color," *The New York Times*, February 22.
"Annlee et ses vies," *Das Kunst-Bulletin*, No. 4.
Elizabeth Mahoney, "Sea of Dreams," *The Guardian*, February 22.
Sue Arnold, "Tusa Raises my Highbrows," *The Observer*, March 10.
Philippe Dagen, "L'Urgent Painting, avec précipitation," *Le Monde*, January 25.
Richard Leydier, "Urgent Painting," *Art Press*, Mars.
Angela Vettese, "Oltre lo steccato della pittura si o pittura no," *Il Sole*, February 3.
"Skulptur als Diskursraum," *Der Kurier*, March 27.
"Dark Spring," *Der Standard*, March 22.
Claudia Ihlefeld, "Der trügerische Glanz von Gewalt im Alltag," *Heilbronner Stimme*, April 4.
Reto Kreuger, "In Kraichtal stört Lee Karls Ruhe," *Badische Neueste Nachrichten*, April 3.
Cornelia Gockel, "Frühling lässt sein schwarzes Tuch," *Süddeutsche Zeitung*, March 19.
"Dunkler Frühling," *Stuttgarter Zeitung*, April 3.
Petra Mostbach, "Nichts ist Unmöglich," *Lift*, April 4.
Martin Herbert, "Liam Gillick," *Art Review*, May.
Jan Estep, "Negotiating the Built World," *New Art Examiner*, May–June.
"Liam Gillick/Hélio Oiticica," *Tema Celeste*, May/June.
Fisun Güner, "If you go down to the woods today," *Metro*, May 7.
Andrew Renton, "How to behave in a gallery," *Evening Standard*, April 30.
Sean O'Hagan, "This is not an art gallery," *The Observer*, May 4.
John Russell Taylor, "Wrapped up in celluloid," *The Times*, May 8.
Nick Hackworth, "Will yoga and a little Plexiglas add up to a Turner?," *Evening Standard*, May 9.
Adrian Searle, "Road to Nowhere," *The Guardian*, May 14.

Martin Gayford, "I'm sorry, I haven't got clue," *The Daily Telegraph*, May 15.
Rachel Campbell-Johnston, "Liam Gillick and Hélio Oiticica," *The Times*, May 18.
Mark Harris, "Liam Gillick/Hélio Oiticica," *Art Monthly*, June.
Liam Gillick, "Literally No Place," *Tank*, Vol. 3, No. 2.
Melanie Klier, "Lesen im Meer der Liebe," *Münchner Merkur*, August 6.
Mike Dawson, "Liam Gillick," *Flux*, August/September.
Alex Farquharson, "Near Favorite," *Artforum*, September.
Duncan McLaren, "The Artist as Builder," *Contemporary*, September.
Dustin Ericksen, "100 Reviews," *Contemporary*, September.
Edgar Schmitz, "Hintergrund ist überall," *Texte zur Kunst*, September.
Catherine Wood, "Inframince," *Art Text*, October.
Beaty Coleman, "Hot Florida Style," *InCircle Entrée*, Fall.
Caoimhín Mac Giolla Léith, "Liam Gillick," *Artforum*, October.
"Literally No Place," *Tema Celeste*, September–October.
Sarah Lyall, "Art Show Asks for it, and the Vox Populi Hollers," *The New York Times*, November 8.
Luis Carlos Emerich, "Thisplay," *Novedades*, November 22.
Germaine Gomez Haro, "La Colección Jumex," *La Jornada Semana*, November 24.

2003 Philip Nobel, "Sign of the Times," *Artforum*, January.
"Ill Communication," *Big Issue Scotland*, January 16.
Knut Ebeling, "Bauen, Wohnen, Denken," *Der Tagesspiegel*, January 18.
Edgar Schmitz, "Interview with Liam Gillick," *Kunstforum*, January.
Laura Grant, "Communication…," *Press and Journal*, January 25.
John Calcutt, "Ill Communication," *The Guardian*, January 29.
Duncan MacMillan, "Pop Goes the Visual," *The Scotsman*, January 28.
Andrew Hunt, *The Unique Phenomenon of a Distance*, Issue 72.
Amber Cowan, "Ill Communication," *The Times*, February 1.
Sebastian Preuss, "Design mit Inhalt," *Berliner Zeitung*, February 19.
Corinna Daniels, "Liam Gillick," *Die Welt*, February 21.
Corinna Daniels, "Zeitlose Wiederholungen bei Atle Gerhardsen," *Die Welt*, February 21.
Brigitte Werneburg, "Der Meister der Korrektiven Geste," *TAZ*, February 22.
Adrian Searle, "This is a stick up," *The Guardian*, February 25.
"Annlee You Proposes (cover)," *Contemporary*, Issue 47/48.
Niru Ratnam, "Hang it All," *The Observer*, March 9.

"Dal post-moderno ai neo-moderni," *Vernissage*, March.

Gillian Lamb, "Private Viewing," *Self Service*, Spring/Summer.

Martin Herbert, "Days like These," *Art Monthly*, April.

Alison Green, "Utopias and Universals," *Art Monthly*, April.

Vincent Pécoil, "Brand Art," *Art Monthly*, April.

Franco Fanelli, "Moderni si...," *Il Giornale dell'Arte*, April.

Edgar Alejandro Hernández, "Sostien diálogo creativo," *Reforma*, April 3.

Maria Louisa Lopez, "Diálogo plástico entre México e Inglaterra," *Milenio*, April 4.

Renato Barill, "Come sono 'antichi' questi Moderni," *l'Unita*, April 5.

Cloe Piccoli, "Contemporanei, no moderni," *La Repubblica*, April 5.

Gabriella Serusi, "I Moderni," *Segno*, March–June.

Roberto Bosco, "Quiénes son los modernos?," *El Pais*, May 3.

Luca Beatrice, "I Moderni," *Flash Art Italia*, June July.

Robert Brown, "The Shape Shifter," *Art Review*, April.

"Bar Americas," *El Tiempo Celeste*, Spring.

F. Samaniego, "25 artistas internacionales formarán el mayor proyecto de escultura pública," *El Pais*, April 26.

Tony Godfrey, "This Was Tomorrow," *Burlington Magazine*, May.

Bénédicte Ramade, "Question de modernité," *L'Oeil*.

Andrew Renton, "How London took a Big Bite...," *Evening Standard*, May 13.

Joël de Rosnay, "L'entretien," *L'express*, May 15.

Lorenza Pignatti, "The art of noise," *Kult*, June.

Birgit Sonna, "Die Farb-Forscher," *Süddeutsche Zeitung*, June 12.

Margaret Sundell, "Exterior Days," *Time Out*, June 19–26.

Sarah Milroy, "A Mighty Brain Stretch," *Globe and Mail*, September 25.

Alex Farquharson, "I curate, You curate, We curate," *Art Monthly*, September.

Alex Farquharson, "Curator and Artist," *Art Monthly*, October.

Rose Aiden, "Brush with Fame," *The Observer*, October 12.

Marc Peschke, "Die Schwierigkeit, nein zu sagen," *Plan F*, October 23–29.

Birgit Sonna, "Alles, was der Fall war," *Süddeutsche Zeitung*, October 13.

Karin Lorch, "Adorno," *Springerin*, Winter.

Jan Verwoert, "Waarom Alleen Schilderkunst," *Metropolis M*, No. 5.

Mark Wilsher, "Wittgenstein: Family Likeness," *Art Monthly*, No. 272, December–January.

Hal Foster, "Arty Party," *London Review of Books*, December 4.

Martin Herbert, "Liam Gillick and Sean Dack," *Time Out*, December 3–10.

Michael Meredith, "Liam Gillick: The Power Plant," *Artforum*, December.

Jessica Morgan, "Tirana," *Tate Magazine*, November/December.

2004 Nicholas Serota, "Journey into Space," *The Guardian*, January 17.

Ronald Jones, "Adorno: The possibility of the Impossible," *Artforum*, January.

Alicia Miller, Interview with Liam Gillick, *Sculpture*, Vol. 23, No. 1.

Abel H. Pozuelo, "Liam Gillick," *El Cultural*, February 26.

Britta Scholze, "Unerwartete Begegnungen, Die Ausstellung 'Adorno. Die Möglichkeit des Unmöglichen', im Frankfurter Kunstverein," *Texte zur Kunst*, No. 53, March.

Gregory Elgstrand, "Liam Gillick," *Canadian Art*, Spring.

Michael Kimmelman, "How not much is a whole world," *The New York Times*, April 2.

Randy Kennedy, "Minimalist oases in a bustling Manhattan," *The New York Times*, April 23.

Max Henry, "Durable Goods, Mysterious & Brutal," *The New York Sun*, April 8.

Charles Barachon, "Liam Gillick," *Technikart*, May.

Joseph Masheck, "Minimalism: NY," *Art Monthly*, June.

Christophe Cherix, "Interview," *Afterart News*, No. 2, Summer.

Charlotte Higgins, "Reprieve for Lost avant-garde masterpiece," *The Guardian*, August 21.

"New York," *Self Service*, September.

Claire Bishop, "Antagonism and Relational Aesthetics," *October*, 110, Fall.

Jérôme Lefèvre, "Superposition," *Archistorm*, 09, September–October.

Carolina Söderholm, "Gåtfull lek med katt och råtta," *Sydsvenska Dagbladet*, November 30.

Yoam Gourmel, "Liam Gillick," *Citizen K*, December.

"The Bulgari Art Conversations," *The Art Newspaper*, December 3.

Boel Gerell, "Konstnärsfylla," *Kvälls Posten*, December 4.

Britte Montigny, "Konsten tänjer på gränserna," *Skånska Dagbladet*, December 10.

Therese Marklund, "Krävande katt-och råttalek prövar tålamodet," *SvD*, December 11.

Pontus Kyander, "Vitigast 2004," *Sydsvenskan*, December 19.

Ulrike Stahre, "Vi hejar alltid på rattan," *Aftonbladet*, December 28.

"Very New Art," *Tokyo*, 4.

2005 Elna Svenle, "Konstnärliga regelbrott," *Kristianstadsbladet*, January 10.

Claire Moulène, "Tête chercheuse," *Les Inrockuptibles*, January

Nicole Duault, "Les paillettes de l'utopiste Liam Gillick," *Le Journal du Dimanche*, January 30.

Various authors, "Emploi travaïe!," *Libération*, January 31.

Benjamin Thorel, "Never mind the Gillick," *Art*, 21, January–February.

Claire Bishop, "Antagonism and Relational Aesthetics," *October*, 110.

"Gatsby le Mexican," *Libération*, February 1.

Élisabeth Lebovici, "Liam Gillick, Économie parallèle," *Liberation*, February 17.

Mary Louise Schumacher, "Artist finds the right words for museum installation," *Milwaukee Sentinel Journal*, February 24.

"Liam Gillick," *Exit*, February.

Vincent Pécoil, "Une histoire à l'envers (a reverse story)," *02*, No. 32.

Charles Barachon, "Volvo, pour la vie," *Technikart*, February.

Jennifer Allen, "Briannnnnn & Ferryyyyyy," *Artforum*, February.

Philippe Dagen, "Liam Gillick ou les limites de l'engagement politique en art," *Le Monde*, February 24.

E. Sennewald, "Von der Utopie zur Positionierung," *Das Kunst-Bulletin*, March 1.

Nigel Coates, "There's no Place Like The Home Office," *Independent on Sunday*, March 6.

Hugh Pearman, "The Government Building that Isn't," *The Times*, February 20.

Philippe Dagan, "Liam Gillick ou les limites de l'engagement politique en art," *Le Monde*, February 24.

Bénédicte Ramade, "Gillick: preparer la visite," *L'Oeil*, March.

"Liam Gillick/Sean Dack," *Pi Magazine*, March.

Eldon Chim, "Liam Gillick/Sean Dack," *Zipmagazine*, March.

"Workshop," *Chinese Esquire*, March.

Lottie Moggach, "Art Buying for Beginners," *Financial Times*, March 13.

"Dior Homme," *Ming Pao Weekly*, March 12.

"The Home Office," *The Independent*, March 16.

Tracey Fugami, "Liam Gillick," *Art Papers*, March/April.

Kenneth Powell, "Home Office Comforts," *Architects Journal*, March 10.

Elisabeth Kley, "Goodbye 14th Street," *Art News*, May.

Alex Coles, "Liam Gillick and the Kenneth Noland Scenario," *Parachute*.

Mark Owens, "Liam Gillick," *The Blowup Magazine*, No. 3.

Mary Louise Schumacher, "Art for my President," *Milwaukee Sentinel Journal*, May 18.

Michael Gibbs, "Populism," *Art Monthly*, June.

Todd Meyers, "Liam Gillick," *ArtUS*, May/June.

Ken Johnson, "Everywhere's the same: Nowhere in particular," *The New York Times*, June 2.

Alex Farquharson, "Is the Pen Still Mightier," *Frieze*, 92.

Sophie Elmhirst, "Architecture as Background," *Guardian Public*, May.

"The Picture Page," *The Buffalo News*, June 16.

Mariano Mayer, "Liam Gillick," *Neo*, September.

J. L. Garcia Gomez, "Liam Gillick," *Málaga Hoy*, September 17.

J. Zotano, "Reflexiones Apalabradas," *La Opinión de Málaga*, September 17.

Marina Polonio, "Juego en el CAC Málaga," *Sur*, September 17.

Inma Escobar, "Liam Gillick," *El Mundo*, September 17.

Francisco Calvo Serraller, "Gillick analiza los cambios socials en un 'proyecto de pensamiento'," *El Pais*, October 21.

Carlos Jimenez, "Obreros atrapados," *El Pais Sabado*, November 12.

Javier Hontoria, "Liam Gillick," *El Cultural*, October 20.

Liam Gillick, "How has art changed survey," *Frieze*, 94.

Stéphanie Moisdon, "Blacklisted," *Self Service*, Fall/Winter.

Roberta Smith, "Liam Gillick," *The New York Times*, December 9.

Paul McCann, "Join a Swish Bank," *Wallpaper*, December–January.

Jesus Miguel Marcos, "Liam Gillick pensando el arte," *El Mundo*, November 15.

2006 Marie de Brugerolle, "McNamara Motel," *Flash Art*, January–February.

"Multicolor," *Neo 2*, March.

Michael Glover, "Best of British Lights up the Tate," *The Times*, February 25.

Adrian Searle, "Foot Fetish," *The Guardian*, April 3.

Ken Johnson, "Charting degrees of separation and connection in the art world," *The New York Times*, April 7.

Peter Bollen, "Artists in Residence," *The New York Times*, April 16.

Julia Chaplin, "Art Blooms in the California Desert," *The New York Times*, April 21.

David Barrett, "Tate Triennale," *Art Monthly*, May.

Jerry Saltz, "The Sublime is Us," *Village Voice*, June 29.

Roberta Smith, "Grey Flags," *The New York Times*, July 14.

Hans Ulrich Obrist, "A community of solitary souls," *Domus*, May.

factoriesinthesnow
textbylilianhaberer
worksbyliamgillick

Edited by Liam Gillick & Lilian Haberer

Editorial Coordination
Lionel Bovier

Editing and Proofreading
Clare Manchester, Salome Schnetz

Translations
Judith Hayward

Design
Liam Gillick & Gilles Gavillet

Production
Gavillet & Rust, Geneva

Cover Image
Four Levels of Exchange, 2005

Color Separation & Print
Musumeci S.p.A, Quart (Aosta)

Acknowledgements
All works courtesy the artist and various public and private
collections: Telenor, Oslo; Private collection, Vienna; Private
collection, New York; BSI, Lugano; Collection Fond national
d'art contemporain, Paris; Lufthansa, Frankfurt am Main;
Städtische Galerie im Lenbachhaus, Munich; Charles Balbach,
Buffalo; Albright-Knox Art Gallery, Buffalo; Tate, London; Lisa
Roumell and Mark Rosenthal, New York; Giancarlo Bonollo,
Vicenza; Caoimhín Mac Giolla Léith, Dublin; Ringier Collection,
Zurich; Hervé Loevenbruck, Paris; Baltimore Museum of Art;
Moderna Museet, Stockholm; Marx Collection, Aspen.

The publication has received generous support from Air de Paris,
Corvi-Mora, Emi Fontana, Casey Kaplan, Meyer Kainer, Javier
López, Micheline Szwajcer, Eva Presenhuber, Esther Schipper.

All rights reserved. No part of this publication may be
reproduced, stored in a retrieval system, or transmitted, in any
form, or by any means, electronic, mechanical, or otherwise
without prior permission in writing from the publisher.

© 2007, the author, the artist, the photographers,
JRP|Ringier Kunstverlag AG

Printed in Europe.

Published by
JRP|Ringier
Letzigraben 134
CH-8047 Zurich
T +41 (0) 43 311 27 50
F +41 (0) 43 311 27 51
www.jrp-ringier.com
info@jrp-ringier.com

ISBN 978-3-905701-64-7

JRP|Ringier books are available internationally at selected
bookstores and from the following distribution partners:

Switzerland
Buch 2000, AVA Verlagsauslieferung AG, Centralweg 16,
CH-8910 Affoltern a.A., buch2000@ava.ch, www.ava.ch

France
Les Presses du réel, 16 rue Quentin, F-21000 Dijon,
info@lespressesdureel.com, www.lespressesdureel.com

Germany and Austria
Vice Versa Vertrieb, Immanuelkirchstrasse 12, D-10405 Berlin,
info@vice-versa-vertrieb.de, www.vice-versa-vertrieb.de

UK
Cornerhouse Publications, 70 Oxford Street, UK-Manchester M1
5NH, publications@cornerhouse.org, www.cornerhouse.org/books

USA
D.A.P./Distributed Art Publishers, I55 Sixth Avenue, 2nd Floor,
USA-New York, NY 10013, dap@dapinc.com, www.artbook.com

Other countries
IDEA Books, Nieuwe Herengracht 11, NL-1011 RK Amsterdam,
idea@ideabooks.nl, www. ideabooks.nl

For a list of our partner bookshops or for any general questions,
please contact JRP|Ringier directly at info@jrp-ringier.com, or
visit our homepage www.jrp-ringier.com for further information
about our program.